Being
Kendra

T0182313

ALSO BY KENDRA WILKINSON

Sliding into Home

Being *Kendra*

Cribs, Cocktails & Getting My Sexy Back

KENDRA WILKINSON

WITH JARED SHAPIRO

itbooks

AN IMPRINT OF HARPERCOLLINS PUBLISHERS

BEING KENDRA. Copyright © 2011 by Kendra Wilkinson Baskett. All rights reserved. Printed in the United States of America. No part of this book may be used or reproduced in any manner whatsoever without written permission except in the case of brief quotations embodied in critical articles and reviews. For information address HarperCollins Publishers, 10 East 53rd Street, New York, NY 10022.

HarperCollins books may be purchased for educational, business, or sales promotional use. For information please write: Special Markets Department, HarperCollins Publishers, 10 East 53rd Street, New York, NY 10022.

FIRST EDITION

Designed by Renato Stanisic

Library of Congress Cataloging-in-Publication Data has been applied for.

ISBN 978-0-06-209119-2

11 12 13 14 15 OV/RRD 10 9 8 7 6 5 4 3 2 1

I'D LIKE TO DEDICATE THIS BOOK
TO THE TWO MOST IMPORTANT MEN IN MY LIFE:

MY HUSBAND, HANK III, AND SON, HANK IV.
I LOVE YOU BOTH, AND THANK YOU FOR INSPIRING
ME EVERY DAY OF MY LIFE.

Contents

Introduction

*H*ank and I had sex on the staircase today. Right there, flat-out spontaneous sex with our clothes mostly still on. Steps digging into my back, the banister acting as a bedpost. It was quick and skillful. I don't buy into that whole belief that married couples don't have sex. Because today was proof that Hank and I still do!

Of course, it wasn't exactly a stairway to heaven . . .

See, as parents now we have to try to fit in sex whenever we can. This wasn't a passionate act of sex where we ripped off our clothes and couldn't wait until we got to the bedroom. I was not a rock star Playboy Bunny getting it on with a stud NFL player. There was no trail of clothes—bra, shoes, socks, and panties—littering the hallway and leading all the way up to our bed. On the contrary, we actually went to the staircase on purpose and hurried through sex. Why the staircase? Hank and I both wanted to have sex, but we weren't alone in our house, as usual. My assistant, Eddie, was there working, so we sent him to the store to get a toilet plunger (we didn't really need one, we just wanted him out of the house). And the staircase just happens to give us a great view of the driveway so we could see Eddie's car pull up. So we did our deed fast and quietly, of course, since baby Hank was upstairs napping. Sure enough, ten minutes later Eddie was back.

In a nutshell, that's my new sex life as a mom. But I wouldn't trade it for the world.

Being on a reality show, I've got people coming in and out of my house at all hours of the day. Sometimes they're holding a camera, a set of lights, a microphone, a rack of size zero (finally!) clothes, or even a toilet plunger, but it's like a revolving door. My life is just one giant production schedule. I may be the boss, I may make a nice living, but I have zero control and have to bust my butt to get it all done by sundown. I've learned how to multitask with the best of 'em. Sometimes when I'm doing radio interviews on the phone from home, I'll press the "mute" button so I can pee. When you gotta go, you gotta go! There are sandwiches to be made, diapers to be changed, and pacifiers to be found (where the hell do they all go?).

My life has been a wild ride: from a stripper to a Playboy girlfriend to a pregnant bride to a mom with milk leaking through her tank top. And every day I wake up thankful to be where I am: in my new house. Of course, it wasn't always that way. I had hit bottom when I was younger and into drugs, but I clawed my way out. I took chances and found a path that worked for me—and landed me in some pretty interesting territory. Since I've already had my "bottom-out" experience, I knew it could only get better. And it did—a whole lot better.

The truth is, if I wasn't on my reality show, there's a good chance I'd probably be stripping. I had very little growing up and struggled for money when I was on my own, so now I work extra hard to build security so my son doesn't have to live that lifestyle. I left it all behind because I knew it wasn't where I was supposed to be.

My good friend, rapper Too $hort (he sings the "Go Kendra" title track on my show), has a song called "Gettin' It," and the lyrics are: "You should be gettin' it. Get it while the gettin' is good." I

live by these lyrics to this day. I live by the mantra of "work, work, work" and do whatever I can to take advantage of every opportunity that comes my way. In this industry, you are only good for so long. I'm not just doing it for myself anymore; I'm doing it for the family.

The whole "getting it" mentality has been with me since day one and stayed with me on my crazy journey to where I am today. I started stripping to make money and give myself a little financial freedom. Stripping got me discovered by Hugh Hefner. So I kept on stripping but took it to a bigger level: *Playboy*. *Playboy* got me recognition, on a reality show, and a guy like Hank Baskett to know who I was. We fell in love and we had a baby. I got it then, and I'm getting it now.

I still try to live by that. It's just the way I go about it that's changed. Instead of stripping to get it, now I'm a mom and that's what I'm famous for. I've let cameras capture my birth, my meltdowns, and my most private of family moments. But I did it all in the name of gettin' it. Right now is my time, so I'm getting it while the getting is good.

Luckily for me, I've had more success post-stripping, and it's likely I'll never have to go back to doing it (except for my husband). Where so many other reality stars party for a living, I have left the Hollywood party scene and struggled through the first few years of motherhood and marriage. I dealt with some crazy things as a new mom, including suffering through a dark depression and an uphill battle to lose weight after Hank Jr. was born. But I conquered it all—and, for the most part, I did so under the bright lights of my reality show cameras.

A lot of my success is because of my husband. I try to keep my marriage exciting and make sure Hank is happy, because he's my support system. I wish I could say that I was his too, but I'm not too

sure about that! The first football game I went to after Hank and I started dating was when Hank was on the Philadelphia Eagles and playing the Pittsburgh Steelers. He had the most amazing game; he had a lot of good games early on in his career. In fact, in the three years before Hank got married, he had seventy-one catches and was on his way to a pretty promising future. Then we got married, and all of a sudden his statistics plummeted. In the two seasons since being married (and now having a son), Hank has caught only six passes. We are keeping our heads up, but I can't help but wonder if maybe being married and having a baby was the curse to his football career. Am I the curse?

Regardless of Hank's on-the-field struggles and my off-the-field struggles, we've somehow managed to get our act together. Being a first-time mom, balancing my work and personal life (which in my career have somehow merged together), and dodging divorce rumors (both false and occasionally slightly, possibly, just a smidge true), Hank and I still managed to find time for dates, sex, and quick cups of morning coffee. I don't know how we do it. But I danced my way out of all my struggles and to the center stage of America's primetime TV sets. Being a mom and a wife has changed me in ways I never thought imaginable.

I've got a car seat sitting behind my driver's seat, I've got wipes in every bag I own, and just the sound of a kid screaming or crying sends my heart into a sprint. In my perfect world, I would put my son to sleep with a kiss on his forehead, share a bottle of wine with my husband, make love, and drift off into eight restful hours of deep sleep. But in my reality, usually the only thing on that list I do is kiss my son on his forehead. And that's just fine with me.

I'm the person I never even knew I could be. And I love it. This is my new story.

Being

Kendra

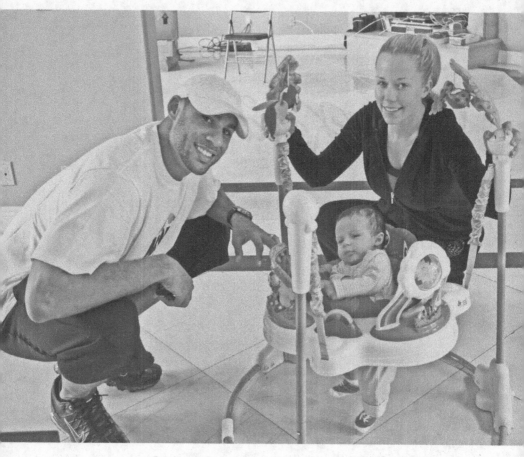

Teaching baby Hank how to walk at a very early age!

1

MOTHERHOOD 2.0

The Plight of the Modern-Day Mom

*I*s this yours or the baby's?"

My husband, Hank, held up a tiny jersey for me to look at. He hunched over open boxes in our bedroom and, of course, a big pile of my clothes mixed in with some of the baby's things. When I replied that it was mine, he winked and put it in a box labeled KENDRA'S CLOTHES. We were finishing up a grueling few days of packing our Studio City apartment—the most recent in a long string of apartments and houses in the last two years. But this move was the most exciting, and hopefully the last. We were moving into our first family house—our forever home—in Calabasas, California.

They say home is where the heart is. Well, my heart is with my family, but I still wanted that permanent safe haven for my one-and-a-half-year-old son, Hank Jr. And for myself.

Moving in was a monumental occasion because other than my marriage and my family I had very little else to call my own. I needed somewhere to put down roots. It took us a while to find the perfect house—someplace where paparazzi can't get into the gates, stalkers can't camp out, and random people can't drive by to look and say, "Hey! It's Kendra's house!" I finally felt like the house had everything we were looking for, but for me the biggest selling

point was when I walked into the community and heard the sound of children playing outside and splashing around in the pool next door. It was music to my ears. And it really was the main reason why I bought my house. We looked in a million different communities around Los Angeles, some of them high-end with lots of celebrity residents, but one thing was missing: kids. And that's not right for my family. I wanted to give Hank Jr. a neighborhood full of kids his age and a family-oriented safe place for him to grow up, not to mention fulfilling my own needs of a five-bedroom house with a pool. It's big by normal standards, but it's well proportioned. Nothing about it is over-the-top or extravagant—it's a home not a mansion.

Hank spent a lot of time at the house getting everything ready for us to move in—painting every room and dealing with a couple small fixes here and there. I was rehearsing and filming for *Dancing with the Stars*, so he worked his ass off trying to get everything in place, including baby-proofing. We had to make sure nothing about our new home would be a danger to baby Hank. The pool is fenced all the way around with metal bars. We like to barbecue a lot, so we have caps on the on/off switch for the grills since Hank Jr. loves to press buttons. We put covers over anything that gets hot, we installed door handle locks on all the doors to make sure Hank Jr. can't get out, and we put in a metal gate at the top and bottom of our stairway. And, of course, socket covers all over the house.

One of the last times Hank went to our dream house before we officially moved in, he took baby Hank with him and the next-door neighbors invited Hank Jr. over to play with their kids! That made me so happy, I just started to cry. Someone could offer me a million dollars to take a different house and I wouldn't care. Money is just money, but when I heard that there were kids baby Hank's age right next door, I was thrilled. He'll probably grow up with them and go

to school with them. This is where lifelong bonding begins. I imagined his wonderful childhood unfolding in that neighborhood. It's the best thing I could have heard.

And since we moved in, I've met all of the neighbors and they are awesome. I know I made the right choice. Hank was over there a lot more than me because I was on *DWTS*, so he got a head start on meeting everyone. But after *DWTS*, I finally got to know them all. We'd run into each other on the street, we'd see each other in our yards, and we'd just start talking about the neighborhood—it's something we all had in common! It was all just so easy. We felt like we'd been living there for twenty years.

This was so important to me because for so long we had been moving baby Hank around to a million cities, in a million homes, and never letting him get to adjust. We were in cities we didn't know and without friends or family for support. I tried to keep him indoors and away from the elements, whether that was freezing temperatures, city life, or just anything we couldn't control. But I don't want to hide little Hank from life anymore. I may be scared of all the dangers out there, but I'm not going to keep my son safely indoors and shrouded in bubble wrap. I'll book him playdates or take him to the park, and whether the parents know I'm a celebrity or not doesn't matter. Raising kids in Hollywood doesn't mean your kid has to only grow up with famous friends. While I will always be paying close attention to anyone who is approaching my child, what's most important is getting baby Hank out there with other babies and letting him develop the social skills he needs.

I take baby Hank to a baby class every Thursday for a twelve-to-twenty-month class where he can socialize. I've noticed that I'm one of the only parents who allow their child to go off on his own and explore. Every other parent is attached to his or her kid like glue. When their child wants to interact with Hank Jr., their

parents just grab them and say, "No, no, no. Be nice." And all I can think to myself is, "What do you mean 'be nice'? The baby didn't do anything! Are you serious?" If the kids tap one another to talk, let them tap each other. That's not hitting. I know when baby Hank is trying to hit someone and when he's just exploring or trying to make friends. I think parents meddle in their kids' business way too much.

I have been noticing that kids are a lot more sheltered than they used to be. I don't know if it's me or society, but it seems like parents are more protective of their kids than ever. Not me; I'm all about little Hank Jr. falling down and knowing what it is to hurt. I want him to be tough. I am raising a kid, not a porcelain egg. He deserves to learn for himself what it's like to fall or get a scratch.

Recently in our old neighborhood I took baby Hank to the park on a Sunday and there were only five kids there on a sunny day in L.A. Where is everyone? Now, I don't expect Shiloh Jolie-Pitt to be there, but surely more than five kids would want to play outside.

Luckily two kids there were his age, so I encouraged him to invite one of the other boys over to play with him. He was so excited to hang out with a boy his age, but before they even got settled, the dad came over and steered his son away so he wouldn't bother us. I said it was no problem—we were just sitting in the grass blowing bubbles, not much to interrupt—but they left. Socializing is good for kids, so I want Hank to ask to play with other kids in the park. Am I the only one letting my child explore? If so, am I raising him the wrong way?

That's just how I was raised. I loved building forts, and I fell from trees and scraped my knees. Now I look back and I thank God for my childhood. I remember a couple times where I got hurt pretty bad and I was bleeding, but I was fine and it made for the best stories. My mom used to kick me and my brother outside to

go have fun and explore. I actually stole my grandpa's wood out of the garage and would take a hammer and nails and put it together. Most kids can't do that kind of stuff anymore, but I wonder with kids so protected and isolated what they will grow up to be.

I'm constantly trying to guide Hank Jr. down the proper path, to keep him away from the bad temptations I faced and move him toward the good experiences I did have. I laugh about it because the only way I can explain it is to say, "I don't want to shelter him, but I do want to shelter him." I've seen so much craziness throughout my life, so much dirtiness, and I lived through it. Now I feel like it's my job as a mom to protect him and prevent him from experiencing any of that. I know a kid is going to be a kid. Scrapes are fine; he will fall. But I want to do whatever I can to raise him right. It's my job to guide him into good habits, not bad habits.

I don't want him to be aware of how crazy adults can be . . . yet. So I shield him from it. If Hank and I are getting heated, we make sure to spell things out or give each other looks that say, "Let's wait to finish this conversation until we aren't around the baby." It's like pressing pause on whatever situation we are in. It's harder for Hank to wait three hours to finish our argument—he usually gets a little more heated during our spats—while my natural instinct is to delay the argument and protect the baby. I don't want baby Hank to have bad memories of his parents fighting; I don't think there's any way to erase that. I will always remember my father's rage when my parents fought or the time he punched a hole through the wall. I will never get that out of my head. I don't want that for baby Hank. I always want to make sure he has nothing but happy memories. Life isn't perfect. I know there will be times where Hank sees us fighting, but I want to do my best to limit it. I am always aware. As much as I might want to fight in that moment, it's not worth it for baby Hank's sake.

Hank Jr. deserves the best chance possible. He's got more of an advantage than Hank and I had combined. My teachers sucked, my friends were as bad as me, and my mom was working all the time. So I'm not letting that happen to baby Hank; I'm guiding him through his childhood. I'm his guardian angel. But I also know that makes me a bit of a control freak.

People are afraid of everything. The reality is there probably isn't so much to worry about. We remember all of the bad things happening in the news and on TV, and we're scared. It's a natural reaction, but it affects our everyday life and how our kids perceive the world. It's either a wonderful place full of opportunity or a scary place. I say, turn off the damn TV, get off the Internet, and just let your kids be kids.

I remember when I was a kid and I had only twenty-one channels on my TV, and that was more than enough. We had lots of news, Nickelodeon, and MTV (which I was banned from watching until junior high), and then we had VH1 and E! and HBO. Having only those channels made me appreciate it more when a movie came on every Saturday night on HBO. With so few options, I was bored just staying inside. It made me go outside and enjoy life. Now we have thousands of channels and too many options!

Hank and I had very similar childhoods and we talk about it all the time. We liked the same sports, watched the same shows, and shared a love for Pogs. Now that I know that Hank collected them too, I'm sure on the same day at the same time we were both playing Pogs. And we both had so much fun playing outside. That's what we want for little Hank. Even though my teenage years sucked and Hank went through hard times too, we are so thankful for our childhoods. We both just loved running around playing tag, playing softball, building forts—that was a real childhood. It's because

of those experiences that we are so passionate about giving Hank Jr. the best childhood he can have. Which to us means freedom and exploring. Of course, we are teaching him his left and right and things like don't cross the street before looking both ways—the commonsense stuff. But everything else we just want him to explore on his own. If he falls, he falls. We are going to let him figure it out for himself.

When Hank Jr. cries we don't always run to him if it's not serious. We want him to gain a sense of independence and not always look to us for help. I don't want him to think that we are always looking over his shoulder spying on him or that we'll always be there when he falls. Hopefully we will, but it's not a guarantee.

We're still adjusting to life in the suburbs, and we are desperate to find him a playdate. Of course, Kourtney Kardashian and I have talked about playdates. But in the year and a half since our kids have been born it's still yet to happen. We both have busy work schedules and travel back and forth between New York and L.A. Now that we're both living in Calabasas we will hopefully end up doing it soon.

As a parent—wait, who am I kidding? In life!—I rarely do anything by the book, but I try to follow my natural instincts as a mother and do what I think is best for baby Hank. There are so many differing philosophies out there on parenting, nutrition, bedtimes, you name it. It's hard to know what to do and which is best for my son. So I try to stay true to my instincts and consider everything in moderation. I try to keep him healthy and use natural products, but when it comes to medicine, I use it as needed and directed. I'm not going to go all-natural with that. If he is sick I'm going to give him medicine to take away his pain. Any time I give him a shot I get so scared because of all of the horror stories out

there that it causes autism. I did my research though and I think that all of the people out there saying "don't do it" are actually doing more harm than good.

Jenny McCarthy is one of the foremost activists when it comes to fighting the practice of immunizations. I like Jenny a lot and I respect what she stands for. But my belief in her cause changed drastically after I had a child of my own.

I first met Jenny long before ever getting pregnant. I was living at the mansion at the time, and we were invited to one of her events (well, Hef was). It was a benefit for autism being held at Jim Carrey's house. She showed us all the information she had and talked about autism and some of the causes of it. That night I realized how serious the issue was and I learned a lot about Jenny's beliefs about the causes and the importance of awareness.

A little while later I got pregnant and the H1N1 virus was going around like wildfire. It was all over the news that pregnant women were at risk, so I went right out to get a regular flu shot. Unfortunately, I got *really* sick. I was sweating, had a high fever, and ultimately had to go to the hospital. It was obvious to me that this was a direct result of getting the flu shot, because it happened within hours of my vaccination. I was so scared I was going to lose the baby. I was shaking and having mini seizures. Then guilt set in. I thought back to that night at the autism benefit and remembered what Jenny McCarthy had warned us about vaccinations. I had filled my body with foreign substances, which my body was trying to reject, so I got angry at myself. I just kept asking myself, "What did I do?" I was petrified that I had put the baby at risk. I spent the rest of my pregnancy, four long months, with this worry in the back of my head.

A few months later in Indianapolis, when Hank Jr. was born,

the doctors asked me if I wanted my child to be part of a vaccination program. I wasn't prepared for the question and struggled to weigh the pros and cons to find an answer. Sometimes with stuff like that I wish they'd just go ahead and do it. I'm not really qualified to make those kinds of decisions; my only education on the subject of vaccinations is what I remember from looking it up on Google while I was pregnant. I thought back to Jenny McCarthy again, and after my flu shot experience, I was really on her team. I needed to know more to make this decision, which seemed more important than ever, so I asked the doctors at the hospital about the benefits and risks of getting vaccinated and not getting vaccinated. What are you giving to him? How much? What percentage of people do it vs. not? They explained to me that if my baby got one of these viruses or infections, it's a much worse outcome than if he were to get autism. I know that's a horrible thing to say, but the chances of something bad happening are far more likely and deadly if he doesn't get vaccinated. With this new information in hand, my views changed. This was about what's best for my son. And now that he was a living, breathing human, I wanted to protect him even more. So I gave him the shots.

I gave Hank Jr. the shots my way though. I spread them out instead of flooding him all at once. I said, "You can give two shots now and spread out the rest. We'll come back as often as needed to get it done. Just don't do it all in one day." That was my way of trying to protect my baby. That's what made the most sense to me and felt right instinctually for my family. We all need an advocate in this world, and I definitely think Jenny McCarthy is doing a great job being an advocate. If God forbid anything were to happen to my son, I'd be an advocate too. Jenny speaks with her actions, and they show how much she loves her son. She doesn't

preach but educates and shares her powerful experiences. I don't believe in telling people what to do. You have a choice, you either listen or you don't. She's had to suffer and she's dealing with it. I listened to her and learned from her experiences, then I made my choice.

Kids living in poverty who don't have immunizations and health care are more at risk of getting infections that turn into other problems. We are fortunate, so we should use the resources we have.

I talk about this stuff all the time with my friends who are also moms. When one of my best friends, Mykelle, was pregnant, I sent her an e-mail full of advice, the facts of motherhood. I wanted to write her woman to woman, mom to mom, and tell her how I survived the first couple months. I didn't go off any books; I went off my own experience, intuition, and instincts. I covered everything, down to stealing everything at the hospital, anything they have laying around.

Here's exactly what I wrote her:

Dear Mykelle,

In the 1st year of being a new mother I've learned so much, but not by the book and I want to share some of those lil tricks, shortcuts, ideas, and ways that made mine and Hanks and baby Hank's lives easier. I suck at typing but here I go lolol. Starting all the way from hospital . . .

1. Once I had the baby the docs were very forceful with breastfeeding it made me stressed out . . . my milk didn't come in until day 3. I would cry because I thought something was wrong with me but everyone's milk comes in at different times. Anddddd DO NOT stress if he doesn't latch on immediately . . . keep trying . . . don't give up even though you will want to.

Don't feel guilty if you want to take those days at the hospital and rest as much as you can because your body just went through war!!!

2. Steal the stuff around that they provide at the hospital for extra stuff. They don't care. Its diapers and wipes and formula.

3. Pack yours and Bob's favorite card game, movie, music, and thick ass pads for you bleeding vagina. Seriously bring a million of them, it's like a bloody Niagara Falls.

4. After the epidural and medication I was sooooooooooo itchy . . . anti itch cream or lotion will help. Bring that too.

5. Feed the baby as much milk/formula as the baby will eat . . . I made the mistake of always giving him only a certain amount and he'd wake up starving . . . I wish I knew that simple thing. Keep going until he stops.

6. Wake up when the baby wakes you up . . . Don't wake him up to feed . . . I killed myself setting alarms . . . don't be afraid to let him sleep, he'll wake up when he's hungry and he'll cry when he's tired to go back down. Especially at first, they don't fight much.

7. I'm getting you some things for the baby shower but if you decide to shop for yourself before that get allot of bottles (so you don't have to run the dish washer every five minutes!) and a BOTTLE WARMER! I didn't have one until the 2nd month and thank god I learned about it, the babies love warm milk!

8. Diapers.com is the site Hank and I use for diaper deliveries, and stuff to stock up on for baby. Don't worry about over ordering, it's impossible. Think about how many wipes you might need and then order five times that amount.

9. Change his diaper where ever is comfortable to you . . . don't always go to the changing table. If you want to do it on the floor or the couch or the kitchen table, do it.

10. I don't think we've used baby powder since first week he was born . . . Overrated.

11. I love the unscented baby lotion better than the powder fresh . . . it moisturizes better I think.

12. When you yourself need to shower, do it with the baby in the bathroom of course in a safe spot and always check on him. Put him in a lil baby swing chair thing or a basinet and keep popping your head out to check on him.

13. It was easier for me to have 2 baby swings . . . one in the living room and one in the bedroom. Of course a crib but also a cheap portable carry around crib thing . . . easy to find and you can just move it from room to room.

14. There is a little bed protector type thing where he can sleep in between you and Bob if you choose to have him in bed, it protects him from you rolling over on him!

15. Have soothing music on for him . . . not too loud but a good volume so he can get used to noise and that'll help cancel out the noise u and bob make :)

16. Lil Hank can sleep during loud ass fireworks and always has because we weren't afraid to be noisy around him. Basically the louder you are when they are little babies, the better off they will be in learning to sleep through anything.

17. ONESIES are the best for lil Hank to sleep . . . You don't have to worry about him getting cold without a blanket because everything is covered.

18. The first month we would go 3/4 days without bathing him or even changing his clothes. They can't move, they have small poops and you are changing their diaper every few hours so they don't get that dirty, especially since they aren't supposed to go out toooo much. When you do wash the clothes . . . DREFT :D

19. Get a wipe warmer, it is awesome . . . isn't so cold on his booty

20. As soon as we got home with baby Hank we just threw him on floor to get used to life lolol of course on a clean floor, but the less you cater and baby this kid the more likely he will be to go with the flow.

21. Burping—every kid is different but baby hank was always messy when he was little . . . so always have a towel.

22. When I saw husband Hank sleep I'd get really jealous and start fights because I was beyond tired . . . leave the room and you or bob sleep on the couch . . . there will be a lot of nights where you'll have to separate. Prepare for two separate sleep areas for both of you. No joke!!! It doesn't mean you are fighting it just lets the other one sleep better!

23. Those store bought plastic breast pumps didn't work for me.

24. Prepare quick meals for u whenever you can and stock up on prepared foods. I only had time for Lunchables and junk like that.

25. COFFFEEEE

26. I used my phone to help with his sight. In a dark room I'd take my phone, not close to him because it's too bright, and move back and forth until he moved his head . . . that was the 1st big milestone baby hank did and I was so happy when he moved his head to the light of the phone lol.

27. Don't be afraid to tell motherfuckers to wash their hands . . . always squirt antibacterial in peoples hands that are going to be around you and the baby . . . if anyone gets mad, slap them!!!!!

Everything else:

- Rice cereal worked to fill him up so he sleeps longer, but it can constipate him, so maybe throw some fruity taste in there when he's old enough.
- Get a baby bath tub to bathe on kitchen counter or bathroom counter for about 2 months so you don't have to mess your back up bending over the tub
- Yogurt is a good healthy quick fix for you.
- A nose plunger to get his boogers and snot and nail clippers.
- Baby Aquaphor for baby lips and dry areas.
- baby monitor!!
- Air purifier or if dry a humidifier
- Diaper genie—it's a trash can for diapers and keeps the room from stinking and you can stack like a million dirty diapers in it

So there you have it. Girl, let me know what you don't get so I can get it for you because the last thing you need is 5 of everything because you will barely have room for 1 . . . well that wouldn't be a bad idea though hahaha. We always put a warmer, thin blanket for his sheet on crib . . . sheets got cold and not comfy for lil Hank . . . but if you are scared then be safe and go the sheet.

I wish someone had sent me a note like that before I gave birth. But I learned it as I went and found what works for us.

2

LIGHTS, CAMERA, DIAPER CHANGE

My life for a long time before Hank Jr. was simple. I did what I wanted, when I wanted to, and however I wanted. I'm not saying I was happier, but it was definitely a whole lot easier. As any working mom knows, it's not easy balancing a busy career and motherhood. There are so many demands and it can feel overwhelming to make sure you're not letting anyone down—your boss, your husband, your baby, or yourself. For me, filming the show, traveling, and working several jobs all while raising a baby can be a lot. But I try to stay grounded, focus on what's most important—baby Hank, my husband, staying healthy—and let the rest fall by the wayside. Easier said than done, of course.

I have had these cameras following me for most of the last decade. Being a first-time mom with no training and little guidance is hard enough without it being documented—especially just hours after birth. The cameras raise the stakes and highlight any parenting lapses. It's that much harder to keep a sense of perspective with two cameramen, a sound guy, and a producer following you from your bedroom to the bathroom to the nursery to the kitchen. I loved the fact that the show recorded the birth of our son and my very real learning curve, but it also came at a price. When you have never changed a diaper before, or never held a

baby, the cameras add that much more pressure. Not exactly the type of home video footage you want to sit on the couch and watch over and over again.

The cameras and bright lights were shining as I tried to wipe poop off my squirming baby or breast-feed him. Can you imagine what it's like to be changing a diaper for the first time and have a producer say, "Oh, can you slide a little bit to the side so we can get a better angle?" But the show's producers were excited to capture every real moment in these early days. They even requested to wake up with me in the middle of the night for feedings and diaper changes. The crew stayed in the house all night long, and if I so much as farted in my sleep, a group of cameramen would come running up the stairs to see what all of the stirring was about. I woke up every three hours to feed and burp and change Hank Jr.'s diaper, like clockwork. His schedule was: three A.M., six A.M., nine A.M., twelve P.M., three P.M., six P.M., nine P.M., twelve A.M. . . . Hank was hungry, and he would cry if I was a minute late.

I'd go to sleep at nine P.M. and three hours later at midnight I had cameras waiting for me to wake up; rise and shine! I had my microphone on and the little battery pack attached to it on my side while I was trying to sleep! Then it would happen all over again three hours later. Who the hell wants cameras in their face at three o'clock in the morning? Especially when you have to get up and pee. And let me tell you, there were plenty of times when I did that (and more) while the microphone was still on.

I had a difficult time breast-feeding in the beginning and was getting really frustrated. But I had planned on breast-feeding and I was determined to do it, swollen, sore boobs and all. It was hard at first; Hank just wouldn't latch on properly, though he liked to bite. And of course, the cameras were on my face so that certainly didn't make it easier. There's nothing worse than that feeling of not being

able to naturally feed your child, especially when the whole world is "recommending" that you breast-feed. I kept wondering what was wrong with me. With cameras rolling, seconds felt like minutes, and minutes felt like hours as I struggled and second-guessed myself. It may seem like one minute of footage on the show, but it was more like weeks in real time.

Finally, though, he latched on. It was five P.M. at this point and I had been up since the middle of the night before, so I was exhausted and running on empty. I had tried to breast-feed for more than a week, but it just wasn't happening. Then, at last, it happened. I was so excited, but Hank was downstairs so I called him on my cell phone and whisper-yelled for him to get upstairs. I didn't want to scream too loudly because I didn't want to startle Hank Jr.—he was in the zone! Hank came running upstairs to join us.

I was on cloud nine—"Hallelujah! I'm feeding my baby!"—and suddenly the producers of the show were knocking on my bedroom door saying, "We need to film this now!" Well, Hank and I went off on them. This was the first time our baby was breast-feeding and we needed to share this intimate moment. Hank yelled and got mad, screaming, "Get out of the room right now." That's my man!

That was a huge reality check for us. On the one hand we had invited these cameras into our lives to film us and we knew that was our paycheck, our job, our security. But on the other hand being new parents and having to go through all hours of the night and day with cameras rolling . . . it just wasn't a good fit. It was just too much pressure. Talk about a father reaching his boiling point though.

I just wasn't prepared for them to knock on the door like that. I will never let that happen again. I'm always struggling to find the balance between my family and my career, and I can't afford to have either of them compromised. I know how to live in both worlds but if anyone's going to combine them it's going to be me, not a camera crew.

Hank and I came up with some rules for the show and the producers, the most important of which was to respect the baby's feeding time. If you want to shoot me feeding him, just sit there and press "record." Don't tell me to say anything or do anything else. Don't laugh, don't help, and don't pitch in, just film. Be a fly on the wall because if you're not I will swat your ass. I learned my lesson and the producers learned theirs and I think we are all better off and happier because of it.

When you're a new parent there's no time to sit down and hold a town hall meeting. As a mom there's no democracy; you are the dictator and everyone else has to listen to your rules, take it or leave it. In a family someone has to take the lead and make decisions, and in my family that's me.

What am I getting at here? Well, modern motherhood means making your own path through uncharted waters. I have a lot going on in my life, but I can still be a good mom even if I'm not staying at home all day with an apron on. The role of a 1950s mom is just so completely foreign. I've got to give it to all of the moms who came before me; they did a hell of a job. But times have changed. It doesn't have to be all or nothing. I'm still going to go out and drink with my hubby, I'm still going to look hot (who says moms can't wear thongs!), and I'm still going to shake my booty on the dance floor. But hopefully I'll be in bed and sober (PS: Chugging some Pedialyte is the ultimate hangover prevention and cure—it's electrolytes without all the sugar) before the sun comes up. Because my little baby's going to be up at the crack of dawn.

I knew my life changed the moment that baby popped out of me. I had a pretty good idea of who I was and where I was going, but then I became a mother and everything was different. So allowing my TV show to film my first years as a mom just added to the stress I thought I'd already be prepared for! I had not only

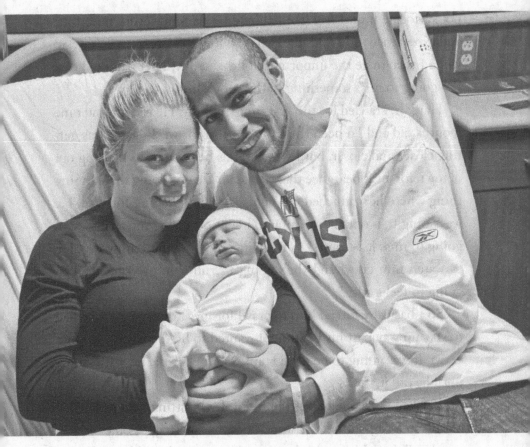

My son, Hank, born and raised in Indianapolis, Indiana—ha!

brought my work home with me, I had let it set up cameras in every room.

And no matter how much help you have (or lack thereof oftentimes in my case), if you are a neurotic mom obsessed with perfection and planning every aspect of your child's life right down to the number of ounces of milk he drinks for a snack, then balance becomes even harder. I find myself wanting to micromanage everything in baby Hank's world because I love him and I want to protect him. And I'm scared that I won't always be able to protect him. But I'm striving to navigate that, to find a way to be there and

not suffocate him. I feel like I should be there for every milestone and experience in Hank's life, which puts extra pressure on me. So while I recognize the importance of the nanny, I get paranoid that I'm going to miss something in the baby's life.

Hank Jr. crawled for the first time in Philly. He was around nine months old and I'd been thinking about it for weeks as he was getting closer and closer, but I was nervous because I was heading out of town for an appearance that weekend. He was doing that lunging thing where he's hunched up on his legs and pitching forward. He was going to scoot at any minute. I kept obsessing internally: "I'm going to miss it because I'm traveling and now this nanny is going to watch him crawl and she's going to rub it in my face and I'm going to feel guilty."

So I basically forced him to crawl for me. I didn't care if he had to stay up way past his bedtime. I wanted to be the first to see him crawl. It was going to be little Hank and me for the next few hours until he did it.

I kicked everyone out of the room. I was sitting next to him on a little area rug on the hardwood floor, whispering, "Come on, you can do it!" I put him on his hands and knees, pushing him and dragging him. I gave his little butt a pinch, almost to give him a little shock and jump start, anything to jolt him. "Come on, baby, this is how you do it!" I kept checking the clock because I was worried I was going to have to leave. It was definitely a "working mom" moment (even though I was dressed in my usual travel wardrobe: sweats). Finally when I started giving up, he took two little teeny crawls. I screamed for joy: "He's crawling!" The nanny came in and I made it a point to let everyone know that I was the first one to see him crawl. It's a pride thing. It was like an hour before I was supposed to leave and he finally did it. I said to myself, "Okay. I can go now."

Hank and I want to be there for everything important in baby Hank's life, and we both have the kind of jobs that can keep us away from our family. When life gets crazy, we try to sit back and assess our family and make sure we acknowledge everything in baby Hank's life. The day baby Hank took his first steps, Hank was away in Minnesota playing for the Vikings. I had this feeling that Hank needed to see his wife and baby—call it a mother's intuition—so I Skyped him. We hadn't been living with him for more than two months and he was really depressed about being away. It was snowing and cold where he was and he was really missing us. Once we got the camera turned on, I showed Hank baby Hank crawling around and then we just started talking. The next thing I know Hank is pointing to the baby behind me. Hank Jr. had just stood up and taken his first steps! Without any prompting, Hank Jr. just stood up and wobbled a few steps. Hank was crying on Skype out of happiness. He couldn't believe it! He thought he was going to miss his first steps while he was away. What perfect timing!

3

I EAT BREAKFAST IN THE SHOWER

I don't want to sound like a whiny little celebrity saying, "Imagine never being able to just up and go to the beach or the mall," but really just for a second try to imagine that you can't go to the beach. We've tried it—me, Hank, baby Hank, carrying tote bags full of sunblock and toys, buckets and shovels. And before we can get the umbrella up and baby Hank's T-shirt off, fans approach us asking for pictures and autographs. It's an amazing feeling to be loved like that, and I appreciate having fans who take the time to come say hello. I wouldn't trade that for anything. But actually, I guess I would just for a day so I can take my kid to the beach to build a sand castle. For us, sand castles will have to be built in the backyard.

I always struggle with finding that balance, between wanting to protect baby Hank and letting him explore the world for himself. And I also look for balance between my personal life and work. I love what I do and the amazing experiences and opportunities I have in front of me, but sometimes I want to stay home with my family. So to have more time for both, I find myself giving up my time and personal needs.

My job doesn't end when the cameras leave. It's an all-day, every-day thing because my image and reputation follow me everywhere I

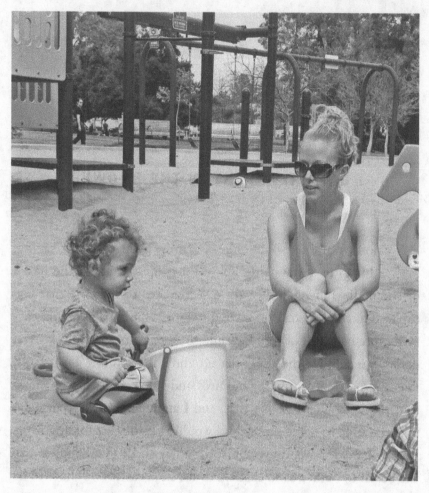

We are obsessed with parks and getting Hank Jr. outside and exploring. It's his world!

go. I know this is the life I've chosen, but sometimes I question whether I am making the right choice as a parent for my child. This is how we live our life. Hank and I try to make sure that if we have a night out on the town it's on a Monday night, the *least* crowded night in a restaurant. We rarely go out to restaurants on a Saturday night because they are too crowded and it's a lot harder to have privacy. That is not a complaint—it's just a reality. Lucky for us, we *love* renting movies and kicking back in our home, no matter where that happens to be!

Our new home in Calabasas is what I like to call "celebrity-ready." Lots of actors, producers, and families in the entertainment business live in Calabasas. They couldn't care less if the Basketts move in. We are no different from anyone else. Right now I'm in the process of getting to know my neighbors. It's funny because in my head I always assume they know who I am, and they probably think, "Oh God, Kendra." That's just my insecure side, but I feel I need to show them who I really am, not just who they see on TV. I feel like I have to really work to have people like me for my real self. That's my *real* job right now, showing my neighbors I'm not a stripper. I'm more than just an outgoing, outspoken blond girl on a reality show.

Sometimes people don't know who I am and I love that. My new neighbor across the street kept saying she didn't know who I was. She doesn't watch TV and had never heard of me. The first time I went over there I stayed until one A.M. and we just chatted about everything. She didn't ask one question about a sex tape, or Hugh Hefner, or *Dancing with the Stars*! She didn't know anything about that stuff. Of course, in the back of my mind, I'm thinking she must have Googled me. But even if she did, she didn't act any differently toward me, and I love her for that.

That's my biggest fear: that everywhere I go, especially among my neighbors, everyone has Googled me. The first things that come up about me on Google are disgusting. It's like my résumé, and it's not a good thing—links to a sex tape, pictures of me in compromising positions from *Playboy*, etc. So I have to make sure I talk about who I am so they know that's not me. I party for a living, not in real life, and I need my neighbors to know that. Last May, I was hired by a company to go down to the Kentucky Derby to host a party. My job was to look hot, drink, and party—so that's what I did. But believe me, if that wasn't my job, I probably wouldn't have just randomly been there. But you know what? I'm going to have

fun while I'm doing it. A lawyer doesn't come home to his family and talk about the law all day. I don't come home to my family and party all day. But a lot of people I meet think I do.

For my fans, I feel like I'm the link to the celebrity life and people can live vicariously through me to know what that lifestyle really is like. I'm a completely normal person who gets to experience some of the perks that come with fame. And, of course, the downside. Most Hollywood stars aren't going to say how it really is. They're going to say they can do as they please, and it doesn't bother them. But do you ever see Hollywood stars fly coach? They don't.

I can still fly commercial (oh, wouldn't it be nice to have to fly in private planes all the time!) but I do need some security assistance to get through the airport. I totally get it; you see someone you are a fan of and you go approach them to say hi! I still do that myself. So we hire airport greeters to take us through the lines and straight to our gate and stay with us. They greet me right when a car drops me off, with my ticket, and then they'll rush me through the lines. It's not bad to avoid the security lines and airport aggravation, but it's not free.

Balancing celebrity life comes with a high cost. You pay extra for everything you need to ensure a little privacy and safety. And balancing personal life comes with a lot of exhaustion, guilt, and effort. I see a lot of moms today who are living two lives at once. On the one hand they're taking their kids to the park, or a class, or for a walk. But at the same time, they've got their Bluetooth in their ear, or they're typing furiously on their BlackBerries, or even BBM-ing with other mommy friends. I can't pull that off. Kudos if they can. I love that moms today have their own lives and aren't tethered to their kids 24/7. But I can't do that. One thing I am when I'm with Hank Jr. is present. Maybe I'm feeling guilty because I'm gone a lot for work or so busy doing a million different things for my career,

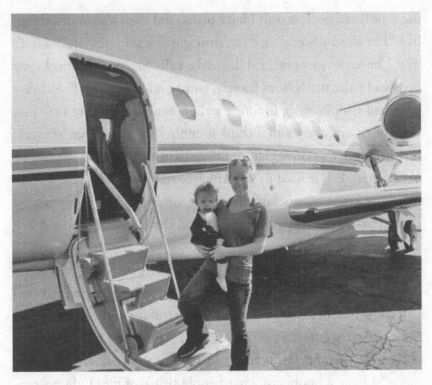

Every once in a while we get to ride in style.
Of course, if I'm paying, we're going commercial!

so I feel like when I am with baby Hank I really need to *be with* him. When I'm spending time with the baby, I make sure the computer is off and the cell phone is gone. It's all about him.

I'm a person who holds on to my cell phone religiously. I take it everywhere I go. But I don't text, return calls, or even pick up calls. That phone is basically in case of emergencies; it makes me feel safer to know that if something happens I have my phone in hand to call for help. I always check out all of the exits in a room and scope out strangers within my vicinity. It might seem like overkill, but I know there are some crazy people out there and I'd rather be safe than sorry.

I don't use the phone for long chats or casual conversations. I like to get my business done quickly, even with friends. So I usually

use it only if I get lost or if I have plans, and then it's a quick thing, like "I'm almost home" or "I'm running five minutes late!" That's why I have my assistant, Eddie, make calls for me. He checks my texts and voice mails from friends, family, and my team. I've always been bad with keeping in touch and communication, but now that I'm a busy wife and mom, I think it might be getting even worse. If I'm driving, or working out, or busy, it's just so much easier for me to dictate to Eddie what to say. Any free time I have is spent worrying about Hank Jr., stocking the fridge, or taking care of my family. I just don't have time for small talk and that's what I've found I've usually used my cell phone for.

If I need to schedule an appointment I freak out. It makes me nervous! I don't know how to leave messages or voice mails, so I never leave them for anyone. I just hang up and call back and hope the person picks up the phone. I hate being like, "Hi, this is Kendraaaaa and I'm coming in for my gynecologist appointment." I have a phobia of what people think of me. I always picture five people in an office sitting around playing my voice mail message over and over again and laughing at it. One of the main reasons I hired Eddie was to help me make appointments, pick up cell phone calls, and leave messages, and keep me in touch with the world!

That's not to say I don't have a little me time. But it's more necessity than luxury. I go to the gym to stay in shape and look good—not to pamper myself—because that's part of my job. But I haven't always had time for that. Especially the first nine months or so after Hank Jr. was born. I was shooting *Kendra*, writing my first book, moving across the country and back, so I really had no time to do anything for myself. Plus it's not always that easy to just go to a spa one day without feeling like the whole world is staring at me. I know I'm not Angelina Jolie, but I do get recognized. With my luck

I'll go into a spa dressing room on the same day as a bachelorette party and I will be butt naked and one of them will scream, "Oh my God, it's Kendra!" and they're all drunk and it's just creepy. People want to take pictures of me in the weirdest places. I'm not trying to sound conceited, but there is a time and place for taking a picture on your camera phone and it's not in a spa dressing room when I am naked! (Full disclosure: That's never happened, but mostly because I refuse to go to the spa and let it happen. My fear is that it will!)

Besides, when I became a mom, hygiene, relaxation, and personal space became things of the past.

I don't even have enough energy to bathe baby Hank every day; I have even less energy (and time) to bathe myself. I don't know how some of these moms do it; kudos to them! I think I'm pretty young and fit, and Hank is definitely fit, but by the end of the day we are pooped. So we bathe him every two to three days. People make such a big deal over bath time—"Oh, I have to bathe him every night before bed," they say. I'm like, "How the hell do you bathe your kid every night? You'll be a hunchback!"

I work really hard so that I can get my stuff done quickly and spend time with Hank and the baby. That's why I eat my breakfast and drink my coffee in the shower pretty much every morning of my life. I don't like to waste time on necessary things, so when it comes to anything to do with myself, like showering, I rush through it. I'm not big on manicures or pedicures, and I don't relax when going to the bathroom. I think all that stuff wastes time I could be using to accomplish something else more important. So I try to avoid taking a shower as much as I can because it's such a time suck for me.

But if I'm going to take a shower I'm going to make the best of that time and multitask. While I'm in the shower, I eat my breakfast, drink my coffee, and brush my teeth all at the same time. If you

think about how much time we waste on showering, blowing out our hair, going to the bathroom, getting our nails done, it's probably a good eight hours a week. That's practically a full day's work!

Usually, I make toast or an egg sandwich and a coffee and smoothie and bring it all to the shower with me. I kind of have it all scattered around like a buffet. Some things on the bath ledge, some things on the sink counter, some stuff on the floor. I'll put my coffee (in a covered to-go mug) on the soap dish and my sandwich right by my razor—close enough for me to grab but still not get wet. Maybe I'll leave my smoothie on the sink and kind of peek out from the curtain and grab a few sips here and there. I'll be shaving with one hand and have a coffee in the other, or have a loofah in one hand with soap suds trying to wash my body while I'm chowing down on an egg sandwich in the other hand.

Here I am scrubbing myself, eating my breakfast, drinking my coffee. After I'm done eating I brush my teeth and there we go, done deal. I put my clothes on and I'm out the door. That's something I do almost every time I shower in the morning, and I do it all so quickly and efficiently that it allows me so much more time each week to spend with my family.

I rush through all of that because there are so many more things I'd rather be doing—like playing with Hank Jr. Things like eating breakfast in the shower may seem bizarre, but it gives me that extra edge to have enough time during the day. I don't do things by the book. I just try to do what works for me.

Now that Hank is eighteen months old and a very independent little boy, and I've got my act together when it comes to balancing work and being a mom, we are in better shape. One thing I try not to do is overbook myself. But I do realize I need to work. Just because I'm not a nine-to-five type of corporate employee doesn't mean I can't put in a solid forty-hour workweek. Sometimes I work

at night; sometimes on the weekend. But I know I have to do it to provide for my family. Even if I'm tired, I do what I need to do (my team calls me the "trouper" because no matter what, I'll work). I spend a lot of time with baby Hank. Sometimes it's a full week, seven straight days, every minute of every hour. So I don't feel bad if the next week I spend seventy-two hours away from him. I know we get a ton of time together and I'm lucky for that. But those seventy-two hours that I'm away I try to book as much stuff as possible. If I'm doing a book signing in Chicago, I'll also make sure I do an Ab Cuts signing in a GNC store, or host a party at a club in town that night, all the while doing interviews and anything else to fill up my time and be efficient while I'm away. I read once that's what Brad Pitt and Angelina Jolie do: they try to stagger their workloads so one of them is always home with the kids. Now Hank and I don't have as much power or money as Brangelina. If something big and important comes up, I'm going to do it, but we do try to make it so that when Hank is playing football, my schedule is light. This ends up meaning that I'm always on, either in full mommy-mode for seven straight days or I'm in full work mode for seventy-two straight hours. Life gets crazy, but since I do my best to separate the schedules, I feel like I have a little bit of control.

So even though by adding a baby my schedule is now ten million times more hectic than before, I feel better. I'm having more fun. I would have nervous breakdowns right after he was born; the slightest things would send me over the edge. I didn't eat breakfast in the shower then because I didn't even have time to shower! Now I don't have nervous breakdowns (as much!) because I've learned how to smile and make fun of things. That's who I was at the Playboy Mansion, the girl who made fun of everything and just laughed. I lost that when I first became a mommy but I've since learned

to laugh again. When I first had the baby I would cry or I would throw a big fit over the smallest things.

Recently while I was on *Dancing with the Stars* I got in a car accident, just a little fender bender. I was getting off the freeway coming home from a *DWTS* practice and I was bouncing around listening to hip-hop. There was a car in front of me at the stoplight, but there were no cars coming, so I was looking left, getting ready to turn right. I fully expected the car in front of me to go, and I thought they would have gone already and turned right. But he didn't. And as I was pushing the gas pedal I realized that, but too late, and I slammed right into the back of him.

If it was my old self, right after I had the baby, I would have freaked out and cried behind the wheel, slamming my hands on the dashboard. But now if things like that happen and I know no one got hurt, I just say, "Let's pull over and do our business and get on with it." I keep telling myself that life's too short to spend it freaking out over every little thing.

But this time I calmly called Hank, because I was right near the apartment, and told him to come. Then I took a breather, I looked through the glove compartment, and I realized I didn't have any registration or insurance info with me because I wasn't organized (shocker). But I felt like, "Why freak out?" It is what it is. I can't change it; no matter what it's going to be my fault. I could have easily screamed at the guy and said, "Why didn't you go?!" But instead I just apologized and he said, "It's okay, Kendra" (his wife was a big fan!). In the past I would have had no filter; I usually couldn't hold anything back. Being a mom has made me relax; it's calmed me down. I have a better sense of what's important. And I'm finding an inner peace in being a mom and letting it go, because really, after taking care of a kid all day, I don't have time to argue with everyone I come across.

4

SEVEN TO SEVEN, SEVEN DAYS A WEEK

*T*hree sevens are supposed to be lucky. For me, three sevens are my reality. Lucky or unlucky, baby Hank is now up from seven A.M. to seven P.M., seven days a week.

Like most babies, he starts stirring long before he actually wakes up. For baby Hank, that's at about seven A.M. We don't allow him to actually get out of that crib until eight A.M., so Hank and I can get an extra hour of "beauty sleep," but we hear him. We'll usually just lie in bed and watch Hank Jr. on the monitor. He rolls around, claps, talks to himself, hums some tunes, but when he sits up and starts standing in the crib that's when we know he's awake and ready to come out.

Depending on who's on morning duty, one of us will quietly sneak out of our bedroom, grab the baby, change the diaper, and then get him dressed and put shoes on him. We rarely let him walk around barefoot since he's still falling a lot, so the shoes help him balance and walk without hurting himself. He has so much energy—he goes in and out of the doors and outside a hundred times a day—so instead of taking his shoes off and putting them back on all day, we just usually keep them on him.

Right now since Hank is in the off-season for football, he's in his "on-season" with the baby. When Hank is playing football, I'm on.

But we are very lucky; Hank's a morning person and overall if he's around he likes to do mornings. He offers to keep on that schedule so that when football season is back, he won't have a tough time waking up. It's for his own benefit, or at least I try to trick him into thinking so.

One of us will usually go downstairs with the baby (he walks downstairs by himself, and every step he makes he says, "Step") and sometimes it can take a few minutes! Hank goes into the kitchen and blends him a smoothie right away, all-natural smoothies with banana, strawberries, and blueberries with a little bit of yogurt. While he drinks a smoothie, we make eggs and we put natural freshly sliced ham and turkey on the griddle. Hank Jr. drinks the smoothie throughout the morning and we make freshly squeezed juice for the rest of the day. Then we take him for a walk outside. We like to think of our mornings as a great way to start off the day, with fresh fruits and proteins followed by a walk. If everyone could start off his or her day like Hank Jr., what a healthy world this would be. It gets his brain working because we like to teach him stuff outside and words like "tree," "sky," "clouds," and "houses." I believe that's as good as staying inside and reading a book. We do the reading thing throughout the day but real-life experiences are so important. I would rather him know "tree" and "sun" and "sky" and "clouds" by seeing them rather than just reading about them.

At ten A.M. he usually starts rubbing his eyes and will sometimes go down for a nap until twelve P.M. Now that he's one and a half, Hank Jr. rarely takes his afternoon naps. I wish I was one of those parents who could get their kid to nap in a stroller or a car, but for some reason Hank Jr. really likes his crib. And we are very strict with his schedule and try not to stray from that. So he has to be in his crib.

If he's napping from ten A.M. to twelve P.M., I get to do my thing.

The second that baby is out, we turn on the shower, get the coffee going, and start spending "adult time" doing errands and taking care of business. We know we've got a good two hours of (hopefully) silence and peace where we can do whatever we need to do. To a parent, two hours is like a day and a half. But throw in a shower, life obligations, or a workout, and next thing you know it's over. So we try to do it all as fast as we can. It's during this time that I'll run out to the grocery store and stock up on groceries, or make sure the tank is full of gas, or that anything else we need for the house is taken care of.

As we approach twelve P.M. we start to get his lunch ready. One practice we try to live by is to prepare in advance for the rest of the day instead of being spontaneous. Hank and I have found that trying to plan out everything, from knowing the weather to what we are going to eat for breakfast, lunch, and dinner as soon as we wake up, helps us be prepared for the full day. We think about the day and our schedules ahead of time, so we don't stress out if anything changes last minute. Preparing everything the second we wake up is the way to go. We have a set day by lunchtime. This also helps us avoid unhealthy decisions like just ordering pizza because we are too tired to make anything.

But as Hank Jr. gets older he naps less and has more energy, so we drink as much coffee from ten A.M. to twelve P.M. as we can, because we need all that energy to chase him around until he starts tiring out at seven P.M.

We'll never let Hank Jr. stay up past eight P.M.; we are very strict. I see some of these Hollywood parents dragging their kids out to five-star restaurants at eleven P.M. on a random weekday or even babies up and about in the Walmart parking lot at that hour. I would never allow my kid to stay out late. I worry about those kids. They may *say* they want to come out, but really they just don't know

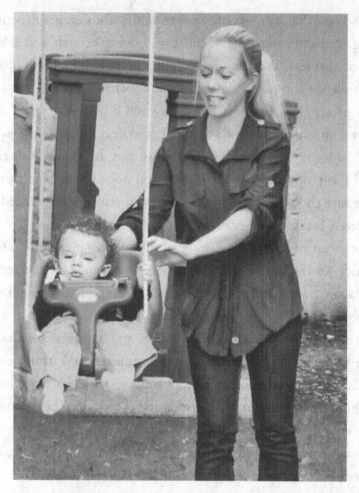

Enjoying the day at a park near our old house in Pasadena.

any better. Kids are on a biological clock and they need their sleep for brain development. Kids should be in bed and sleeping late at night, not at Nobu ordering sashimi and a cocktail! I feel like now that I'm a mom, I have every right to have an opinion about other Hollywood parents. You'll never see baby Hank out that late. He's home in his PJs cuddling up in bed. That's just common sense. Hollywood parents have enough money to have a babysitter sit there and watch the monitor as they sleep.

My son is not a perfect angel. Sure he's "perfect" to me, but he's not a perfect angel. He has his tantrums just like any other kid. When he doesn't nap (and every day he gets older, his naps become less and less of a guarantee) his tantrums start. And disciplining isn't easy because he's only just now learning the word "no." It's hard on little Hank, but we're not afraid to use that word. He needs to know, and we as parents are the perfect people to explain it to him. The world is not going to cater to him, so he might as well get used to it now! But we like to keep a clear difference between getting in trouble and the word "no." When he gets in trouble he's going to cry because we take something away from him or have to give a loud shout at him. Drawing on the walls calls for a big fat "no!" He's got to learn what he can and can't do, and we are going through that stage right now.

We can always tell when those tantrums are about to come. They usually start bubbling up when he doesn't take a nap, because he starts to get cranky. He doesn't know what he wants, he runs in circles, and he cries and points at things he thinks he wants. So we'll shove every piece of snack in his face, or water or juice, but he doesn't want it. Then Hank and I usually start arguing! "Maybe he wants this, maybe he wants that! Well, if you had done this! Or if you hadn't done that!" We just want to be able to help him and fix what's wrong. Sometimes arguing is just a reflection of the fact that we want everything to be right.

The tantrums can go on for twenty or thirty minutes at a time. If he's teething we'll put medication on his gums, but ultimately he doesn't know what he wants. We try to teach him to tell us what he wants by pointing, but sometimes he just points to the sky. I can't give him the sky, as much as I'd like to, and it gets really sad and frustrating to watch a meltdown. The best I can do is try to comfort him and get him to settle down, hopefully with a nap.

Of course, we aren't always in the comfort of our own home when a meltdown comes. Hank Jr. had a big meltdown on a flight from L.A. to Minnesota. Hank and I hadn't seen each other in a couple of weeks while Hank Jr. and I were living in Pasadena and Hank was playing for the Minnesota Vikings. We had been Skyping each other a lot all week saying how excited we were to see each other. So my emotions were definitely running high. Hank Jr. and I got on the flight with my assistant, Eddie—I was in one seat with Hank Jr., Eddie was in the other—and a producer to film the whole experience of Hank picking us up at the airport and me running up to him to say how much I missed him. It was a late-afternoon flight and the second we took off Hank Jr. started to cry. From then on, he was uncontrollable. The entire flight he was screaming, crying, and kicking. This was an almost four-hour flight and by hour number two I had had it. There was nothing I could do. He would not sit still; I must have picked him up fifteen thousand times to put him in the chair and take him out of the chair and put him back in and take him back out. I tried to give him anything I could to distract him—toys, milk, juice, water—but nothing would work. It was the flight from hell. Luckily, most of the people in first class kept saying to me they were parents themselves and totally understood what I was going through. But I couldn't help but think that a lot of them were assuming I was a bad mom or Hank Jr.'s a bad kid. I thought they must have been thinking to themselves: "Oh, of course he's a bad kid. Look who his mom is." I had to take the flight; I had no choice. We had (and wanted and needed) to go see Dad. But when you've tried everything to calm a kid down, there's not much else you can do except pray he stops or falls asleep. I can't hit him or say shut up. I was helpless and just had to take it.

When we finally landed in Minnesota, I took the baby and handed him straight to Hank and just said, "Here! Take him!"

As much as we try to keep the baby on a schedule, sometimes the cosmos doesn't allow for it. Stroller walks replace sweaty workouts, showers get neglected, and errands go undone. Sometimes he doesn't take those naps and our plans fade away. For Hank, working out is important for his career, but a lot of times those workouts are canceled because baby Hank won't nap. And when the baby gets tired and cranky, we are all tired and cranky. We get so tired by four P.M. if the baby is off schedule, and we rarely get a moment to ourselves. We don't have an office to go to, and if we're not working in a studio or in football season, we're working from home. And usually during the day I have interviews, photo shoots, appearances, and meetings for the show, and they often all get canceled because of the baby, because we are so tired, because we barely have energy to keep up and drive all the way to a meeting and talk about our lives, a.k.a. the show. Sometimes I'll resort to doing meetings over the phone, but really being a mom is the nine-to-five job I have now. My show, my books, my appearances—those are my second job. Sort of like bartending at night to pay the bills.

The tantrums, the rush, the sprint—it gets to us at the end of the day. Hank and I are exhausted after a full day of work/home/life. I've always heard from other parents that being at work is a thousand times easier than being at home with the kids (though certainly less rewarding), but in my case I'm at work *and* at home with the kid. A double whammy.

Hank and I used to like to drink a glass of wine before bed to slow us down from the day. Now we don't drink wine because we don't need it and we end up crashing easily without it. We just need water to stay hydrated because we are so worn out!

Hank will try to sneak in a spa appointment for me ("Kendra, you have to relax, baby!"), but he knows those things just slow me down. My life and my job are so fast paced that if I stop and get a

massage or do some sort of breathing thing it just slows me down. I have so many things to do, breathing gets in the way. But when shit really hits the fan, that's when I know I need to stop.

I see stuff about those Real Housewives or celebrities in Hollywood always being pampered and doing stuff for themselves. Yoga seven days a week, Botox parties, Thai massages on the beach, seasonal trips to Cabo—but if I had the chance to spoil myself I wouldn't want to be like that. When it comes to getting my nails done . . . Hank has to force me to get a manicure. If I have spare time on my hands, I don't want to waste it getting a massage; I want to spoil my husband.

5

NO, MOMMY AND DADDY ARE
NOT GETTING A DIVORCE

*I*T'S OVER! SPLIT! KENDRA LEAVES HANK!

Yes, I've read all of those headlines too. I try not to pay attention to any of that, but what I will say is that whatever is going on between me and Hank is our business and nobody else's. Sure, we have had our moments. But doesn't every couple?

If married life was just sitting on the beach in Hawaii sipping fruity cocktails then there would never be anything to fight about. But that's not reality! When you're married you've got two lives to plan and coordinate. Throw in a kid and life becomes a little slice of mayhem. We make it work and we love it, but it's not without its little hiccups.

Being married to a football player isn't easy. In just two years Hank went from the Philadelphia Eagles (the team he was on when we met and fell in love), to the Indianapolis Colts (we mostly lived in Indianapolis during the pregnancy and birth of baby Hank), back to the Philadelphia Eagles for a few weeks, to the Minnesota Vikings for a few months, to being back home in L.A. unemployed and without a team.

None of that was easy, but our troubles culminated in the summer of 2010 when we had made the decision to pack up our

lives temporarily and leave L.A. to move to Philadelphia for Hank. It was his second time playing for the Eagles, and we thought it would be a long-term job for him. We'd film the show there, move into an apartment, meet some families, and live a fun city life. Not forever. But for as long as Hank was with the Eagles, which we thought might be a couple of years. It didn't work out the way we'd planned, and when Hank got cut in September (just a few months after Hank Jr. and I had relocated to the East Coast), our world was thrown into a tailspin.

When we first arrived in Philly, the show told us we were going to stay in a gorgeous hotel until our apartment was ready. Wow, hotel living—not too shabby! Lobbies, restaurants, bellmen, concierges—the full white-glove treatment! We were like, "Okay. Sign us up!" They said, "The place is beautiful, it's amazing, with room service, a penthouse, and all that." But when we got to the hotel and checked into the room I turned to Hank and said, "What the fuck?" We had no kitchen; it was literally a plain old hotel room where I couldn't cook for my baby. So, in order to eat, we had to order room service and pay for everything. As a mother I felt completely unprepared for this. I was stripped of the tools I needed to properly take care of my family. Dinners shouldn't be served with packets of ketchup on a roll-away table.

I was the star of a hit show on E!. I had worked my ass off to get where I was in life and Hank was an NFL athlete—so why were we living in a hotel room? We were there for three days before I started to go crazy. Claustrophobic doesn't even begin to cover it. The three of us—and all of our stuff, including Hank Jr.'s toys and essentials, and my clothes—could hardly fit in the room. There was no space for him to play or to move around. I lost my cool and said to Hank: "Get me the fuck out of here right now or I'm leaving you." I threatened Hank and gave him an ultimatum. This was a

wife speaking to her husband, a mom saying we need a better life for our child. Was it over? No. Was it close? Well, it was pretty bad. But all he had to do was fix it.

What people don't know is that Hank actually had a house in Philly all picked out for us. The show's producers wanted us to live in a condo or an apartment (or a hotel apparently) so they could execute their "Kendra comes to the city of Brotherly Love" angle. Fun angle, bad execution. If Hank had only told production that he already had a house, we could have filmed there! He gets shy sometimes and lets others control him and push him around because he's too nice of a guy, but his being a wimp really put us into this horrible predicament. It jeopardized our happiness and our safety (we had hotel guests pounding on our door at all hours), and I wasn't going to stand for it. Sometimes you just have to light a fire under your husband's ass.

I freaked out on him. I made him call everyone involved with the Eagles and E! and basically said, "Fix it!" (File that under things he should have done before his family moved across the country.) It was Hank's responsibility to put a decent roof over his family's heads. Sure, we were there for the show, but we could have argued and arranged to live elsewhere or figured out a way to make it work for the show and, most important, us. He moved us to Philly without checking out the living situation. Show me any woman who would put up with that shit. I had no home; the baby had no home, no kitchen, and nothing stable or grounded. I said to Hank, "Get it through your head: We have no home right now. The baby has nowhere to eat and sleep. What is wrong with you? You are failing."

Finally, after more drama and yelling, we packed our stuff in a U-Haul to move into the Two Liberty Place apartment building we were supposed to be staying in for the rest of the season, but in a continuation of the disaster that was our life, they moved us into

an eight-hundred-square-foot model suite—you know, one of the places you tour when you're considering moving into a building. Sometimes they have fake TVs made out of plastic or fake fruit in the refrigerator. Well, that was our new home. For a family whose life was being filmed by a camera crew for a reality TV show, things couldn't have been more ironic. I expected to one day wake up next to Hank and realize he was just a cardboard cutout or, even worse, his stunt double. But we had no choice but to take it.

I had never lived in a condo before, let alone a skyscraper type of situation. Every time I left my apartment building there were people waiting out front to see me. I had my two dogs with me, Martini and Rascal, and they too weren't used to this urban life-style. Plus I had to get a dog walker to avoid the crowds out front who would follow me when I tried to walk them. Everywhere I went with my baby, people were pointing at me. It was a hassle, and it was a little scary. I just wanted to click my heels together and make it all go away. We were not in Hollywood anymore. I was slowly losing my grip on any bit of sanity I had left and my mood was sinking lower and lower.

Any attempts at normalcy were met with even more bizarre re-sults. We hadn't had a chance to go shopping yet because of the less-than-comfortable living situation, so we didn't have anything like soap or shampoo or any home products (we had been using the hotel's products, which the housekeeping service replenished on days when we removed the Do Not Disturb sign). So my first shower in the model shower I was using the model soap to wash myself. I think it had been sitting there for a year; it was as hard as a rock and completely impervious to water.

A month later, when we started actually filming the show we had to take everything we had and move from the thirtieth floor—a.k.a. the model suite—to the fiftieth floor, a much bigger place

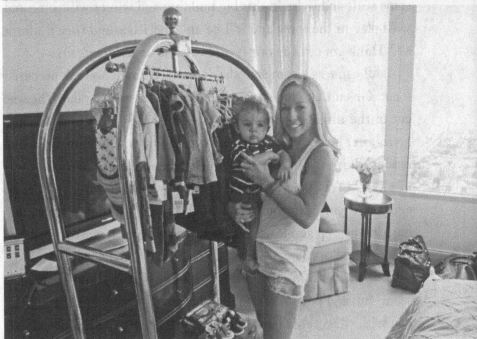

Putting on smiles even through all our moves. Look: clothes on luggage cart—check-in time!

more suited for shooting a TV show. The new apartment actually belonged to Richie Sambora (from Bon Jovi). He didn't live there much and because of the economy he didn't want to sell it and take a loss, so he loaned it out to the building as another model or party room. We moved into it and we were using model silverware and model plates and all showroom-type stuff. It was like a joke! It was like living in a home furnishings store—don't touch the china! At least it was big.

Finally we got settled and we started getting routines down. I was beginning to feel comfortable again, and I could sense Hank Jr. relaxing a little. That's exactly when Hank got cut from the Eagles. Just when I got over being really pissed at him and started thinking, "Well, at least we've got each other and he's playing for the Eagles and the show is working out; we'll go shopping and get some stuff and we're in this big building and winter will come and we'll play in the snow and it'll be an experience and they'll film it all," Hank got cut and our future became uncertain again.

It all came as a complete shock, and we totally weren't prepared for it. Given that games are played each week on Sundays (he was cut in the middle of the season), he had to fly to Minnesota just hours after he got cut to join a new team that wanted him, the Minnesota Vikings. There was no time for good-byes or to pack. It was just like, "Okay, you're on a new team now, their color is purple, go and join them." Obviously it's not the greatest thing to have your husband just up and leave the town he made you move to, but I was supportive. Sort of.

The crazy thing about reality shows is that while most of it seems fun and fluffy, they do catch a lot of the moments that maybe you wish they weren't around for. When Hank got the phone call that he was cut from the Eagles, the cameras were right there. The show producers came in and were like, "We have to film." That's

when I plain old said, "Get the fuck out." I've rarely told the cameras to leave, but times like this call for a family to hunker down and figure things out, without a camera crew hovering over them. It was sad because I wanted Hank to be okay and I certainly didn't want to watch him get fired on national TV. So when the Vikings called to hire him (I'm glad the cameras were there to catch that one though!), I told Hank he better decide and accept fast or I was going to grab the phone and make the deal. He was actually having trouble deciding whether to go or not. Sometimes a wife needs to give her husband a good kick in the ass!

Hank didn't want to leave us all alone, but going to Minnesota was a guaranteed job for the remainder of the season. We had only a couple of hours to make up our minds because Minnesota was going to go with someone else if Hank said no. Hank didn't want to leave me and the baby behind, but his agent was pressuring him to make a decision. I took the phone and I just said, "Yes, he is going to play with the Vikings." I told Hank he better pack his bags and get there. I ordered him to go. It was hard for him—no man wants to voluntarily leave his family—but as a father and a husband he needed to go where the work was. On the show it played out as if it wasn't a huge deal, but it was a big decision for our family. I started to question why the hell I moved to Philadelphia in the first place and yelled at Hank, telling him it was all his fault and calling him selfish. Things started to unravel really fast. We were never in danger of divorcing, but it got pretty bad.

Hank left and I was stuck there in Philly alone. I knew he had to go, and while I wouldn't equate it with a soldier heading off to war, I did feel a little bit like a military wife left all by myself to take care of things until Daddy comes home. That night I went to sleep alone and the next morning I woke up alone with the baby. It was a shocker and my reality for the next several months. What else

could I do? Hank's job is to play football and Minnesota wanted him, so that's where he had to go. From the get-go, I was support-ive. But as time wore on, things took a nasty turn for the worse. As wives we are programmed with "support your husband, support your husband, support your husband," but when I actually got into that situation it was the last thing on my mind.

I began to feel like a single mom as I was left to look after the baby on my own in a strange city for the rest of the season. It wasn't Hank's fault, but after a while it took its toll. Doing morning duty every day at seven A.M. and handling every feeding, nap, diaper change, tantrum, snack, and bottle, along with all of the washing and cleaning, became impossible on my own. I don't know how all those moms out there manage it. Doing it for one day plain old sucks, but you'd do anything for your baby. Doing it two days in a row starts to wear on you. By day three (call it three days or seventy-two hours or almost half a week—whatever sounds worse) I was ready to jump off a bridge. I needed my husband there to help out and give me at least one morning off, and I didn't have it.

That first morning alone it really hit me. Even though I knew I was going to have to dig deep and just deal with looking after the baby on my own (and not give Hank any shit), I still was like, "What the hell just happened?" It was so depressing. I had no net-work in Philadelphia, few friends, no family, no support. City of Brotherly Love? More like City of Husbandless Kendra. I didn't know anyone in or anything about this town I was living in. I was all alone in this big dark city when I could have been back home in L.A. with more of a support system and an easier life.

I blamed Hank for all of our troubles, but in reality, it was the show that had wanted me to go to Philly. Hank had been telling me to stay in L.A., but the producers were really persuasive and in the end he went along with their suggestion. So Hank went to

Philadelphia for the team and I went for the show, and everybody (me, baby Hank, the show) relied on Hank to stay on the Eagles the whole season. No one thought he would get cut—it never even crossed our minds—so that was a slap in the face when it happened.

So my husband was leaving me and I was in a panic at this point, with the show in even more of a panic. We were all at a crossroads—basically we couldn't film anymore if I left Philly, since that was the only place set up for production. I would have happily moved back to L.A. but I had to stay in Philly (separated from my husband) because of the show. E! didn't have the budget approved to follow us to Minnesota or L.A., nor did they have any filming permits, as those take several weeks to get. To set up a home for filming, they needed to install bright lights and shades and get the whole production crew there and arrange for them to stay in a hotel, not to mention work out paperwork, insurance, and everything else that goes with making a TV show. At best that would have taken a month. So even if I did decide to go to Minnesota, we wouldn't have been able to film there immediately. None of this was my fault and I immaturely told E! they should have had plan B set up in advance, which they didn't.

If I quit the show then I'd have been unemployed. That wouldn't have bothered either of us before, but it was a wake-up call when the Eagles cut Hank. We realized we were a decision or so away from *both* being unemployed, homeless, and frankly on the verge of a separation, so we couldn't take any chances. We both pushed forward with work because though we may have been oblivious to it before, we now knew our jobs were never guaranteed.

Life was hell. On TV nobody saw what really happened in Philly; you didn't see me crying into my pillow or staring up at the ceiling all night instead of sleeping. They made it seem like everything was set up for us nice and easy, but that was hardly the

case. On TV it looks like we flew to Philly and ended up in this nice penthouse. But that's certainly not how it happened.

I spent a lot of time alone in Philadelphia with the baby after that, and while I may have thought I was making an effort to have friends and a life there, it just didn't work. I knew I would be leaving soon, so subconsciously I hardly made an effort. Sadly that had been my mind-set for several years, since I never stayed in one location more than a couple of months at a time. I felt like an outcast, alone in a big city where I didn't know anyone except for a digital Skype image of my husband a couple minutes per day.

I may have mentally been alone, but physically there were people coming in and out of my apartment all day. I still had a show to film, with or without my husband. Never mind the fact that I didn't put a lot of effort into friend making; it was virtually impossible anyway given my schedule. We were in a mad scramble to make the show work, given the giant wrench that was just thrown into the overall plan and plot.

In order to make it through the day, I needed to enlist help to do the "dad/husband" things that I just wouldn't be able to take care of while looking after Hank Jr. and working. We had the dog walkers, and my assistant, Eddie, came over every day (he lived in a hotel across the street) to wake me up and give me coffee and a breakfast burrito from a little café nearby. I don't miss my Philadelphia situation overall, but if there's anything I do miss about it it's the burritos, the coffee, and, of course, the cheesesteaks. Something about a big city like that churns out amazingly greasy and delicious comfort foods.

The baby would wake up around sunrise and I'd feed him. As I woke up, the production team would start filtering into our apartment, setting up tripods and lights and wires, all while I'm trying to get Hank Jr. (oh, and myself too I guess) ready for the day. Then

I would put the baby down for a nap, and while he was sleeping, we'd start to film the show. Until, of course, the baby woke up and I had to feed him lunch with the cameras on me. Then the baby went down for his nap again and I had to film; then he'd wake up and I would take him out to Penn's Landing on the riverfront. He'd crawl on the grass and see ducks, and then I'd rush back to put him down for a nap. While he was napping, I'd do interviews and voice the narration part of the show. That would take us well into five P.M., when he had to eat again. Finally the producers would put the cameras down, and I'd go and mix up his little food or get spaghetti and veggies. I'd blend his food, heat it up, change him, put him in a high chair, call Hank, arrange various things for the house and our life, work, film, and then try to get the baby down for the night, hopefully in the seven-to-eight-P.M. range. After that, for me it should have been pass-out time. But I barely had anything to eat myself because these days were never-ending, so I tried to have a late dinner. I call those days the three weeks of pure hell because this was my schedule for the most part while Hank was gone. At nine P.M. we'd Skype and that would be it for the day.

Ultimately, I decided neither Philly nor Minnesota was right for me and the baby—so we moved back to California.

Of course, the fact that I didn't have a home to go back to in L.A. was just more great drama for the show, but for me it was just another sad reality of my life and my marriage. The show found a real estate agent who showed me this beautiful house that looked great on paper and I was like, "I want it." It was supposed to be this beautiful house in Pasadena and I got there and I was like, "What is this?" It was three miles up a mountain and you had to drive up the side of a cliff to get to it. Once you got to the house, the last thing you wanted to do was drive back down that scary road, especially with a kid in the backseat.

A perfect fit, right there on my shoulder. We make each other relaxed.

So I started not wanting to leave the house. And I got it into my head that the house was haunted, so in addition to not wanting to leave, I also didn't want to be there! I'd gone from feeling isolated in Philly to feeling isolated and trapped in Pasadena. I couldn't take it anymore after more than three weeks, so I called Hank's parents to help me with the baby—in-laws 911! They flew out for a few weeks and helped me with the baby while I did photo shoots and interviews and work for the show. I couldn't do it all and raise the baby alone. I could feel myself unraveling.

I started to blame Hank, and our relationship began to deteriorate fast. I said, "How could you do this to me? You don't even know where I'm at right now." I felt like he had let us down again. He wasn't involved in our day-to-day life and it was like he had checked out, at least in my mind. I felt us drifting farther and farther apart. Hank is a very caring, loving man, a good seed. If this is the kind of interaction *he* has with his family when he's away for the season, I can only imagine what some of the bad seeds out there are like. I started to question his involvement and devotion to us. What kind of a father and husband is that? I didn't want to be one of those "wives" who ended up on a reality show with other wives bitching about my lowlife, cheating, absent husband who's on the road all year playing football. I knew deep down Hank was a good man put between a rock and a hard place, but I felt like he didn't man up. Forget me; didn't he want a better life for his son? I was so focused on and angry about things that had already happened and couldn't be changed that I really started to lose it. You shouldn't dwell on the past but I was focusing on what had happened over the last few months and it was causing me to freak out in the present. My past has always been a disaster. For me what works is looking forward, but I'm not always capable of doing that.

6

MELTDOWN IN MINNESOTA

When the house didn't work out in Pasadena, I flew out to Minnesota with the baby to live with Hank for a couple weeks so we could try to be together. It was the holidays and I wanted to do everything possible to make sure we could at least have some family time even if the rest of the year had been anything but normal. We had a little Charlie Brown–type tree for Christmas and a lot of snow. We were dealing with a five-hundred-square-foot apartment and blizzard weather, but at least we were reunited as a family.

The place was roomy enough for Hank by himself, but add a wife and kid and things got cramped real fast. I quickly learned I couldn't stay there full-time, there just wasn't enough space, so I spent the next couple of weeks going back and forth between L.A. and Minnesota (Hank's parents came up to Minnesota to help out and keep an eye on the baby since Hank was playing football) and moved us out of my Pasadena house and into a month-to-month apartment in Studio City—a place we'd call home until we bought our new house several months later. Finally, after trying to get our lives settled in California, I flew back to Minnesota for a three-week stay, possibly the longest three weeks of my life. That is when I lost my cool, to say the least.

I now understand what some moms go through on a daily basis when dad heads off to work. One day I found myself alone in the apartment with the baby during a blizzard while Hank was at practice. It was pretty bad out and I wasn't going to risk driving anywhere with the baby in that weather. One day stuck in the apartment turned into two, which turned into three. I hadn't showered in a while, hadn't really seen daylight, and other than "goo-goo ga-ga" with Hank Jr., hadn't really had much of a face-to-face conversation with anyone in the outside world. All of a sudden I started to lose it.

The room started to spin, my dreams and reality started to mix together. I wasn't sure what day it was or what time it was, and I didn't know whether I had eaten or what I had eaten. I could barely see five feet in front of me. I was pretty out of it. That is when I knew something terrible was about to happen. Thank God my son was safe. I'm not saying I was a danger to Hank Jr., but thank God he was sleeping quietly in his room away from my madness, because things were spiraling down very quickly. He is a heavy sleeper; he could sleep through a thunderstorm, a giant tractor trailer whizzing by, or in this case a parental meltdown of epic proportions.

It was around bedtime and I just went crazy. Something just snapped inside me and I ripped everything off the walls. I smashed everything, cleared off shelves and tables and shattered anything breakable. I had a sudden bout of depression and hate, and I just broke any object in plain sight. I started shaking. I thought I was going to have a heart attack. I was trying to wrap my hands around anything and break it. I threw plates and shattered them. I ripped up papers and bills and envelopes. Stuff on tables like forks, knives, glasses—I just picked them up and slammed them all. This went on for at least an hour, with occasional breathing breaks in the middle to catch my breath for a minute. But nothing could stop me.

I knew something bad was going on internally with me but I couldn't control it. I was raging, and the more I raged, the heavier and more intense it got. I wasn't stopping for anything or anyone. Of course, being alone (Hank Jr. was sleeping and daddy Hank wasn't home yet), there wasn't anyone or anything to stop me anyway. I was screaming and crying beyond what you could imagine. The neighbors, if they didn't know me yet, certainly knew me now. I thought someone was going to call the cops; I was having my Britney moment. Apart from shaving my head and bashing in a window with an umbrella, it was pretty much as you would think. This was not the pretty blonde posing on a billboard on Sunset Boulevard with her family announcing the season premiere of her new show. I was an angry, depressed monster with no producers or editing to fix my flaws. I was crying uncontrollably. I just kept screaming, "Fuck! Fuck! I don't deserve this shit!" I couldn't think straight and I was ready to leave Hank. Not divorce; I will never divorce Hank. This was more of a "I'm going to get away and start a new life and you come when you're ready."

It was beyond bad. Looking back, I'm not embarrassed about it. I think it happens to a lot of moms. I've told this story to a few moms and they all look at me with sympathy because every one of them says, "Been there, done that." I thought I was going crazy, but what I've been told is that I was actually perfectly sane. This happening to me showed me that everything in my brain was actually working well; it was a sign—get out of that apartment, get help, get away, and take care of yourself. It was a "fight or flight" situation, and after fighting it for the longest time, I was now ready to leave.

And I'm lucky the incident was interrupted by Hank.

Anxiety and depression, anger and fear, and just being overwhelmed—that moment showed up right when it needed to. I was feeling so much pressure and I had been bottling it all up. I

couldn't take it anymore, I couldn't pretend everything was okay anymore. When he got home from practice, he found me, and the apartment, in shambles. When Hank saw the state I was in (and the state of the apartment), he made the mistake of picking a fight instead of trying to console me. He looked right at me and asked, "Why did you trash the apartment? What's wrong with you?" Little did he know . . .

Hank made a huge mistake; you don't fight with a depressed person. Because we'd spent so much time apart, he wasn't in tune with what was going on with me, and maybe it was my fault for not cluing him in. His lack of compassion got us into the biggest fight. He was yelling at me instead of trying to understand what I was going through. His screaming at me only enraged me even more—did he not know the hell I had been through the last couple of months? Not only from the roller coaster that is childbirth but the constant moving and being alone. Man alert: He was clueless. He should have picked up on the fact that I was nearing my breaking point, but he didn't.

Our fighting escalated and Hank's blood was boiling so much he lost consciousness and literally fainted, falling to the floor on top of the baby's toys. He had a panic attack of his own from the stress and passed out. Ever seen a six-foot-four man fall over and thump to the ground? That scared the hell out of me! I knew I was in no shape to care for anyone, and if Hank (whom I had always thought was physically indestructible) was now down and out, we were all in big trouble. I looked at Hank for a second (he was unconscious for at least ten seconds; it was very frightening) and realized my fit was over and now we both needed to get our act together. I kicked him and yelled, "Get up, you can't pass out now!" I think that was a wake-up call for the both of us that we just needed to breathe, chill out, go back home to California, and get a damn house. We

couldn't do this anymore. He spent the next hour cleaning up my mess. Two days later Hank booked me a one-way flight home. He understood why I had to leave and he said he would leave too if he was in my position.

Hank's not the type to sit down and talk about this stuff all the time. So it had been building and he and I hadn't dealt with it. He's not a therapist. I had to realize that. He understood, he listened, and he digested it all *after* the fact, but he's not going to ask me what I need to talk about every day. After that he never yelled at me.

Because of that night Hank decided he was going to quit playing football that season. He had the phone in his hand and was about to tell his coach. He was going to quit because he was so worried about me and my health, and I have to say even though I was angry as hell with him, the fact that he offered to do that showed me his true colors. I would never want him to give up his career though.

I realize now that a lot of my inner turmoil was guilt because of what I was doing with the baby—forcing Hank Jr. to stay in this tiny apartment because of the snow and my own issues of being scared to go out. Minnesota has one of the largest shopping malls in the world, but going to the Mall of America isn't the smartest thing to do when you are famous. So I couldn't just take the baby for an indoor stroll. I was forcing my child to have no life because of issues I was responsible for. I went crazy and I snapped. I had no friends and no life and that was rubbing off on the baby. What I wish is that someone had told me, "It's okay. Don't worry about the baby like that. Feed him, love him, keep him safe, and he'll be just fine." But by isolating myself, I didn't even have that.

Since getting pregnant and then actually having a baby, my isolation had grown worse. I started to lose a lot of the friends I thought I had made over the last decade. Some stayed, but most just grew distant. So it wasn't like I had this great support system to vent to.

Of course I'd had relationships with people like Holly Madison and Bridget Marquardt in the past, but they were really just roommates, not close friends. We shared a boyfriend, we shared the spotlight, but now that I'm a mom we're all just in different places. I just changed. I think it's something that just happens naturally when you become a mom. You just grow up. Someone like Holly has a different lifestyle from me. I love her but I don't know the people she hangs out with—they are more on the party scene, and I've put those days behind me. We still talk (she always gave me amazing words of encouragement during *Dancing with the Stars* and sent me fun little notes) but being a Vegas showgirl and constantly on the prowl for a new boyfriend . . . that's her world, not mine. When it came to the baby, people like that just weren't around. I was very alone.

After hitting my breaking point, I immediately flew back to L.A. and I gave Hank a deadline. If I didn't have a house in three months, I was prepared to call it quits. I couldn't do this anymore—the constant moving around and instability was too much. I told him, "I can't live your life anymore. I'm not just a football wife." After that he started moving quickly, because he knew I wasn't fucking around.

Hank is the man in my life, and I think the man should step up and take care of things. Even though we make the same amount of money, I'm old-fashioned that way. He is the one who builds the nest. I'm the woman. I'm the one who raises the kid. He likes it that way too, and he chose that role. But that is why he let me down, because he didn't hold up his end of the bargain. If I had my way and we could have guaranteed security I'd quit working today and let Hank do it all. But we need the money.

So I was doing my job and he wasn't doing his job. I knew we weren't done as a couple, but it had been a tense couple of months,

so I had to threaten him and let him know that part of us being a family was starting a life together in a home. Without that, we were incomplete. If we couldn't have afforded one or were unemployed or down and out then our options would have been different. But working our asses off had given us the ability to have a secure, stable place to live. We (and by "we" I mean Hank) just hadn't done anything about it. The amount of pressure that was on us at such a young age—I was twenty-five and he was twenty-eight—was too much. It's a lot of pressure and we've never done any of this before. Not only being in a marriage but also both working and being parents.

I'm having fun with it now, thankfully. Once you get through the tough parts parenthood is obviously extremely rewarding. Hank and I have figured out our lives and roles more, and it doesn't hurt having the off-season, when we are all together and Hank's not traveling the country and playing football. I feel much more secure in our relationship and that we're providing stability for baby Hank. We opened up an account for baby Hank a long time ago so that every day we are working for him, his security and college. We want to make sure that he's never moving around from city to city searching for work and a home like we did. Hank is going to hopefully grow up enjoying the fruits of our labors. I'm not a person who likes glamorous stuff so our money's not going to get tied up in Chanel bags and Tiffany necklaces. I look at life before glam and I want to make sure that Hank Jr. is secure. I've been on TV nine seasons; I know I deserve my home. I don't need a mansion but I do need a home. Doesn't everyone?

At one point or another, we had seen what a mess we were in aspects of our life, financially, health-wise, emotionally, and physically. We spent a lot of time and effort getting all that under control, but one thing we still needed to figure out was taking care of our finances. We were clueless.

I got to the Playboy Mansion at eighteen years old. I was fresh out of high school, and I had no idea what real life was like. Real life, bills, taxes—I just thought you lived day to day and things didn't really affect you. I knew a little about taxes, but I thought they were just something you tack on to the end of a meal or a purchase. I thought I could get away without acknowledging it for a while. I mean, it's not like I was going to get into trouble because I didn't pay taxes! I didn't think I would. But because of that attitude, taxes and finances became one of the biggest stresses of my life in the last decade. I was so delinquent in paying taxes and simple bills that cleaning up finances has been a several-year process. I've since received hundreds of letters, and though I've taken care of most of it, I still to this day get notices from places that have tracked me down saying I owe them money. They're probably right. I really don't know what I spent my money on because I never kept track. So at this point, I don't even question it. If they say I bought something in 2002, I probably did.

My credit score was so bad because I was never responsible enough to pay anything. And while I know I'm fully to blame, it's not something even if I was responsible I'd have been able to keep track of. The amount of residences I've had since leaving home, whether it was the mansion or Philadelphia or Minnesota or Indianapolis or one of the more than five cities in California I've lived in—my bills and taxes were sent all over. The minute I changed my address from one town to the next, I was off to a new one. Bills never caught up to me, and I was of the mind-set that it would all just go away. If the bills from L.A. didn't reach me in Philadelphia, and my bills from Indianapolis didn't follow me to Minnesota, it was like they never existed. Or at least in my head they never existed. In reality, they did.

Around when baby Hank was born, I realized I needed to settle my losses and get set up for my future. I had so much clean-up to do that I ended up hiring a business manager to handle our money properly. Being a parent makes you mature whether you like it or not. It was one thing to screw up my life, but it was another to screw up my child's. It was one of the most mature things we ever did: realize that with all of the financial trouble I was in and the various outlets we had money coming in from and going out to, we needed someone to keep track of it all. "Kendra" is a business. I couldn't let a stripper be the CFO of Kendra Inc. I just wasn't cut out for it.

Now our business manager has the passwords to our bank, he does our taxes, he pays our bills, and does it all on time and correctly. I know not everyone has that luxury, but for me it's not a luxury, it's a necessity. I'd probably be in jail if not for this. I haven't seen a bill in more than a year, my paychecks go straight to him, and all past credit issues are directly handled. I have clarity and security now.

7

FULL-BODY BLUES

*T*hrowing plates against the wall, screaming four-letter words at the top of my lungs, and trying to pull my hair out of my head may have been the climax of my problems, but it certainly didn't start there. Everything wrong that happened during the first few months of Hank Jr.'s life can be traced to one small body part: my brain. I had an imbalance, wires were fried, things weren't communicating properly. Physically, mentally, and emotionally I felt like a giant jigsaw puzzle with all the pieces mixed up. With the meltdown in Minnesota, my weight gain, and marital problems with Hank, my depression was dominating every moment of *Kendra*. But at the time I didn't realize all of my problems were classic postpartum symptoms.

When you are knee-deep in it, you just don't get why everything is aggravating you. I blamed my anger on the fact that we had no place to call home, I blamed my anxiety on the fact that we were cooped up in tiny little living spaces, and I blamed my lack of sleep on the baby. Those were probably all true and certainly played a role in my meltdowns, but really it was all just my brain not being able to adjust to my new life: motherhood. If I was just a wife and all I had to do was travel the country with Hank, from hotel to hotel,

city to city, I probably would have embraced it. How fun! But throw a baby into that mix and it was just a recipe for disaster.

I'm not sure if I can accurately say I had "postpartum depression." I was never diagnosed officially, but I'm going to go ahead and self-diagnose myself: I had it. I think once you've had the dark days—and I had them bad—you realize that depression is only one minor part of everything going on in your brain. Yes, there is a lot of depression involved, but I also experienced bouts of anxiety, anger, insomnia, and hatred—really a little cocktail of every bad symptom I'd never want on its own, let alone all of them mixed together.

When baby Hank was born, we were living in Indianapolis in a nice gated community and it was beautiful. It all began during the first few weeks after the baby was born. While it was always snowing and freezing cold outside, for the first three weeks there was a sense of calmness and beauty. The skies were gray, the ground was snowy white, and there was silence everywhere. That's where the beauty ended though, and the weather and being trapped in the house began to take its toll. I am not a cold-weather person; I wear sweatshirts during the summer. We were fighting winter in every way because the house wasn't made with weatherproof windows or doors, so in addition to the constant whistling of the cold wind, we always had portable heaters going. We had about fifteen of them set up throughout the house and we even kept one going in the bathroom 24/7.

The house was made in the sixties (we were temporarily renting it for the show) and furnished and designed with really ugly stuff. It wasn't the least bit comfortable, but then again I was kind of used to that type of lifestyle at this point in my life. We were sleeping on someone else's bed and showering in someone else's shower—a foreshadowing of things to come for the next several years of my

life. With cameras, TVs, wires, lights, and a production crew set up in the basement, our house became a mini production studio, which meant we always had the camera in our faces.

It was beautiful outside with the snow, but you never wanted to go out because it was just too severe of a winter. Trapped inside the house, I developed bad eating habits and stopped caring about basics, like personal hygiene. It was hard for me to quit eating poorly because I couldn't exercise, I couldn't get outside much or go anywhere, and I didn't have the time to cook anything healthy. I ate nothing but junk food. I was in survival mode. Dinner was sometimes carrying around a bag of popcorn while I did laundry or arranged the baby's toys, clothes, and essentials.

With studio show lights in every corner and every hallway and on every ceiling, no matter where I was the spotlight was on me. Even when I closed my eyes on the couch just to get peace, there were lights. Comfort was hard to find under about two feet of snow and in the glare of the TV lights.

At this point I was showering about once a week, a far cry from the twice daily I used to do. You can always tell how depressed I am by the number of times I shower and brush my teeth. The better I feel, the cleaner I am. If I'm down, I'm going to be dirty. So during my depression teeth brushing went to a minimum, and even when I did it, I did it in the dark, because I was so ashamed and in denial about the way I looked. I had gained fifty-seven pounds during my pregnancy and in the first few weeks after Hank's birth, I still looked and felt bloated. I didn't look in the mirror, nor did I ever look up. Deodorant and personal hygiene became last year's problem. I was sweaty, with milk leaking out of my boobs.

Nights were even lonelier. I would be down in the living room—it was a two-story house and we let the baby sleep anywhere (we never gave him a specific place to sleep really)—at four A.M. breast

pumping. So I'd creak down the stairs, open the fridge, get the breast suctions and bottles, and pump my boobs in the dark, all the while trying to keep my eyes open. Hearing the breast pump and the drip of the milk was like Chinese water torture every night; I was the only one awake, all alone, repeating the same mundane steps over and over again every night. I was watching the baby sleep peacefully while Hank was upstairs sleeping; it was like I was the only one in the world awake, and all the while the pump was going *chug chug, chug chug* and the milk was going *drip drip* into the bottle. The wind was banging up against the thin windows; it was about 40 degrees in our house unless you were standing next to one of our fifteen portable heaters, and the sun was about to start rising in around 180 minutes, and I'd yet to get two consecutive hours of sleep.

There would be nights too where I would purposely wake up Hank because I was so jealous he got to sleep. I felt really alone. I was so tired and miserable and without help I'd just give a little cough and he'd pop his head up to see what I was up to. That was my evil side taking over.

I had no sleep for a full month. I didn't initially hire help or a night nurse because I said to myself, "I don't need help, I don't need a nanny. I'm doing this myself." I brought that baby home and I took on the role of being a new mom the day after I had a C-section all by myself. Hank was working hard playing for the Indianapolis Colts and I was working hard being a stay-at-home mom. I wanted to be put to the test. I wanted to show people that I was going to do this on my own without help. It was a matter of pride, and I felt like I had a lot to prove.

But that schedule of waking Hank Jr. and feeding him every three hours hit me hard, and during a twenty-four-hour period, I would average about two and half hours of sleep. As soon as I'd

finally fade to sleep, I'd have to wake back up again. This went on for about a month. I have ADD, so once I was up I would wander around the house or look outside or just kill time. Sleeping became something of the past, a sort of fuzzy memory, something only "Hanks" got to do.

A month went by and I was fried. It became harder and harder to string a sentence together and remember what I was doing when I entered a room. I knew that I needed help. I was not only taking care of the baby but shooting a show on top of it. Here I was taking care of baby Hank with a sense of obligation. It had nothing to do with love or a desire to care for him. I was changing that kid's diaper because he couldn't do it himself. I was feeding him a bottle or my boob because I was taught to take care of those in need. I was running off of obligation but I wasn't loving him or anyone. I was angry at the world and my love for everybody was starting to fade away and diminish. Imagine that when your baby is crying you just shove a pacifier in his mouth to quiet him instead of giving him a hug. That is when I got help.

I finally gave in and hired a night nurse, Genie. She was from Indianapolis and recommended by my ob-gyn Dr. Webber. I didn't love the word "nanny," but I loved the word "nurse"! Even better, a night nurse! A nanny felt too much like I was having someone take care of my kid. A nurse felt like I just had someone around to help because I had never done it before. Genie was older and had kids of her own. I could tell immediately having her around was a good thing.

Hank Jr. liked her and that made me happy. She would come from ten P.M. to six A.M., so that meant I technically should have loved her too. But I felt a little threatened and jealous of all the things she could do that I hadn't mastered yet.

I would still take care of baby Hank during the day, but I was

mature and responsible enough to know that I wasn't doing anyone any good trying to do this all on my own. So the nurse woke up with him during the night. I felt guilty, but sleep was what I needed more than anything in the world and staying up at all hours of the night for me was dangerous. Too much of anything is really dangerous, especially for me. Not only for me but also for the baby and my husband and our relationship. I was at the point where the yang was taking over. I needed more balance in my life. For me, sleeplessness turns into paranoia and I started to hallucinate and see traces in the light, walking around like a zombie. I never laughed and I never smiled. I was not Kendra Wilkinson.

I knew that I was at an all-time low, without love for everything in life, including myself. During the first couple of nights Genie was there, I became even more depressed. That's when I finally found the time to look in the mirror and see what I had actually done to myself. The first two weeks were tiring but the third and fourth week were downhill even more. It was like torture, and the longer you are tortured the less likely it is that you'll be able to withstand it. I thought about self-mutilation and was mentally attacking myself. I wanted to pull my hair out and I wanted to cut myself. I didn't do it because I had been down that road before earlier in my life with drugs. I knew that the second I started to do that again I wouldn't be able to stop and we'd all be in real bad shape, to the point where if I did do it I'd probably need to go away and get help for a while. It was purely out of experience and what I had learned in my past that I was able to keep my head above water in that department.

I hated life. I hated myself. And I hated Hank because he was getting more sleep than I was. I was so upset. And I still couldn't sleep at night. I began to hallucinate and I saw myself as a pig when I looked in the mirror. Literally, I imagined myself looking like a hog. I would

stand in front of the mirror (or sometimes just think of it in my head) and imagine I was a dirty hog with a snout, that I was unclean and fat and just gorging on food and scrounging around in filth.

I started just to be mad at anyone who got in my way; I was an assassin. Feed the baby, scream at people, change the baby's diaper, be angry, put the baby to sleep, ignore others, wake the baby up, do laundry, lash out at someone—that was my life. I started saying angry, hurtful things that I've never said before to loved ones like Hank, like "I fucking hate you." On numerous occasions I told my husband that I hated him, and I meant it. The lack of sleep physically started to show on me: My eyes were drooping and my skin was completely pale like a ghost.

The word "hate" was the word I was using more than anything else, and I was hours away from the boiling point where I'm not sure what would have happened. The pig was out of her pen and on the loose.

When the nanny came I had the time to sleep, but that sleep just let my paranoia get the best of me. I was still beating myself up for letting someone else take over the child care situation. *Why couldn't I do it on my own?* My mind started playing tricks on me again. I was afraid of what Genie could be doing at three A.M. when I wasn't around. She wasn't even family. I felt like a failure for hiring this night nurse. I couldn't let go. I was feeling selfish for taking off a few nights!

As soon as the sun came up I would fly downstairs and be like, "Okay, Genie, I can take it from here." I knew that I had to prove to people that I could do it. I didn't even know who I was talking about, but I wanted to prove to "people" that I could take care of this baby by myself. Who were these people I was trying to prove wrong? It was my family. My husband, my son, my mom, my brother, my grandma, my in-laws, my fans, and America. I needed

everybody to know that I needed to do this right and on my own. Part of me psyched myself up out of pride—the needing and wanting to do it—and part of me did it out of insecurity, the old "What will everyone think of me if I don't do it?"

The problem with me during that time was that I wasn't thinking straight or rationally. If and when I actually got sleep I just dwelled on the fact that I was not there for my baby. I was angry when I got sleep and I was tired and angry when I didn't. Either way it ended up the same, and I stupidly convinced myself that Hank Jr. was going to remember all of this, he was going to know I wasn't there for him. Looking back, he didn't know the difference. When a baby is thirty days old he really doesn't remember if a nurse took care of him for two or three nights a week. In fact, hell, compared to me taking care of him at that point, if he could remember, he'd probably have preferred the nurse. But my depression led me into thinking he was going to see the night nanny as his mom. I was so delusional that though he couldn't even really see, I thought he was going to start recognizing her. The worst was when she got him to stop crying. I felt jealousy, anger, and insecurity all at once. She was comforting my baby when I couldn't! So I would wake up at five thirty A.M. or six A.M. just to rush downstairs and give Genie the "Okay, you're gone. Here's your money. Bye."

Yes, even Kendra Wilkinson got jealous of the nanny. Was she this young girl Hank was going to cheat on me with? No. But I was still jealous of her. Because when I first had baby Hank I was very insecure in my role as a mother. I was a hormonal wreck and beyond protective, a real mama bear. I was protecting him from everything, even family. And I just assumed everybody thinks I'm stupid and I had no idea what I was doing. Even family members didn't trust me. They thought I was going to have a blond moment when it came to baby Hank.

During these first couple of months all of my insecurities just came out and resulted in my not accepting help from anyone. I was so protective of him I basically told everyone, "Get away, I don't need you." I guess I've always needed to prove everyone wrong. And I thought I could do that by being the best mom, without any help. I'm so stubborn in that way. I had this persona—the blond girl with big boobs who's been on TV, that stupid-girl character—and I wanted to break it once and for all. People think that's the real me and therefore don't trust me to do a good job with anything other than partying.

It was a nightmare for me. I feel like I'm going to have to live my whole life having to prove people wrong. I feel like I'm trapped in a body that's not mine; on the inside I'm nothing like I look on the outside. I'm this former *Playboy*-type model but internally that's not who I am as a person. Every time I leave my front door I feel like I'm zipping up a Halloween costume of someone that I'm not, just like a businessman has to wear a suit every day to go to work. I feel like I'm zipping up a whole body outfit, but my suit is blond hair with big boobs and cleavage. When I come home I feel like I am zipping down that same costume and stepping out of it.

Now that baby Hank is out of his infant stage, I have calmed down. The second he looked at me and said, "Mom," I relaxed. I could go about my way and do some work now. I was okay leaving him with a nurse or nanny because I knew I had been there for him. My only goal was for baby Hank to look at me and call me mom. I didn't want him to call anyone else that. I needed it for myself.

So my nanny advice? Get that help if you need it. Don't be stubborn. I spent so much energy trying to prove that I could be a good mother and in order to do that, I had to do it all on my own. Ask for help. Take time for yourself to sleep or shower. Or eat a decent meal with veggies . . . maybe even sitting down at a

table! I learned that you can't be a good mother if you're filled with hatred and anxiety and you're not taking care of yourself. There's a saying, "A happy mom makes for a happy baby," and I agree with that 100 percent.

To those who had to deal with me during that time, I'm sorry. And thank you for standing by me.

On the flip side, a lot of celebrities claim they are doing everything for their baby but then dump their baby with the nanny. No one knows what happens behind closed doors. I see a lot of these Hollywood moms out till two A.M. or going out to dinners five nights a week or traveling around the world without their kid. In the tabloids, you see them strawberry picking, shopping, lunching during the day—everything is great! Am I to believe they installed the car seats all by themselves on their own? That they got up at 6:40 A.M. and made their kid breakfast? Put them down for a nap at one P.M.? Brushed their teeth? All the while still having time for their Brazilian bikini wax, facial, hair-straightening appointment, and Pilates? Doubtful. I couldn't do that. My goal has always been to avoid that. If being a mess and having all of my problems meant I finally got this whole mommyhood thing, then it was well worth it. I had a devoted and very involved husband, an assistant, and sometimes a nanny. But even with all of that, having a newborn turned me into a disaster. Anyone who emerges three months after a baby with clear skin, six-pack abs, and a smile is cheating you. It's just not reality.

Now I'm okay and I can leave baby Hank with the nanny every now and then. I still don't like to, but I will if I need to. I learned my lesson, and when I started to shoot my show when we moved to Philly with baby Hank, I knew I needed to bring in a nanny. I just couldn't get everything done while taking care of the baby. Filming a show, being a wife, getting the new place together in a new city— it's a lot! I needed help. Don't ever be afraid to ask for help, just

make sure it's good help! So that's when we brought in Genie again. I paid her to come to Philly, live in the hotel, and take care of baby Hank whenever I needed. We were paying her just in case because I didn't feel comfortable hiring a random person in a strange new town. I knew myself and I needed someone to rely on. I didn't care how much money it took. But I needed that freedom to travel or go to work for a night. She was basically my security blanket.

I couldn't have wished for a better nanny, but it was still hard for me. I wasn't too nice when it came to just handing him to her. For instance, if she put him in an outfit I didn't like I would get mad and say things like, "I'm firing the bitch." Deep down I knew I needed her. Looking back I know that was just my insecurity and that she was a great nanny. She could handle me so she stuck around. I could handle her so I kept her around. It was a unique relationship, an understanding, and it worked for us.

A few months later in the off-season when we moved back to L.A., I couldn't see hiring another nanny, so again, I paid her expenses to come out and live with us, on top of her salary.

But the longer she stayed, the deeper my jealousy grew. My boiling point happened once when Genie was leaving through the front door and I saw baby Hank running after her. So I had to let her go. Even though she was the best nanny I could have ever imagined, I couldn't handle the close relationship she had with my son. I stupidly couldn't handle the attention my son gave her. At the time, I thought it was the best decision and felt like I finally had some control. But the good feelings were short-lived.

I gave her two weeks' notice. I said, "You can stay with us and work or I will pay you if you want to leave now." I didn't want to keep dragging her around the country and pay her to live and work when ultimately I was too afraid to let her do anything. It was a waste of money. We still keep in touch with her, and who knows,

maybe one day when Hank's playing in another city we may need the help. Never ever let good child care slip away!

After firing Genie I was like, "Shit, wait, what do I do now?" I had no nanny. I was shooting my show and I was going through hell. I actually had my mother-in-law and father-in-law come in and help with the baby when I had to work and travel. I was spending more time with Hank's mom and dad than Hank was. What would I have done without them? Looking back, my decisions and attitude toward Genie were so misguided. Thankfully I know that was a different time and a different "mind-set" for me. Sane, I'd never treat someone like that. I was not 100 percent sane.

My exhaustion and depression gave me a complete understanding of what it meant and what it took to be a mother. It's nothing you can ever understand until you've been through it. Though I was never actually suicidal, I certainly thought about suicide. I knew full well I'd never actually do it; it was more on the level of pulling my hair out of my head, the Britney Spears–type stuff where you are just having a complete DEFCON 1 meltdown.

When I was younger I would cut myself, pull my hair out, self-mutilate, and do a lot of hard drugs to either numb the pain or feel the pain. There was a time when I was suffering from postpartum when I felt that low, and all I could think was, "Oh God, am I right back to that?" It was like I came to a fork in the road again and had to choose (though I know all too well you don't choose it, it chooses you) whether I needed alcohol and drugs and a knife to cut me to make me feel better. But I didn't need those things anymore, thankfully. There's no place in my life for that kind of harm and selfishness; I have a family now.

That's why I cry so much now. I don't have the substitute for my downs. I don't drink, I don't smoke, and I don't do drugs or harm anyone or myself. I'm sober to the point where I barely eat fried

foods or sugar! Clean as can be. I don't have anything to use to cope with my pain and depression anymore, just good old screaming and crying. Three weeks after having the baby, I felt just as low as I did the days when I was doing drugs and was suicidal. The only thing I could do was cry and scream, "Fuck you!!!"

Completely alone and unprepared, I had no one to talk to about it all. When you are down, it's even harder to reach out and ask for help. Plus, people are afraid to ask the question "Are you okay?" Because it implies you're not. Postpartum depression and anxiety is something that mothers have had to deal with for a long time but someone like me only talks about it after the fact. When it was happening I just kept it all bottled up inside. But it's no more prevalent now than in the past, we just talk about it and discuss it more now. The only reason we are paying more attention to it now is because of the media and books.

What angers me the most as I look back is that during the post-birth checkups, none of the doctors asked me how I was feeling emotionally. They'd check my vitals, they'd check my reproductive system, they'd check my blood and my weight, but they never checked my brain. That should be part of the release process in the hospital. New mothers are taught to pump breast milk, so why can't someone come in and pat us on our back and ask if we need someone to talk to? I wouldn't even have cared if it was a doctor or a social worker, or even if someone just sent in another mom to say, "Hey, how are you handling all of this?" That would have made a world of difference. Instead the only thing I left the hospital with was about a dozen stolen diapers, a package of burp cloths, and as many "free" boxes of wipes as I could fit into my suitcase.

On a scale of 1 to 10, 10 being the most severe, I would say my postpartum "depression" was an 8. That's pretty bad if you consider that my drug days would be about a 10. I will never forget the pain

that I was in back when I was younger and doing drugs. I wanted to end it all. My drug days and then the days of the postpartum are two times in my life where I could honestly say that people around me really had no clue what I was going through. Only a small percentage of people have been hooked on really bad drugs to the point where it threatened their life. But a lot of people have been through the severity of the postpartum that I had. I have had the unfortunate experience of going through both. But both times, I survived.

As I've said, Hank isn't a therapist. I didn't expect him to be one and I'm not going to treat him like one. I don't expect him to give me the right answer and that's not his job. If you are a wife or a mother and you have problems, don't expect your husband to be able to fix them; go to a therapist. But one thing my husband and I were able to come together on is the conclusion that next time, for baby number two, I will definitely get help. I'm not going to be ashamed about getting the help that I need. I'm not going to be scared to ask for help. I will take the time and I will hire a therapist during and after pregnancy. Men do not understand these things and we shouldn't ask them to. You better go to a professional when you can, during and after pregnancy, and that is what I'm going to do.

8

GETTING BACK TO KENDRA

ometimes in life you just check out. Maybe you're buried in work, maybe you are dealing with personal issues, or maybe (like in my case) you just had a baby. I had checked out of real life for a couple of months. Calls went unreturned, messages went unanswered, priorities shifted. It's kind of like a temporary leave of absence from life. I wasn't consciously avoiding the outside world, but there was no way I had time for anything other than breastfeeding and changing diapers. I knew at some point it was time to reemerge, but it wasn't something I could control. I'd get back in the swing of things as soon as time allowed me. For me, that was getting my body and my brain in synch. My eating habits were horrible, my workouts were nonexistent, and my mothering skills were average at best. If I couldn't do the "normal" things in my daily life, how would I have time to socialize, work, and be "Kendra" again? It was just going to take time. Time not only heals wounds physically from birth, but it also heals mental wounds.

For one reason or another, things always work out for me. It's not because I do anything right or make any of the right moves, but as always, one day things just changed. One day a long time ago I woke up and luckily got off drugs. One day I met Hugh Hefner, one day I met Hank, one day I had a baby, and one day I went to the doctor's

office for my six-week clearance, and when he told me I could go to the gym I came alive again. For me it always seems like I just need to make it to the next step and survive. It's always about survival, whether it's drugs, adolescence, depression, or scandal. All too many times I've been in situations where I could have given up and ended things, and yet, as long as I keep on pursuing that light at the end of the tunnel, things seem to work out. I know for me, quitting is never an option. In fact, I somehow end up better off because of it all.

I was still stuck at 140 pounds at my six-week clearance, thirty-five pounds more than my comfortable pre-pregnancy weight. I was all layered up because I wanted to sweat off the fat. I remember it exactly: I was dressed in three sweatshirt hoodies, spandex, and a couple pairs of sweatpants. I wanted to sweat those pounds off. But the second the doctor said I could work out, I had my moment of clarity. Green light! I headed right to the gym straight from the doctor's office. I felt high for the first time in months.

I was still cut open down below, but I didn't care. I walked into the gym and I beelined for the treadmill, my old friend. It felt like a long time since I had been on the treadmill, but I couldn't have been more excited. As I stepped on, I thought, "I'm about to fucking murder this gym." I put on some gangsta, ghetto-ass hip-hop music, like Lil Jon, Lil Scrappy, and Dr. Dre, and I just started sprinting. "Ahhhhh, Kendra is back!" That was the day that brought me back to life.

I was just so happy to be running and be out of the house and be listening to rap music instead of lullabies and nursery rhymes. I had my identity back, and that is the one thing I needed. I needed to put my headphones on and listen to some gangsta music. My pulse quickened to the beats and I remembered who I was. For thirty minutes, I wasn't a mom. I was just a chick on the treadmill trying to sweat off some pounds. I was back!

When I first got on the treadmill, I ran harder and better than I ever had in my entire life. Even though I hadn't run in several months, I was sprinting like I was in the greatest shape of my life. I felt like Forrest Gump. I could have run across America, I had so much energy and motivation. I felt like that was the way to be me again. I had a destination but I knew I couldn't get there overnight. So every time I ran, I ran more than I ever had in my life. I felt great.

I felt so good I went back the next day and the next day and the next day and the next day. It became a routine. The second Hank got back from practice I was going to the gym for thirty to forty-five minutes. I was going to murder the gym, then going to the tanning salon in the middle of winter and getting my tan on. It was like I had been stuck in this black hole and then one little trip to the doctor triggered me right out of it.

My first point of focus was my mental well-being. But as soon as I got my smile back, I started paying attention to the rest of my body. I knew I had put on weight, and I knew I didn't look that good or feel that good anymore. So I needed to fix it. I wasn't worried about my belly—that's where my baby came from and I wasn't surprised to see it had gotten bigger. I was honest about the fact that my stomach wasn't going to go back to being a six-pack again any time soon; I'm not Gisele Bündchen. I wasn't stressing about that. I was stressing about my back. I hate my back. It's always been a "problem spot" but being pregnant made it that much worse. It's boxy. And my boobs got too big and made me look bigger than I actually am. Especially when my milk came in. Then my neck area got big, so combine that with the fact that my back exploded and I just looked like a giant Volvo. I gained a lot of weight in my back, upper and lower. Most women hate their arms and legs, but I hated my back. From top to bottom and left to right (especially under my armpits—my traps), I felt like I had wings.

Although I was sweating it out daily on the treadmill and painted over the rest with a spray tan, I couldn't shake the baby weight no matter how many miles I ran or what diet plan I was on. Let me tell you, there's nothing babyish about baby weight. This stuff is a monster. I had Freshology delivering all my meals, I was running on the treadmill, I was barely drinking, and I was breast-feeding. Losing weight should have been easy! But contrary to some of the Hollywood moms who flaunt their bikini bodies just weeks after giving birth, it wasn't.

Five months into motherhood, I still couldn't shed the weight. I was feeling better about myself and more optimistic since getting back to the gym, but the number on the scale still wasn't budging. I ended up throwing away the scale because it became my enemy! I weighed about 140 pounds the day the baby came out of me, and five months later, I still weighed 140 pounds. This really started to anger me because mentally I felt healthy. My postpartum depression was gone and I was working out, dieting, and trying new things like smoothies and new exercises. Other than motherhood, weight loss was my number one focus, but you'd never have been able to tell that by looking at me.

I was technically "cured" of my postpartum depression, but the fact that I couldn't lose a pound was starting to get to me. But I didn't want to give up; nor did I want to get fatter either. I started to think about other options because I thought there was no hope. I was doing everything I could and not losing the weight. I was working out twice a day in 120 degree heat and hadn't lost a pound yet. I didn't know what to do.

So I tried throwing up my food, but bulimia just wasn't my thing. I gagged myself with my fingers and the food came back up. I was desperate for something, anything, to work. At this point, nothing that anyone recommended actually did the job. So desperate

times called for desperate measures. But I immediately thought, "Well, that was horrible and uncomfortable. This isn't for me." The thought of vomiting up my food made me even more nauseated than the actual act. I wanted to lose weight but not that badly. I forced myself to do it, but it's not me; I'm not a person who was made to stick my finger down my throat, thank God. It actually made me sicker.

Then I considered surgery and lipo but figured that was a last resort. I was young; I shouldn't have needed liposuction at this point. Sometimes you just stare at yourself in the mirror and think "Surgery could make this all go away." But I was looking to try other options before getting to that. Something had to work! So I took diet pills and started to wear Spanx, but neither was working. The Spanx actually made me look (and feel) bigger, because in my head it was just an extra layer of material making me look even thicker. People would come up to me and say, "It's okay, it's only been three months." That bugged me, but it bugged me even worse when they said, "It's okay, it's only been five months." Meanwhile I would see pictures of Kourtney Kardashian in the magazines, and her body was already back to normal after a few months. I kept thinking, "What is wrong with me? Why can she do it and I can't?" I couldn't understand what I was doing wrong. We had kids three days apart and she was back to her pre-baby body while I hadn't lost a pound.

It got to the point where I knew I was becoming a poster child for struggling to lose the weight when businesses wanted to hire me for their weight-loss campaigns. That meant I was still "fat," because they wanted to portray me as the "before," hoping I'd get to the "after." They all submitted me proposals and gave me time limits by which I had to lose the weight! When I started to shed a few pounds there was a diet pill manufacturer that wanted me

to work with them, and they wanted "before and after" pictures. So I took my "before" picture and sent it in, but they said I wasn't fat enough in the photos! They wanted me even heavier. So this company actually told me to eat a ton of bread and whole bags of chips and drink a lot of soda and then take a picture so they could get their good "before" picture. I tried to look fat and I gave them a good "before" picture, but ultimately my team and their team thankfully figured out I wasn't a good fit.

Diet pills, bulimia, plastic surgery—nothing seemed to be right for me. So when we were in Philadelphia I went to the gynecologist just to check things out, because at this point I just wanted to make sure I was healthy. I suspected and maybe even hoped that something else was going on so I would have an explanation for why I couldn't lose weight despite my best efforts. So I went and got my blood drawn as part of the usual checkup.

I left the doctor and went to an interview for MTV's *When I Was 17*. And during the interview, Eddie comes running over with the cell phone screaming, "It's Hank! He says it's an emergency. He's been calling everyone looking for you." So Eddie gives me the phone, and I shout to Hank, "What's wrong?!" Hank says, "Kendra, do you know what's wrong with you right now? Your doctor just called me and told me what you have. Your blood test shows your thyroid levels have plummeted. It's the lowest level they have ever seen."

The doctor said my thyroid levels were ten times less than what they should have been. They were worried about it getting worse and sent me to take another blood test to double-check it. New test, same result. It was obviously a real and growing problem, so that same day she sent me to an endocrinologist.

The endocrinologist started talking to me about my problem and asked me if it had been in my family, which it hadn't. He asked

me if Hank Jr. had any problems; I said no. Doctors don't get me nervous because I always assume they exaggerate; I think if there's a problem it will present itself. But this was making me nervous because it was actually presenting itself. I had been exercising, eating healthily, and getting further and further away from the day I gave birth, yet I couldn't lose any weight. So something was obviously wrong. The doctor explained the science of my body, specifically the role of the thyroid in controlling hormones, metabolism, the brain, and the pituitary gland. And half of my thyroid had shut down, so basically my body was working at only a fraction of the capacity it was supposed to. My metabolism had all but shut down. I was dieting and exercising just to maintain my current weight and keep up my energy. But no matter how much I did, I was never going to lose weight. He said to me, "Frankly, I'm shocked you don't weigh two hundred pounds and that you are not passed out in bed right now completely tired."

So when I moved back to L.A. shortly thereafter, I got in touch with a new doctor and got on a new diet. This doctor prescribed me 180 milligrams of Synthroid, a prescription synthetic thyroid hormone intended to replace a hormone that is normally produced by your thyroid gland. I'm now on only 100 milligrams, but I'll have to take it for the rest of my life. The Synthroid regulates me and keeps my level at a livable state. It started working immediately, and within two weeks I had lost about three pounds—three more than I had lost since giving birth! Five months after going through hell, I finally figured out my problem. Better late than never!

There was so much ridicule in the tabloids and on the blogs over my not having lost the baby weight, and yet what people don't realize is that I was fighting a serious condition. Being in my body at that moment made me realize what other people go through, people who can't lose weight, people born with genes that mean

they are going to be big. I feel bad for them because I was stuck in that body despite my efforts. I felt so lucky that the right medication was going to help me fight it off. It was weird because I was used to being healthy. I'm used to fighting to be a size zero, but here I was fighting something bigger.

I took all of the doctors' advice on what to eat and what to do, along with medication, and finally the weight started melting off. I started pushing myself so hard that I fainted a couple of times from working out. I just felt like I needed to do everything I could to make up for lost time; I didn't want to give up. I was so proud of myself for finding out what it would take to get over my problem. I didn't care that I hadn't lost weight anymore. I felt proud that I had figured out what was wrong with me and was trying to take care of it. Even if I never lost another pound at least I was getting healthy now. I remember looking at the mirror and smiling for the first time at my body. Even with the stretch marks, even with my fat rolls on my stomach, even with all of the uneven and unbalanced weight-gain areas, I remember thinking, "I'm well on my way to getting back to being Kendra."

I linked this thyroid problem back to the postpartum depression immediately. I was such a mess for so long, and so many people think hypothyroidism is a joke; they don't believe that this thyroid thing is real. But just like postpartum, the more you talk about it the more you hear of so many other women who are affected by it.

When I finally got my head on straight, I was mad at myself (and Hank) because I realized the main contributing factor to my not having anything diagnosed sooner was that I was traveling all over the country following Hank. Every few months I had a new doctor, and then just when he or she got to know me I would leave. Nobody took the time to properly assess me and what was going on

with my body. I was in Indianapolis for the last stages of pregnancy and then birth, L.A. for first few months of Hank Jr.'s life, then Philly, then Minnesota, then back to L.A. No one had the time to fully check me out. It was always a quick test of my blood pressure, my vagina, and my weight. As if that was *all* that could be wrong with me. If I had been settled in one city I would have caught it. Like kids whose parents are in the military, here I was an "NFL brat" moving around from city to city with a severe condition that was going untreated.

After pregnancy I knew I was going to have to consider dieting, something I never in my life had really done. The first few weeks of postpartum I still ate like I was pregnant. But I knew better. I don't see eating healthy as a diet, I see it as something normal I just

Steak and fries for Hank! So we hadn't started our diets just yet.

do. Before pregnancy I ate healthy, I worked out, and I had a great body, but I could eat whatever I wanted. I knew those days were over. But I must say now I look at pictures from before pregnancy and I think I look too skinny! I like my body thicker and more muscular. I would always ask some of my black friends how they got their butts and thighs. And they would say to me, "Eat fried chicken and corn bread and sweet potato, then you'll get a bigger butt!" So I tried that, but only my stomach got bigger. But now after pregnancy I'm happy (and obsessed) with my bigger butt and thighs. I finally have the body I've always wanted.

I was never ashamed of my body during pregnancy. In the beginning it looked like I was gaining all of this weight because there was no belly, so people just assumed I was fat, and I didn't enjoy that. During our honeymoon I was about four months pregnant and sad about getting into a bathing suit because I looked fat, not pregnant. It's especially disheartening when one of the things you are most known for is your body. I'd rather have people say, "Oh, she's pregnant," instead of, "Oh, she's fat." As long as they had the right information, it didn't bother me. But at first, it takes some getting used to. No one wants to be called fat. So that was the reason I actually told people I was pregnant. I didn't want them to think I had just put on some extra weight!

But overall I actually felt sexier when I was pregnant than when I wasn't pregnant! My skin was glowing, my hair was thicker, my lips looked fuller, and my cheeks were pink. It was a fuller, sexier look, and I embraced it. I was rocking it! Even though I wasn't eating great, I stayed fit by working out and swimming.

My diet was supposed to take a drastic turn for the better after birth and I tried to mentally prepare myself for it. The instant the baby came out of me I looked at him and thought, "This is the love of my life; I need to be healthy. I love you more than I

love Dunkaroos. My diet will change right now." Let me tell you though, it's easier to think about than to do. I did love baby Hank more than Dunkaroos, but I convinced myself that I could love the both of them! My body was still craving the sugar and the fat it had been given for the past nine months; it wasn't like I could just stop. I was flat-out addicted to the stuff. I tried to mentally fight the cravings but I was also battling insomnia, depression, anger, and the overall lifestyle of being a new mom, so the last thing I had energy for was fighting cravings. It's a lot easier to just give in.

Before I got the six-week clearance from my doctor that I could exercise, I was just a blob. My arms lost their shape and got bigger. In fact, I felt bloated and bigger all over. I hated my body immediately after birth. I couldn't work out, my blood wasn't flowing, I was uncomfortable in my own skin and still felt depressed. I ate a ton of bad food, and I generally started to put on even more weight. I was frustrated by my inability to fight cravings and lack of self-control. Instead of slimming down, I just shoved anything I saw into my mouth. I was busy learning the ropes as a new mom and it was so much easier to just stick my hand in a bag of cookies and eat it for lunch because that saved me time and I wouldn't have to think about it.

In my life, I have quit drugs cold turkey. I just decided one day, "That's it, no more drugs." I guess I was never *really* addicted to them. I used a lot of them, but luckily I was just able to one day wake up and quit. Quitting food wasn't as easy. For me, quitting junk food was ten times harder than quitting drugs, because Twinkies and Oreos are so much more readily available and convenient to do than drugs. They fit into your daily schedule and are everywhere you go.

I was really hungry postpartum because I was breast-feeding and chasing around a little toddler. All I could think was, "OMG, I need to eat. Eat. Eat. Eat." But I wasn't burning enough calories

to counteract what I was eating! I breast-fed for four months and I didn't shed any pounds and/or inches. You can't lose weight when you are single-handedly keeping Dunkaroos in business. I was constantly thinking, "No one is looking, I'm going to sneak a couple handfuls of popcorn, I'm going to sneak two big brownies and some Dunkaroos." I really could have had an endorsement deal with Dunkaroos. I probably would have done it just for free product. I would eat two packages of Dunkaroos before I even left the kitchen.

I saw pictures of myself online and I knew that I needed to lose the weight. There would be a paparazzi shot of me or a posed red carpet shot and I'd just see fat all over the place. I remember looking at baby Hank and saying, "Suck harder!" I was pumping to feed him *and* to lose weight, but it wasn't working!

I think a lot of my weight and body issues were self-imposed. While I had a condition, I also brought a lot of the problems upon myself. I exercised and tried to stay fit during pregnancy, but I also developed nasty eating habits that stuck with me. And, of course, I had spent the better part of my adult life showing off my body. I guess it shouldn't have come as a complete shock to me or anyone that losing that body and putting on weight wasn't going to be the easiest thing to deal with. That came up in a dramatic way when it came time to debut my "bikini body after baby," something pretty much every mom in Hollywood just loves to do now.

I did a shoot with *OK!* magazine about losing my pregnancy weight—it was all about diet—and yes, I was trying, but I just wasn't successful. At least trying to maintain a diet and knowing that I was supposed to focus on it made me feel good. In my head I was trying, but then in reality I would sneak a brownie or a bag of white cheddar popcorn, in addition to the meal-replacement smoothies I was chugging. I was lying to myself.

I was not excited about that shoot. I love *OK!* magazine and they treated me well. A few weeks earlier they had done our official newborn baby shots, for a full cover, and they gave us all of the photos to blow up poster-size so we could have them forever. I loved that. But I had signed this contract with *OK!* before giving birth, which also locked me into doing the newborn photo shoot *and* the "body after baby" shoot in a bikini. I totally had forgotten I had signed up for that, and one day they just came calling, saying, "We're ready to do our bikini shoot!"

I was supposed to take off the baby weight by then, but as you know I struggled through the first several weeks and I wasn't in any kind of shape to do it, not to mention it was only about two months after birth. Plain and simple: I was still fat. And in the weeks since I had gotten the six-week clearance I was sweating my ass off at the gym. But I still couldn't shed a pound. It was obvious and I can admit that I was, shall we say, touched up. I would have rather had that photo go out not touched up, because I had to see my fake self in photos every day and try to live up to it from that point on. I was not this rock-hard body in a blue bikini. I was a blob still. But I had to give off the image that I was fit. We had a deal so I had to follow through. They thought I was going to lose the weight faster, but because of my condition and the fact that I had a C-section, it didn't turn out as planned.

I topped off at 165 pounds during pregnancy, meaning I put on about fifty-seven pounds overall. It wasn't going to just melt off me.

I walked around wearing extra-large clothes after the photo shoot to put out the façade that I was losing weight still. I didn't want people to think I was a liar. But that photo shoot made me obsess over my body even more because I had to live up to those photos. It was the worst feeling of all time, to look at myself on the cover of a magazine and say, "I wish I looked like that." That made

me get on the treadmill twice a day and try even harder. I realize now what other women must feel when they see beautiful actresses and models on the covers of magazines; it's just not realistic, and certainly not fair.

Hank is my worst critic, just like I used to be his. He knows what I want and he knows that I truly want it, so he helps me stay disciplined. But I tried my best to go behind his back. If he catches me he's like, "Ahhh—what are you doing?" I love it when he does that. No one has ever made me feel like that or put me in my place. I never had a father to yell at me or that male voice in my life that I had to listen to. When I hear that deep voice bellowing, "I know you are sneaking a Dunkaroo!" I love it. He always knows! It's like that scene in *A Christmas Story* where the dad is cutting into the turkey and the mom is in the other room screaming, "Stay away from the turkey!"

So, I did what I had always done with things I'm hung up on—I threw it all away. It was hard to do but I did it. I cleaned house. I knew I had to. If it wasn't in the house, I wouldn't eat it. I wasn't ready to get rid of all of this stuff—my cravings weren't gone yet—but I had to do it. It was just the only option left. Once I stepped back on that treadmill, I regained that sense of self and empowerment that I used to have and used it to fight my food cravings.

You can see how low I got. And how far I strayed from being myself. I felt like I had no control over my body and my health. And my body had been my calling card, my moneymaker, what I was known for for so long. It was a scary journey. Losing that part of my identity, in some way, might have helped me redefine myself in other ways, as a wife and mother. But now that I have lost the baby weight and am back on track, I feel so much better.

Hank and I are making sure that our diet knowledge spills over

to Hank Jr. too. I make sure he eats a variety of different healthy options and doesn't eat the same thing twice on the same day except for veggies and fruit. He can eat those all day long. Anything with meat or bread I don't let him eat two of the same thing a day. I make sure that if he eats ham for breakfast he won't eat it for the rest of the day. We make sure we are very balanced in diet. I make sure I don't give him too much bread or sugar or salt. Kids these days will have juice and sugar cereal in the morning, and then sugared snacks, juice all day, a cookie at lunch, a cheeseburger and fries for dinner with juice, and ice cream. That's just not right. I'm so OCD about a balanced diet with him. Most of the time we cook his food and make sure that everything (including his sugar and salt) is balanced. He's so good, he'll eat steamed veggies without anything on them. We make sure he gets his iron and red meat and chicken and I have fresh-cut deli meat from the deli, not anything that's prepackaged and soaked in sodium or preservatives.

When we got the clearance that Hank Jr. could eat solid foods, I had so much fun! The very first thing I stuck in his mouth was veggies. I was obsessed with blending; I blended everything I fed him. Carrots, broccoli, squash (spinach was way too stringy)—we gave him everything you could imagine and he loved it. I was so into it that a few times I would meet new moms who had given birth around the same time I did and we'd be talking and they'd say they were just giving their kids jar food, and I passionately started preaching to them—go and get a blender, start blending!

The result? Success. Now he eats straight-on adult food. We are still on the veggie diet for him. You can't go wrong with any veggies. He loves broccoli and squash. They make it so easy nowadays; everything is prepackaged and you can buy it frozen and organic and washed. The grocery stores are doing it for you. They cut that shit up! There's no excuse—"This takes too long!" Hell no. We

steam and add garlic and whatever—it takes five minutes to do this! Ten minutes and you can make it for the whole week!

Of course, sometimes I feel like I'm all alone in this mission. If Hank feeds him a cookie or cake or if I find out Hank's mom and dad fed him something fattening, then I get so pissed. I'm like, "That's not good. Never feed him that!" But on the flip side, of course it's okay if I do it every once in a while. If anyone is going to give my baby sweets, I'd rather it be me. I'm the one who knows him best and keeps track of that stuff. If I give him a cookie, I need to know someone else didn't give him one two hours earlier. I'm getting less crazed about it but I just want to make sure that he has a good diet. I want him to have healthy habits and not bad habits. I want to put in his mind that this is the way it is.

I want all of us to live long, healthy lives and have the best life possible. I want to feel great and look great just by eating great. It's an added bonus. I believe eating healthy is just like wearing your seat belt—you are gambling with your life if you don't do it. I don't want to limit our lives because of food. Life is life, food is just there. I want to get the most out of life, not food.

When baby Hank was eight to nine months old, he couldn't chew but was able to eat solid foods, so I would make him home-made baby food. Any meal we ate (meat, chicken, spaghetti, turkey dinner, fresh veggies), we would add a jar of Gerber baby green beans to help liquefy the food, pour into the blender, and blend till it becomes baby food. That's it! Baby meals done easy!

9

FAST FOOD AND FAST SEX

Obviously, eating healthy and staying fit has been important to me for a long time. I've struggled with it, and when faced with temptations, it really becomes a test of willpower. Maybe it's so important to me because I remember what it was like to live as unhealthy a life as possible—drugs and alcohol replaced fruits and vegetables for a while, and I was too close to wasting away. So that's why abandoning healthy eating when I was pregnant set me up for disaster! All those Dunkaroos and Ho Hos screwed with my biology and I got on a cycle of craving more and more. My brain was totally overpowered.

Getting my healthy practices back was a struggle, but I know it's good for my son to see, and—duh!—it keeps me looking good. I recognize that looking good is half the battle toward success in Hollywood. And maybe even life! The other half? Mental. When I'm looking good, feeling good, eating good, and working out—I'm HAPPYYY! Happy and healthy: two things I strive to always be, despite the many obstacles I've faced that try to keep me down.

Health isn't just about working out at the gym. Health is head to toe, breakfast to dinner, Monday through Sunday. So I try to be more in charge than ever. And I mean taking charge of the *whole* family. Not just the kids. Hank Jr. is my number one priority, but

I always make sure my husband is taken care of too. I've got to do everything I can to make sure my man stays on the right path. From sex and drugs, to gambling, to diet and God knows whatever else men can get themselves into these days, I've got my eye on it all.

Right now my biggest pet peeve is texting and driving! It's like having unprotected sex with a stranger or drinking and driving. It's that dangerous and I won't have it! That's the one thing I've made Hank promise to me (other than the usual marriage vows like no cheating): no texting and driving. He'd be talking to me, driving, and checking sports scores on his phone all at the same time. It's not something to take lightly. The first time I saw Hank doing it I screamed at him. I'm not going to put little Hank in a dangerous situation like that. The text can wait. How dare you put our child at risk? He'd be driving sixty miles an hour and thinking he can take his eyes off the road for a split second to see who the latest text is from. But sometimes I'd catch him and one second would turn into two. If a car in front of him stops short and he's going sixty miles per hour that split second is barely enough time to react, let alone if he's not fully focused.

Hank saw how worked up I was getting about it and he began to understand. I'm so against it that any time I see anyone else texting and driving, I'll yell at them too. I'll roll down my window, I'll honk, and I'll scream out. I don't care who's watching me. We should *all* do this, because one day that person is going to be behind you and not looking. As moms, that's our job!

Besides looking sexy, keeping things hot in bed, and making sure my man is satisfied, I've got a lot of other things that I need to do as a wife and a mom to make sure my family is running properly. I've also taken full control of the diet situation in our house. I do the shopping and most of the cooking, especially when it comes to

what baby Hank eats. If Mom's not doing her part from the grocery store to the dinner plate, then you end up with a household that's unhealthy with poor eating habits. And if I hadn't come into Hank's life that's exactly what would have happened.

Poor baby Hank would be eating chili cheese dogs for breakfast if Hank had his way. But luckily for the both of them, I stepped in and transformed Hank from a meat- and fried-foods-eating giant into a healthy, smart eater of all food groups. It *can* be done!

Hank is from New Mexico and he grew up eating unhealthily. A healthy choice to him would be a hamburger instead of a cheeseburger, although I've never even actually seen him make that choice. He's not part of the Hollywood fraternity that obsesses over health. I don't know if he even knew what vegan was before he moved here. He's an athlete, so he knows the difference between a protein and a carbohydrate, but that's about it. He was pretty big when I first met him, on the heavier side of 220 pounds. A really bulky, unhealthy, big-time eater.

His family loves to eat. They are naturally bigger people. Hank's brother, his mom, and his dad all love their ribs, steaks, sausages, bacon, hot dogs, and French fries, and they just pour tons of sauces and gravy all over ribs, hamburgers, mashed potatoes. Basically they love anything with a sauce or cheese on it. And Hank was no different. During the first few months we were together, I watched him as he ate one hot dog, two hot dogs, then he was about to eat a third one, and I was like, "Are you serious? That's not good." I didn't want to be around someone who eats like this, and while I consider Hank the perfect guy, if I could point out one flaw from back then it was his eating habits. It's not healthy and it's not attractive to me when someone gorges on things that just clog your arteries and fill your body with excess fat. Anyone who eats just to eat and gets so much satisfaction—and believe me, you should see

how lost and in a daze Hank gets when he's digging into a huge, dripping cheeseburger—is not doing the right thing for their body. It nauseated me to watch him eat, but I also felt like he treated food like an activity. He needed to learn about the pros and cons of food. It can be a beautiful thing, but it can also be a dangerous thing.

As he was eating that third hot dog, I took it out of his mouth, threw it down on the ground, and I screamed at him, "You don't need that third hot dog! You don't need it!" He got so mad at me, but as I was looking at him salivating at it, I swear he was going to pick it off the ground, scarf it, then go for numbers four and five. I firmly believe men would do that if we weren't around to stop them. "What is the point of eating three hot dogs? You don't need three hot dogs! You had two, two is a lot," I said to him. I should have slapped that second one out of his hand too. If he didn't know that three hot dogs were too many to eat in one sitting and that he ought to be eating fruit or some salad or veggies instead, then I was going to have to show him. I cared about him too much to turn a blind eye to his eating habits. It's something that as a woman who loves her man very much I was going to have to take a stand on. I know no man wants his woman to tell him what to eat, but it was impossible for him to stop on his own; he needed me.

I had to break it down for him that he was headed for a physical collapse. Maybe not now, but a decade or two down the road, those hot dogs were going to build up inside him like a wall. So I said, "Look, babe, you're getting to an age where your metabolism isn't what it used to be. You used to be able to eat anything you wanted, but maybe you can't and shouldn't now." Of course his typical guy reaction was, "Don't you tell me what to eat!"

I may sound controlling, but I pick my battles. I'm not going to tell him what to wear, but I'll be damned if I stand by and let

him eat five heart attacks in a bun. So we had a big talk about health and diet and lifestyle. It wasn't a debate; it was me clueing him in that right is right and wrong is wrong: Broccoli is healthy, chili dogs are not.

I wanted Hank to know the difference between apples and apple pie. I wanted him to have a healthier heart, a better diet, and more knowledge about what he was putting into his body. And it would help his performance on the field too! It was a beautiful thing. We hadn't known each other that long but for us to both get on the same page about something so important—our health—was a major milestone in our relationship. From that hot dog on we changed our lives for the better and started going to the gym together every day. I said, "I care about you, babe. If we are going to get married, I need you to be around for as long as I'm around. I want you to be able to go on hikes and run around with our baby and I don't want you having heart problems. You are my partner through life." We knew then we were a team.

Now Hank and I pay a lot of attention to health news, following stories about disease, nutrition, and exercise. Some people are living so miserably because of food and how they eat. That is surrounding us so much, so we figured we should try to learn from it. I almost think of food as medicine. If I overdose I'm fat. If I don't get enough I starve to death. My body will tell me what I need and if I have the knowledge, then I know I never really need Twinkies. I know broccoli is good for me because broccoli makes us poop!

Hank's mom and dad still don't eat like we do. So when they come to visit Hank wants to get cheese curls, potato chips, and all this junk food. We know we need to put food in the house that they like to eat; it's the right thing to do. But when they go, that stuff is still in our house—they don't take it with them—so the second

they leave I dump it all out. The saying in our household is "What you don't see doesn't exist." If it's there we eat it, so we do everything we can not to have junk in our house.

The moment I slapped that hot dog out of his mouth was the moment we had major clarity about our future together. At this point we were in my town house that I lived in right after I moved out of the Playboy Mansion, and Hank had just come out there to live with me. We had been living together for a few months—everything was new to us. But I knew that if I was willing to really care about a man's eating habits so much, and that man was willing to return the care by actually listening and following through with my suggestions, then we were in it to win it. We were in love and planning our future—a healthy one—together.

We threw away everything bad. We just went through the kitchen cabinets and drawers and the fridge and freezer and started chucking all the junk food—and it was a lot. We cleaned house. It was liberating. And it brought us together. You don't realize until you start paying attention to all of the crap that you put into your body—chips, processed foods, high-sodium preserved meats, cookies, sodas—that this stuff is slowly killing you. It was the best feeling when my future husband and I went to the grocery store for the first time on our new diet. We were ready to take the first step toward the rest of our life.

The grocery store is an amazing place when you view it as a positive place that can change you—not just somewhere to load up on Ho Hos and Twinkies. And instead of grabbing a bunch of white bread and fried foods and sugars, we took the time to look around. The grocery store has every food you could ever dream of buying. Yes, these days so much of it is prepackaged and frozen, but all grocery stores have fruits, vegetables, and options. Options are the key. What are you going to buy, what are you going to make? It's

a lot easier to buy a microwaveable frozen meal with fried chicken, mashed potatoes, gravy, and apple cobbler. But if you actually take the time to look around the store, there are a million other options (in slightly less colorful and snazzy packages) to consider. We were young, childless, and had a lot more time on our hands, so I wanted to make the most of it. It was an epiphany, a brand-new life that took us over, and we bought veggies and fruits, all these bright, vibrant colors and tastes.

We spent hours exploring food and read the labels and the boxes—we were in team mode. We started thinking about percentage of daily intake and fat, sugars, and carbs. If one bag of chips had 10 percent of our daily intake of fat per serving, and another had 5 percent, the choice was simple now. And that's what we looked for. We felt so good about ourselves. We even explored spices, and that's when we found our secret ingredient—garlic. We put it on everything from chicken to meat to fish to vegetables. Garlic is a magic potion and makes everything taste so much better. It was the key to our diet. We threw out the butter and salt and replaced it with simple old garlic.

GARLIC CHICKEN RECIPE

1 package of skinless, boneless chicken breasts, sliced thin
Herbs to taste, fresh preferred (but let's be realistic, dried
 are okay too)
1 clove garlic to taste (we use a lot!)
Olive oil

Marinate the chicken in a mixture of herbs and garlic for at least two hours. Add 1–2 tablespoons of olive oil to a nonstick pan and cook chicken on medium-low heat for five

minutes on each side. Sprinkle chopped garlic on each side of the chicken breasts. Continue cooking till it's done.

Side: Add broccolini, carrots, and cauliflower to a steamer and steam till soft, and make some quick-cooking brown rice in the microwave.

Every morning we woke up and had freshly made smoothies and low-cal oatmeal, and we actually ate more because we were working out and hiking. These were the last few moments of freedom before baby Hank came along, and we worked out and hiked every day. When we teamed up and got on our official diet plan—it was more of a life plan—the sex was awesome. Because of diet and exercise—it's all linked together—our sex drives just skyrocketed. I just wish everyone would realize how much better sex is when your blood is flowing better. It's like putting premium gasoline into your engine; you are just working at 100 percent capacity, your breathing is smoother, and everything works better—and of course I don't find it a coincidence that this is when I got pregnant. We stopped using condoms because the sex was so good we just wanted to make it even better. I never was on birth control because it makes me sick. We were both already talking about a baby, but waaaay down the road. We knew not using a condom was a risk, but in the moment we just couldn't help ourselves. We were also both looking better, so attracted to each other, and we were having sex everywhere, in the back of cars, in public, pretty much anywhere we could steal a private moment (or five). I liked being naked with Hank—we were hot! We were having so much more sex and it was great!—and then *bam:* pregnant! I like to think of Hank Jr. as a result of not just our love but also our health.

My Ultimate Health Fix Recipe:
Fruit and Veggies On the Go

1 handful broccoli
1 handful carrots
2 handfuls strawberries
2 handfuls blueberries
1 handful grapes
1 apple
1 orange

Add ingredients to juicer and liquefy.

I've learned a lot about nutrition, healthy eating, and recipes since I got married. I had pretty bad eating habits growing up, and then when I was living in the Playboy Mansion I had cooks at all hours of the day who would whip me up whatever I wanted: chocolate sundaes, greasy hamburgers, and pizza at three A.M. You might remember from *The Girls Next Door* that I ate a lot of chicken fingers and fried foods and gained some weight as a result. Even though I learned some bad habits there, I also picked up some cooking tips by watching the cooks prepare food. Subconsciously I knew how to prepare delicious salads and veggie options—I just wasn't acting on it! And, of course, living in Los Angeles gives you the ability to pretty much stop off anywhere and get fresh fruit, a salad, or a smoothie. The world was openly ready for me to get healthy, it was just going to take a lot of willpower.

Ever since then Hank and I have been on the same diet. Even when I was pregnant, Hank was on the same eating plan as me. If I was craving pickles with mashed potatoes, Hank would eat pickles

and mashed potatoes. He loved it when I was pregnant; he thought it was a great excuse to chow down! Unfortunately, that's when we both ditched our new diet plan. It was a junk food fest and he put on the "daddy fifteen pounds" before the baby was even born!

Hank and I love to spend time together, but when I was pregnant we'd be like two girls with the same mood swings, as if he had my menstrual cycle. Our energy was the same and a lot of that came from us sharing in a lot of bad eating habits. Pregnancy was my time to forget about dieting. I had spent the last four to five years trying to look a certain way and maintain an image that said "*Playboy*," and whenever I got fat it was evident I should slow down on the eating. There were times at the mansion where I knew I was putting on the pounds, but it was a lot easier to take care of that problem then.

Pregnancy was a whole different ball game. I told myself I was allowed to get fat! I thought, "If I'm going to do this for the next nine months, I'm going to at least eat whatever I want." I cared about avoiding caffeine and liquor, and I was very careful to make sure the baby got his nutrients, but I ate pretty much everything I wanted. Hank did too because he was always with me, so we were eating like there was no tomorrow. My stomach popped and I got big. And I couldn't wear my sexy outfits anymore. But I loved being pregnant! I felt sexy even if I wasn't. It's all a mind-set, because during my pregnancy I felt like I glowed and Hank wanted me just as much as ever.

I'd eat batches of brownies in one sitting, literally a whole cake pan. I ate a lot at night. My stash of junk food was in my nightstand drawer. I pretty much moved the kitchen cabinet into my bedroom so I could access it quickly. I always had a huge box of Nutter Butters close by and I'd go through the whole box in one sitting. I was addicted to white cheddar popcorn—something about the salt and

Caught! My cravings were kicking in, yet again.

cheese—and I would devour it by the bag and then top it off with a whole bag of pistachios. I was obsessed with pistachios, although I guess you could technically say I was obsessed with everything. So we ended up having to separate and stay in different rooms—Hank slept on the couch for a lot of my pregnancy because otherwise he'd have been up all night snacking with me or, even worse, waking up at four A.M. to have some brownies. It was bad enough I was doing

that; I certainly didn't need him joining in. We were both ballooning and soon there'd be no room in bed for the both of us.

Once Hank moved to the couch, it got even worse because I had free rein. Hank would sleep, and now I could chomp and chew all night without worrying about waking him. Plus I was up all night peeing and eating; it was a nightmare.

I didn't want Hank to be on my pregnancy eating plan, especially since he (like me) makes a living out of being in shape. So eventually he got back on track, but I was still pigging out.

This went on for months, and I knew it was wrong but I was craving this stuff so bad there wasn't much I could do to stop it. Having cravings during pregnancy is like a domino effect: The second you have a brownie, your body craves more and more. Until I gave birth and got that baby out of me, I was going to eat for two as long as I could. So the night before I went to the hospital to get induced, we ordered my last meal. We called it "the Last Supper," and I chose McDonald's. A McFlurry, fries, burgers, chicken McNuggets—we ordered it all. This was the last fattening meal I was going to eat because you can't eat once you get to the hospital and I promised myself that after giving birth I'd get healthy again. I'm not a fast food person because I know how bad it is for you, but I thought, "If this is the last unhealthy meal I have, I'm going out with a bang." And I did.

Speaking of going out with a bang, I convinced Hank to have a quickie with me before we left for the hospital. I said, "This is the last good sex we are going to have for a couple of months." We went in the bedroom closet, because our family and friends and camera crews were all in the house waiting to document my going to the hospital—so we had to be careful and quiet. While we were in the closet, Hank was nervous and kept repeating, "We gotta get you there!" It was snowing outside, and he kept saying, "We

have to go now. You're scheduled to be induced in ten minutes!" I looked at him and said, "You can get the job done in three minutes. I just want to have a good three minutes of sex before they tear my vajayjay up forever!" (My C-section wasn't planned, Hank Jr.'s head couldn't fit through.)

Hank's an overachiever and we did it for a good five minutes, surrounded by dresses, shirts, jackets, and dry cleaning. It was the best five minutes ever! I had always heard that after you give birth sex doesn't feel good for a long time, so I wanted to enjoy myself one last time. And anyway, it's good to have sex when you're pregnant—it's inducing! My last night of pregnancy was filled with fast food and fast sex.

10

THE BIRDS AND THE BEES

*W*ell, by now you've realized that I am not perfect and Hank isn't either. But we do have amazing communication skills—especially when it comes to our sex life. We treat every day like we are still dating. Not becoming too comfortable in our relationship is the key. When people get comfortable they get bored and lazy. We don't want to be one of those couples that fall into the mundane scheduling habit of "Here, lay down and get on your back and let's do it real quick." Hank and I have never been that couple and we do everything we can to make sure we don't become that. That's selfish. Hank and I need each other and we need sex from each other, so we work hard at it. If I forget that, I'm a lazy bum. The last thing I want to be as a wife is a lazy bum in bed. I know life is crazier than ever for most couples nowadays, but I can't stress enough the importance of good sex in a marriage.

Before pregnancy Hank and I were like bunnies, having sex at least five days a week. Even though we were busy with football, filming the show, and appearances, we always had time for sex. We were young and in love. Guess what? Even though we're married with a baby, we're *still* young and in love and we love having sex. But we've hit bumps in the road along the way.

Now Hank and I don't have sex every day anymore. I'm tired

and too busy. But that doesn't mean I don't think about it all the time. Frankly, if you aren't attracted to your partner and you don't want to jump his bones every second you get, then maybe you are missing something in your relationship. I come home after a long day and instead of thinking, "The last thing I want to do right now is have sex," I actually think the opposite. The first thing I want to do when I come home is have sex. As I said, we don't always act upon it for a variety of reasons, but we sure do think about it.

During *Dancing with the Stars* I had a practice session every single day that took about five hours in total. Wardrobe, hair and makeup, rehearsals, press, stretching, breaks, fueling up on carbs, and hydration—it's exhausting. Plus, we were moving into a house, choosing paint, decorating, dealing with paperwork—I was a mess. And I was also writing this book, shooting my show *Kendra*, making appearances, and traveling, all while being a full-time mom and wife, so I had a lot going on. You'd think the first thing I'd cut from my jam-packed schedule would be getting intimate with my husband, but it's actually a priority (and a stress reliever) that helps me handle all the other craziness that's going on.

All day long it's running around appeasing producers and show runners and media and networks and fans, and shopping for the family, and taking care of life. But sex—that's me time. It's not like something I have to do; it's something I want to do and it's a pleasure.

For a few months while we were finalizing the paperwork and getting the new house ready, we were living in a small apartment in Studio City, about a thousand square feet. It was a normal apartment in a normal apartment complex, meaning if we got too loud the neighbors would hear us. But it was a place we called home, along with my two dogs, Martini and Rascal, and Hank Jr.—who, technically a toddler now, was at that run-around-and-explore stage—and a variety of other people coming in and out of our home

at all hours of the day. So the idea of Hank and I getting busy with Barry White playing on the stereo and cinnamon-scented candles burning with rose petals gently sprinkled on the floor was the furthest thing from our reality. We had to find other ways to be intimate and keep that connection with each other.

Hank and I have a great sexual relationship and we talk about sex just like we talk about anything else you could communicate about. We don't shy away from it. When we get little ten-minute breaks during our busy schedules, we call and get each other all worked up. If I'm driving home from practice, I'll call him and tease him a little. I just plant the idea in his head with a little flirty comment. We don't have to do it every day, but we talk about it. Of course it's not all we talk about; we certainly discuss a million other things, like bills, Hank Jr., work, family, and life. But those quick phone calls and flirty messages help to keep the heat going, even if we have to wait three days before we get the chance to have sex.

So when I get home at nine P.M. after a full day and I come in the door dead exhausted, I take comfort in the idea that I am home with the man I love and I'm going to turn off the world outside, kiss my husband, and just say, "Let's do it." And is he going to turn that down? No. He's a man.

Even though it's sometimes quick and not completely spontaneous, we have great sex. In fact, while I was on *Dancing with the Stars*, the sex was better than ever. I'm flexible, I'm strong, I'm confident, and Hank is noticing it. All day long I was stretching, getting blood flowing, and working my body so it was just itching to have sex. I once Tweeted, "Sooo Louis [my *DWTS* partner], thanks for warming me up for my hubby tonight." I had spent three hours grinding on the dance floor with another man. All I wanted to do when I got home was have great sex with my husband, Hank. So I did.

You don't always have to be spontaneous—sometimes we are

just working toward having sex in forty-eight hours' time, not necessarily right now. When you are married to someone, you see that person more than anyone else. You're always there, always together, always in contact. But Hank and I never let that make our sex life mundane. We act as if we are still dating. And going out to dinner or spending time together isn't always a guarantee we're going to have sex! I'm not a "sure thing"! It has to feel right.

We still play it the same way as when we were dating. The rock on the finger and the piece of paper don't change who we are. Hank still holds the door for me, lets me order first, knows what wine I like, and is an all-out gentleman who makes me want him more than ever. You have to put in the effort. You can't let your looks get away from you and you can't let your manners get away from you. Hank works hard at being Hank, the man I met and first fell in love with. And that's hot as hell.

We had sex all throughout my pregnancy. We were not gentle at all. Sure, we were careful at first, because the first month is the most risky, but once we realized we couldn't hurt the baby (or poke it), we started to relax and get really wild. By the third month, around the time of our wedding, we were having a ton of sex. I loved feeling different, I loved the fullness in my body. It really made me feel like a woman, and Hank didn't mind the extra weight. It's almost like having sex with a completely different person when their body is so much bigger! As you know, we had sex in the back of a limo on the way to the hotel. I basically just threw my wedding dress over my head and we had sex. Something about being pregnant made me super horny. I wanted a lot of sex and Hank was happy to oblige. At the end of my pregnancy, it got more difficult because I was so heavy. It just became awkward and there's not much you can do except plain old stick it in.

But as any mom knows, in the months directly after the birth,

the sex situation can get a little tense. For us, it was a disaster, for me especially. After Hank Jr. was born, sex went out the window big-time. There were a variety of reasons, one of which was the C-section I had, so I was in pain. The last thing I wanted to do was physical activity, let alone have sex (not to mention the six-week "no sex" rule the doctors advised). But in addition to any physical pain, mentally I wasn't there either. I felt fat, I felt ugly, and now that I was a mom I thought I had to be very conservative.

I got a whole new wardrobe complete with turtlenecks and "mom jeans." I just assumed that a mom shouldn't be dressing sexy anymore. I thought I had to do away with my thongs and tight tops. Plus, regardless of what I assumed, I just wasn't feeling sexy anyway. Covering up seemed like a smart thing to do. I started wearing stuff that wasn't me, clothes that made me depressed. I didn't know it but dressing like someone else, thinking I had to act a different way, and looking in the mirror and not knowing who I was could be a really depressing thing. I was lost. I wasn't being myself, and our sex life suffered. I wore oversize outfits while purposely trying to hide my body. The amount of sex we were having went down to twice a month. I finally realized what was going on after my bout with postpartum depression and I changed and started to be me again. But it took forever.

I had given in to all of that labeling stuff, ideas about what I should be doing and what I shouldn't. Why was I going to be some-one I'm not? Having a baby doesn't mean I can't dress sexy or act a certain way. Our little boy is going to grow up and know me and who I am and what I do and what I've done and he's going to love me and I'm going to love him. Love is all that matters—not what you wear and how you wear it. I think a lot of us get caught up in too many other ideas of who we should be around our children. My mind was clouded.

After pregnancy I dealt with a lot of heavy emotional stuff. And one of the side effects of all that was that I lost my sex drive. I didn't know who I was. I felt self-conscious. And I had my C-section scar and I didn't want Hank or anyone to see. I'd turn the lights off because I had my stitches down there and it was just gross. I see it every single day, although now it's more of a reminder than a bother. It's so much a part of me now I don't even think of it as a scar, it's just there. But at first I hated it. It was a long red cut with black stitches and it was nasty. And it really hurt because any time I bent over or moved quickly, the stitches and the scar would stretch. Still to this day when I do an abs workout, I feel like I don't have feeling or tightness in my ab muscles anymore, and my scar still tingles. The C-section may have "healed" six weeks after birth, but any time I'm doing physical activity I'm reminded that the scar is still there.

Thankfully we got out of our slump, which came naturally as I began to work out more and, of course, when I finally got the weight off. We're now back to two to three times a week. Are you shocked to hear I have sex only a couple of times a week? That's the perfect amount for us.

I'm so open when it comes to talking about sex because it's natural. It's just like farting, we all do it. Anything that has to do with nature I don't hold back. We all have sex; why not talk about it and compare and ask questions? I'm also a huge believer in getting it on when you need to get it on.

I'm all about sex in a car and spontaneous places. I'm all about sex in public as long as you know that no one's watching, but if you feel like one eye is on you then I don't think it's okay. I wouldn't like it if people watched me like that. I'm not an exhibitionist, though some people get off on stuff like that.

The craziest place that Hank and I ever had sex was on a Jet Ski

in Cabo in the middle of the ocean. We kind of parted from our friends a little bit and I was in the front of the Jet Ski and he was in the back. I was driving and we just stood up and did it. There was something just so hot about us in our bathing suits, all wet, and it was sunny out and we were pressed up against each other and I just wanted Hank right then and there. No one was around, so why not? We were far out, so we knew no one was watching. It was great, because at the same time we were Jet Skiing we were having amazing sex. The bumps from the waves were just making it ten times better. The wind was flying through my hair, Hank was really getting into it, the sun was on me, and I was flying on the Jet Ski! When I hit the gas, the motor (Hank's and the Jet Ski's) really got going. Sun glistening, salt water splashing—I was in heaven! Public sex when no one is watching is awesome. You get such a rush because you know you are doing something against the rules and you need to hurry before you get caught. It's thrilling to know that you could get caught at any moment.

That said, sex in a bed is so damn boring. I try to avoid the bed as much as possible. Why limit yourself? The bed is the bed, it's where you sleep and read. Would you exercise in bed? No. So I try not to have sex there; it's just not an exciting place to be. If you have nowhere else then it's fine, but most people should be able to come up with other, more exciting places. A chair by the bed, a desk, up against the wall, anything other than the bed works. On the counter in the kitchen is a great place. I think anything in your house that you can sit on or stand against is fair game. You have to visualize yourself everywhere in your house and say, "Can I have sex there?" On the toilet, in the closet, on a table, in the shower, in the bath. Every place will be a new experience. There are so many different angles that you could be reaching depending on where you are sitting or how you are positioned, and it feels so

On the set of *DWTS*. Hmmm . . . wonder why I'm smiling?

much better. Deeper, longer, harder—you get so much more out of sex not being in bed. Think of it like a car; would you rather ride in a Ferrari or ride in an Oldsmobile? That's the difference. The bed is an Oldsmobile. Most people are missing out on the Ferrari! It's about the fun and the experience. You shouldn't be concentrating on just up and down, up and down, up and down. Sex is more than up and down. Basically, if you are in my house, there's a very

good chance that wherever you are sitting or standing, we've had sex there. Sorry! (Luckily I'm obsessed with cleaning and disinfecting, so don't worry.)

Hank and I had sex once in the trailer in the back of the studio lot during *Dancing with the Stars*. We weren't ashamed; we were horny! We were just like, "Why not have sex in our trailer right now? You only live once!" We hadn't spent a lot of time together and were crazy busy, but I was all worked up from grinding with Louis and Hank came by, so why not! It's fun, it's something to spice things up a little bit. Sex in the middle of the day at the workplace, it doesn't get much better than that! We were in my trailer and the door was shut, so no one was watching. How many people can say they had a little afternoon delight in a *Dancing with the Stars* trailer? I can! It's not our bed, it's not our home, it's not even a hotel—it's our trailer! Any time you can, you should take advantage of where you are. I'm not saying the whole world needs to start having sex in the Gap changing room or the Applebee's bathroom, but if you are feeling it and horny, take advantage of the time that you have and just go for it.

Of course I'm always aware of our surroundings. The trailers at *Dancing with the Stars* were connected to one another, so when we were doing it, I was looking around the trailer like, "OMG, everyone's probably feeling this movement right now." The whole damn thing was rocking—Hank's a big guy! Lucky for us, Hines Ward was in the trailer next to me, so while I was a little bit worried that someone would notice what we were up to, I'm sure that Hines would be the coolest about it. And I swear because it's so easy, some other people do it too, because as I've said *DWTS* is a really sexually driven show; there's no way I was the only one getting worked up that day. After all, you've got your own private trailer to go back to. When we were doing it, I stopped for a second and realized how

much the trailer was really moving. But once we got going there was no turning back! It was a brilliant performance; I'm sure the judges would have given us three 10s!

All right, so not everyone has their own private star trailer. But everyone has access to mirrors. If you want to spice up your sex life, a simple mirror will do it. It's fun to see you and your partner from a million different vantage points. I don't think it's necessary to go to the extreme with whips and chains, or crazy porn, or even strip clubs. You can spice your sex life up with each other; you don't need anyone else or any crazy tools in particular. Why watch someone else on TV or bring a stranger or strange object into your sex life? With a mirror, you can see all of your body and places you don't normally get to see—there's nothing hotter than watching yourself have sex. We women are used to not getting to see everything because of the "usual" sexual positions. And when you're proud of your body, that's when the sex is going to skyrocket. Regardless of your body shape, if you are confident and feel sexy, it's hot. Hank and I use mirrors all the time. I think any time we have a reflection it spices up our sex life times ten. You can never have enough mirrors.

I have friends who are so shy about sex, so I'm there for them; I'm like everyone's sex therapist. I try to encourage them to enjoy themselves and let loose, but they laugh about it all because they're shy. You can't be shy about sex. A body is a body. Sex is your number one natural opportunity to feel good, so take advantage. One of the few times that I wasn't having sex was when I felt depressed and fat and ugly. I realized I needed to get back to being aggressive. No matter who you are, be a woman, and go and get what you want!

Of course, I have a great partner to get creative with. And everything about Hank turns me on, but especially his back. I love Hank's back at nighttime and in the morning, because it's covered

during the day. So I'm the only one who gets to see it. He's got this big sexy tattoo on it. For me his tattoo represents the full dynamic of who Hank really is. On the one hand he's a really polite guy, a gentleman. But when he takes off his shirt it's like he is this total badass. His back is muscular, with this big tattoo with the Roman numeral III for Hank the third (baby Hank is Hank the fourth). He is such a good man; he respects everyone, he opens doors for people, he brings me roses, he takes care of the baby. But ohhhh, that tattoo. And it's only me who gets to see his back with the tattoo on it. That tattoo represents the bad boy in him, and that's what turns me on the most. When we are having sex it's like I feel safe knowing it's with Hank, this man I love and trust, and yet it's totally hot because of his bad boy side. In general I'm not a huge fan of tattoos—too many sort of signals sex sex sex and it can just be too much. I don't have any tattoos and I don't love them on women, but on men it says self-confidence, it says they're good in bed or they want to be good in bed, and I like that. I read "sex" when I see a guy with a tattoo.

Louis, my dance partner, understands sex and, being a dancer, I would think he has sex on his brain all the time. And as a dancer, he really understands a woman's body. He is always talking about the inside of a woman's thigh. He knows all of the sexy turn-on spots. If you watch *Dancing with the Stars*, it's a very sexy show and a lot of the dancing is designed to be sexual. Louis is always talking about posture and standing up straight and having confidence. He says that when a woman is pigeon-toed, you don't get to see the inside of her thigh, so it's kind of a turnoff and she doesn't give off any vibes of sex. But when her leg is slightly out—not too much, but when your inner thigh is showing just slightly—a man will read "sex" all over that. Because he's seeing the inside of her thigh, an area he's not used to normally getting a peek at, a guy will be instantly

turned on. I thought I knew so much about sex, but I didn't really know anything. After talking to someone like Louis who understands seduction and chemistry, I'm taking what I learn from dance and bringing it home, and it's made my sex life even better. I feel so much more confident and better in bed now. I thought I was good before, but now I'm a champ!

One thing I've always known with regard to sex is what my man wants. There's nothing sexier than confidence and knowing exactly what your partner wants. Hank loves it when I wear little booty exercise shorts. Of course, he doesn't mind seeing me in lingerie, but he prefers when I'm being myself. Even in bed he loves me wearing a sports bra with little booty shorts on and my socks pulled up high. That's his fantasy, so I give it to him. When Hank first met me I was the "sporty" one of all of Hef's girls. And to this day he still loves that look on me. So when I want to give him what he wants, I wear a sports bra! It's very easy to fall into the habit of just getting naked for sex. But I like to I mix it up and throw on the fantasy costume that gets Hank all worked up. It's better than asking for it.

You probably think Hank and I are pretty kinky, but other than sometimes having sex in places other than our home and adding in the occasional mirror and outfit, we're pretty much just like any other couple. There's a certain freedom in being in a loving, committed marriage. We love having sex, and while we are willing to try a lot of different things, we do have our limits. One thing we don't do is videotape our sex . . . yet. But we will. I'm not going to stop doing that because some asshole a few years back taped me and then sold the tape to the world once I became famous. The sex tape represented a really tough time in my life, but it didn't finish me. That motherfucker was probably thinking, "I ruined her life," and felt powerful for a minute. But I'm not allowing that to ruin my life or my relationship. Right after the sex tape came out, my first

reaction was to act and look more conservative as a way to offset it or show I was different now. I thought I'd have to be a prude, but life goes on. You cannot stop your life because someone is trying to sabotage your success.

I'm not going to allow some asshole to ruin my sex life with my husband. If I want to press "record," I'm going to press "record." Hank and I talk about that all the time actually. Of course, we haven't done that yet because it was traumatizing, but when we are ready, we'll do it. I think we have to be in our own element and we never did it before because we were in an apartment or a hotel or traveling and it wasn't creatively anything to showcase, so it would be such a waste of time. But now that we're in our house, we have big plans: We're going to get a tripod, maybe some lights, and really do it up! Maybe I'll make my own private little studio; I'm not ashamed anymore. I will make another sex tape. But this time, only my husband and I will see it.

That guy who released the sex tape tried to make me feel guilty. But why should I feel guilty about having sex? Sex is a great thing; I love sex and we are made to have sex. Some people love to shop, some people love to eat, I love to have sex. Sex is a way to feel alive, and when you have it, you know you are living and you are feeling good. Think about the first moments after sex with someone you love—doesn't it feel great? I like having that feeling. Materialistic stuff makes you feel good when you put it on and you look good, but you need to also find something that makes you physically feel good, something that will make you feel good on the inside, and what feels good on the inside will show on the outside.

11

MARRIAGE IS MY DAY JOB

Marriage is all about give and take. Hank and I are a team, and one person needs to step up when one of us is down. Such was the case for baby Hank's first birthday party. It was a true test of our marriage and parenting skills. We were in Minnesota at the time, but I had to go back to L.A. for business a few days before, so I left the actual planning in Hank's hands. I'd be back just in time for the party.

Hank did a great job. He booked a private party room at the Mall of America, ordered a special cake, and put together all of these Dora the Explorer and Diego decorations. He went all out. But, of course, the day of the birthday we looked out the window and it's another big blizzard, like one of the biggest they'd seen in decades. The snow was coming down hard and the roads were completely covered. Hank had put his heart and soul into planning this party and said, "Let's go! Let's do this!" I had different thoughts in my head, but I knew how hard Hank had worked on the party, so I went along for the ride. It wasn't my place to throw in the towel just yet. I was being a good wife, even if as a mom I wanted to call it a day.

My mom was there, as were my brother and Hank's parents and brother. We were all ready to celebrate baby Hank's first birthday. We all left our apartment at the same time, piled in our car, and

drove off. That's when I said to Hank, "We can't see as far as we can piss!" I kept saying that and the whole family was cracking up. But Hank was really mad; it was a very touchy situation, because deep down he knew the odds weren't good we were going to actually get to the party. Everywhere we looked, cars were stuck in ditches or turning around and heading home. I knew in my heart we should have stayed home. It was risky and super dangerous, but Hank was so passionate about getting there. He kept saying, "We gotta try!" Hank's pride was taking over, and I knew I couldn't say anything else negative. But after ten minutes in the car I felt a skid. I opened my mouth and said, "Nope." We slid again and I opened up my mouth and said, "Babe, let's not go. This isn't right." Then what I thought would happen happened. Hank yelled out, "No! We are going." But I said no again. It was an argument, and I needed to let him see that harming us and getting us stuck in a ditch would be much worse than a canceled birthday party. I insisted we needed to turn around. I wasn't being a girl who was scared, I was being a parent. I begged him and said, "Please don't let your pride take over. Your pride will get us killed. Think about the consequences. We could get stuck in a ditch and end up being stuck in this car for hours." So Hank was really sad, and I swear I saw a little tear drop down his face, but he finally turned around.

We ended up in the little vacant party room in our apartment complex. It was kind of sad: just one single window, a pool table, and a fireplace that we lit. We put presents all around and tried to create a birthday party atmosphere for the baby. It was kind of quiet for a birthday party, but our family was all together and that's what mattered most.

Hank felt like a failure because I had been trapped inside all winter and had no real home to live in, and all I had done for the last year was travel from city to city. He wanted to throw a good

first birthday for Hank Jr. as a way to make it all up to me. He was devastated, and even though I was depressed and struggling, I had to brush my issues aside and take care of him and his emotional needs and talk to him about it all. I wanted him to know that in my heart I knew what an amazing job he had done. That was my job as a wife and a mom. Hank had done good. So my brother and Hank's brother ran out to the grocery store to get a birthday cake (in this weather it took them almost two hours to drive there), and we took pictures and smashed Hank Jr.'s hands in icing. We made it work.

A week went by and the Mall of America told us they'd hold the room for us and the decorations and let us celebrate when the

Hank Jr.'s first birthday party—a week late, but still just as fabulous as Hank had planned.

weather cleared up. So we gathered Hank's teammates and their kids and we celebrated for real, a week later. Hank Jr. (and daddy Hank) got their big birthday celebration after all.

But even when things are going good, there are feelings and emotions that you've been bottling up that tend to rise to a boiling point, and if you aren't careful in a relationship, they can blow up right in your face. Sometimes you can get too comfortable in your marriage and you don't pay attention to what your partner is feeling or saying. While I know we all have the best intentions (like during baby Hank's first birthday), I know there have been times certainly where Hank was clueless about what I was feeling.

That's why we try to sit down and talk as much as we can. On date nights we remind each other how much we are in love. During phone calls we flirt. When we are away we Skype. We don't ever take our relationship for granted. But I'm the first to admit, it's not always gumdrops and cotton candy.

As long as I've known Hank, we've gotten in only two bad fights in our entire relationship. The first was our brutal argument after I had my meltdown in Minnesota. That ended with Hank passing out unconscious on the floor. But we never got physical with each other. We know how to debate and argue, but we rarely fight anymore because we have learned our lesson. One nasty fight in a relationship might happen. But you should learn from it. Having it happen twice is unacceptable. If you had walked in immediately after that verbal sparring in Minnesota, you would have thought I had knocked out my husband. I hadn't, of course. But during our second bad fight, the shit really hit the fan and I did knock him out.

We were in New Mexico for our annual charity event for the Oasis Children's Advocacy Center in Albuquerque, New Mexico (Hank's home state), in 2010. We help raise money to benefit abused children with a golf tournament called the Tee'd Off About Child

Abuse Golf Scramble. Hank and I raised a lot of money during the event, so we ended up celebrating with friends and family and both got very drunk pounding shots of tequila at the hotel bar. That was right around the time when the sex tape came out, so I was very self-conscious and my world had been turned upside down; just another dramatic day in the life of Kendra Wilkinson. I assumed that if an ex-boyfriend was out there hawking a sex tape from stuff he had filmed us doing several years back, then I guess the whole world was out to get me. I was feeling down because I felt like I had been publicly humiliated. Well, not even "felt." I *had* been publicly humiliated.

So Hank and I were both belligerently drunk. We don't drink all the time, but we both have wild sides and when we do drink it can get a little crazy. Plus Hank is an athlete, so guys are always buying him drinks and shots and he thinks because he's six foot four he can just guzzle and guzzle. He can't. We split up at the bar; he was hanging out with his boys while I was hanging out with my friends. I looked over at the bar and there were two girls who looked very suspicious hanging around where Hank was. I went up to him and said, "Hey, watch out, these girls look really suspicious." He took it the wrong way. He was like, "You're just jealous. Why would you think I would do that to you?" I was like, "No, Hank, I'm not saying you're cheating on me, but there are writers and journalists here, so just be careful. You know there's a lot of heat on us right now."

The last few months had been horrible for us: Magazines were saying we were splitting up, blogs were revealing the sex tape, and reporters were following us everywhere. Literally I would buy a soda at a store and a few days later I'd read about the conversation I had with the store clerk in one of the tabloids. Hank and I had flown separately to our charity event because of our schedules, and

one of the magazines actually bought the plane seat next to Hank for the flight down. A reporter sat right there next to him trying to get a big interview about the sex tape, me, and our relationship. Hank spent two hours next to this girl and had to repeatedly say, "No comment." So yeah, I was a little paranoid. If a reporter is going to chase us onto a plane, why wouldn't they try to get Hank while he's drunk in a bar?

Hank was pretty drunk and wasn't listening to what I was saying. He still kept saying things like, "You think I would do something like that to you?" Ultimately, he wouldn't stop drinking or leave the bar area, and the girls were still near him, watching him. I got so frustrated that he wasn't listening, and I went up to our hotel room. He quickly followed me and we started arguing and screaming at each other. We weren't even making sense, just fighting and lobbing insults back and forth for the sake of fighting, so I told him to leave. I was done with the fight and over being drunk. He went back to the bar to drink some more with his friends, and I tried to calm down and stayed in the room.

But then I looked at my phone a little bit later and there was a text message that read: "Come by. I would love to see you right now."

I flipped out. I had just gotten done fighting with him, so who the hell was he texting that to? He had said he wasn't paying attention to the girls in the bar, but This was one of those moments where I saw my life flashing in front of my eyes. I had put all of my eggs into this basket—Hank's basket—trust, family, money, love, my whole life built here with Hank Baskett, and he's downstairs sending "sext" messages to other girls? I had the heart-stopping, gut-wrenching feeling that he was cheating on me.

I knew I needed to find out the truth immediately, so I called him and screamed, "How dare you? You cheated on me!"

It was a messy fight. He came storming back to the room, trying

to show me he wasn't cheating. "I'm not cheating on you, what are you talking about?" I said, "You just sent a text to me that read you 'would love to see' me. That wasn't for me! Who are you talking to? You just saw me so you certainly weren't talking to me! And those certainly aren't the type of messages you send to your wife. You were sexting! Who were you sexting? One of the girls from the bar?" Hank truly had nothing to hide, but when you're drunk you tend to get a little bit loopy. He was like, "Here, look through my phone." He said, "I don't know what you're talking about." I looked through his phone and I looked through his text messages and didn't see anything, so I just assumed he had erased the message. Of course, I was checking his text messages, too drunk to realize he had actually sent me a BlackBerry message.

I forgot to check his BBM. I just assumed he was lying to me anyway, so I smashed his phone and my phone together repeatedly, trying to break them. He just kept repeating, "Look at my BBM!" But it was too late; I was full of rage (and alcohol) and unfortunately, I just swung at him, not really trying to hit him but just for the action of swinging, and—oops—I clocked him bad. He had gotten too close to me and my fist went straight into his head. Crunch. He looked like he was going to cry, not because of the pain (though it was a pretty rough hit), but because I had actually hit him.

You can't really imagine what the situation is like until you've been in it, but a husband and a wife hitting each other, that's a betrayal. Couples fight, and while celebrities make it seem like everyone's happy and there's a ton of money and no one's ever stressed, that couldn't be further from the truth. But what happened with us, it should never have come to that.

Hank was devastated not only that I hit him but that I had accused him of cheating. The hit really sobered us up and brought us to a calmer, more repenting level. Nursing his eye, Hank calmed

me down enough to show me that he had accidentally copied and pasted a message to a friend on his BBM. He proved me wrong on a very broken and now cracked phone. It was a very accidental fight and he was able to prove his innocence to me. He was like, "How could you punch me?" He was so upset and showed me the message over and over again that he had sent a while ago to his guy friend in New Mexico and accidentally copied and pasted to me. Then he took me downstairs to the bar, where the friend he texted was waiting.

Ooops.

Morning came and I was still angry. I don't know why but I was angry at the both of us, mostly at him for getting so drunk and just not explaining himself to me right from the beginning. I said, "Why didn't you just show me the damn message?" I didn't know what I had done and he didn't know what he had done. It was like, "How do we apologize for something like this?" He had an imprint of my wedding ring right under his eye, but mentally he was hurt even more. Hank rarely holds a grudge, especially against me of all people. He wasn't mad at me, but he was upset it got to that point. He just looked at me and said, "Kendra, you had a nice shot. You should be a boxer." We started laughing about me punching him. We were so drunk we didn't even know what happened. Till this day we still make it the biggest joke. Accidents happen; I was trying to push him, but I did it a little too much.

Just because you are married doesn't mean you are immune to feelings of embarrassment with your partner. We felt awkward for a few days, but from that day on we said we'd never go that far with drinking ever again. That morning we had a three-hour talk on life. We said, "We have a son now, so we will never do this again. This will never happen again." It never did happen again and it never will happen again. So we created a drinking limit; only one

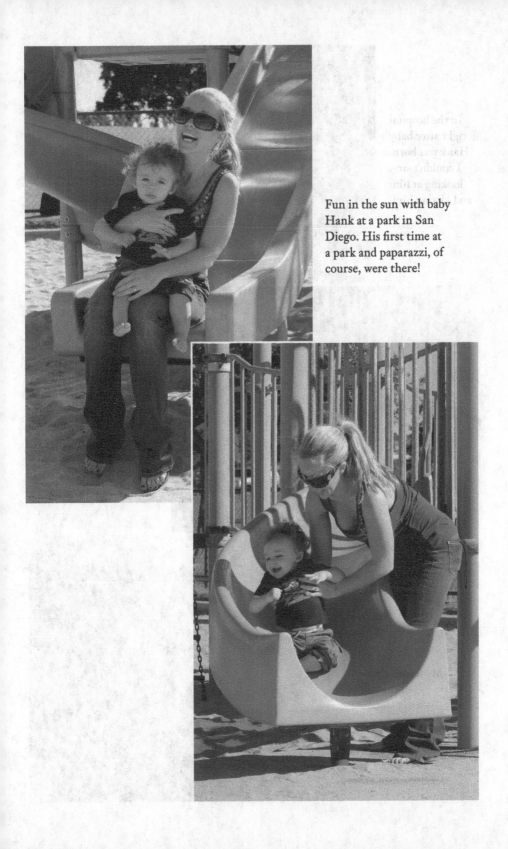

Fun in the sun with baby Hank at a park in San Diego. His first time at a park and paparazzi, of course, were there!

In the hospital
right after baby
Hank was born.
I couldn't stop
looking at him
and kissing him.

When he was small
enough, we would bathe
him in the kitchen sink
at our Tarzana house.
It beats bending over a
bathtub and breaking
your back!

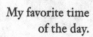

My favorite time
of the day.

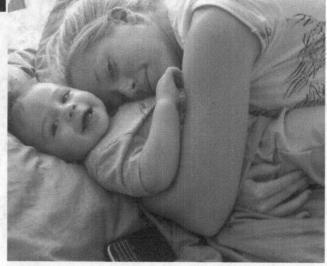

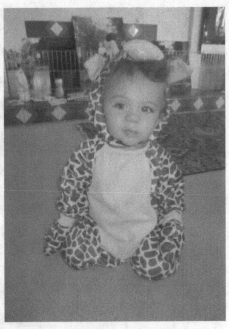

Hank about to head to Miami for the
Super Bowl (we'd follow a week later).

Little Hank dressed up as a giraffe
for his first Halloween.

Christmastime in Minneapolis, Minnesota.

Workout sneaks come
in all sizes!

The family at
sunset in Malibu.

In front of the
Playboy Mansion.
I owe a lot of
my success and
happiness to the
opportunities that
Hef gave me.

One of our regular date nights.
Isn't he handsome?

A well-deserved cocktail!

With one of my best friends,
Brittany Binger.

Out for a girls' night at a club
in Atlantic City! You can
see I wasn't in the mood to get
dressed up.

Celebrating a huge moment in my career at a signing for Ab Cuts. I became the product's spokesperson after the supplement helped me lose those last few pounds.

It's all about multitasking.

Behind the scenes at *People* magazine's 50 Most Beautiful People photo shoot. What an honor!

Me and Mom Mom.

Backstage at *Dancing with the Stars* with my brother, Colin; my mom; and Mom Mom.

This was one of the highlights of my crazy experience on *Dancing with the Stars*! I really shook up the performances that night. (*Adam Taylor/American Broadcasting Companies, Inc.*)

Our new house in Calabasas, California!

Little Hank and me at a post-baby bikini photo shoot.

of us can get drunk if we're together, not both of us. That's our rule that we set from that day. It's kind of like a four-to-one rule. If I have four drinks, he can have only one. If he has four, I can have only one. We will never get to that level again ever. Thank God the baby wasn't around and we were just with each other. That was a great thing we got through, and while it's not something to brag about, it happened and I think we are better off because of it. It was bad and we're ashamed of it, but we know how to laugh about it. Nobody else knew about this and Hank had to wear sunglasses for a couple of days to hide his shiner. We kept it between us until now.

Sorry, Hank, secret's out now.

But that's the beauty of a healthy marriage—you rebuild and move on, stronger and closer because of it. We learned a good lesson that night, and we haven't made the same mistake again. That night also reminded me about trust, and how I do trust Hank entirely. He has always been there for me when I needed him, during tough emotional patches in my life and, of course, during the day-to-day moments. And I've got to be there for him. After all, I'm a football wife too and I need to help my man do his best on the field, as well as off.

Hank and his teammates always stay at a hotel the night before a football game so they can be fully focused and not distracted. It's very common for NFL players, though it surprised me when we first met. He'll have a ten P.M. curfew and need to be in his room at nine P.M. Sometimes he will pick us up before the game and we'll drive to the stadium as a family, but really I'll let him do his thing. He loves his game-day music; it's usually old-school West Coast hip-hop and it gets him and his energy levels pumped up. Game day is his life.

Football season is hard on our family. Including game days and practices, Hank's pretty much busy six days a week and is at practices and team meetings from seven A.M. to six P.M. He's working hard

mentally and physically—lifting weights, running sprints, practicing drills, and going over plays—all week long, so he's exhausted when he gets home. It's my time to take care of the family, just like he does when it's his off-season.

On game day, I usually end up sitting with friends and family at the stadium, but also with a lot of the wives of Hank's teammates. If I'm in town, I'm at the game. I'm so connected to sports I feel like I'm going out there playing myself when it's a game day. And I'm not a typical wife out there saying, "Go Hank!" I take it further. I'll say things all day like, "Hank, you better get mad, think of stuff that pisses you off and rip their heads off." I can't help but want to win too!

Some game days aren't as fun as others though. Like my life, Hank's career is full of ups and downs. I know how much heart Hank puts into the game; he works harder and more than anyone. He gives it his all and practices his butt off, but if he goes out there and drops a pass during a game (it happens), I worry. You don't get a lot of chances in football, and you don't want to screw it up. So if he messes up I get so pissed and he knows it. I'm not pissed at him because he failed to catch the pass, I'm pissed in general because I know what he can do when he's on. But if he drops a pass or makes a mistake, I get sick to my stomach. He stays a little more upbeat after an error, saying he will do better next time. But I get frustrated because there may not always be a next time! Drop too many passes or get too old, and that's it for your career in the NFL. He doesn't get mad; he's so calm and positive about everything. But I feel eyes on me when he drops a ball and, I have to admit, I get mad. All that goes through his head (other than the coaches and the score) when he makes an on-field mistake is, "Aww man, Kendra is going to be pissed at me." It's embarrassing, and as much as I'm there for him and want to be supportive, if he drops it I'm like, "Okay, that's it,

we're done with football. We have to find another job." I'm his wife and I love him, but I'm not going to sit here and say, "Go get them next time." I'm realistic and I know how the sport works. This is his time. I know he can do it now.

Marriage is my nine-to-five. But I also work weekends and nights, because a marriage is a 24/7, 365-days-a-year job and I'm committed to it. It's for eternity, till death do us part. My show might get canceled, Hank may get cut from another team, or our house could get repossessed, but in the end we have each other. Hank is the one person who's not with me because of business or for a cut of the action. We've practically been homeless together, we've certainly been at war with each other, but we've never questioned our love. And we work really hard at our marriage. Our fights only strengthen us and prove our commitment. Part of me smiles at the fact that I got so worked up over Hank supposedly "sexting" another girl. He forgave me, but in the back of his mind after seeing that showdown, I'll bet he'll think twice about ever actually doing it!

12

MAMA'S BIG NIGHT OUT

My life isn't always about diapers, eight ounces of formula, and making veggie dinners for the family. Sometimes I do get to go out and let loose. I don't love to do it too much—as you know I'd rather go out on a quiet date with my husband—but there are a lot of fun opportunities that come up and I'd be crazy to turn them down.

I make a living out of being me, so I can't ever be lazy about it. Going out, being in public, and showing off a little is all part of being Kendra. But even a homebody like me who spends half the day in sweats likes to get dolled up every now and then, and it doesn't happen in one quick wardrobe change. It's a process that starts days before the event ever actually officially begins.

About two days before a big event—let's say something like the ESPY Awards, which is the sporting world's biggest night—I start preparing mentally and physically. It's a big process. I have a stylist named Lindsay Albanese come over and help me get prepped. She knows my body and what I want. She knows that less is more on me when it comes to the dress, accessories, hair, makeup, shoes. I like it simple. I just want her to bring over something simple so we can look good and get it over with. I'm not a diva; I don't call in dresses and looks from the world's top designers, not that they sit around

trying to send them to me anyway. If it looks hot on the hanger, I'll give it a try. Now that I have my body back I can wear anything I want. My body is in different shape from the way it was before pregnancy. It's in the best shape it's ever been.

Before pregnancy, even though I was skinny, most regular clothes didn't fit me. If I liked something I'd be like, "OMG, I love it," but then it wouldn't fit because I would be too curveless and couldn't properly fill it out. I had a strange body—big boobs but

Racks of clothes, my stylist, and toys—all in my home office. My life in a nutshell!

Shoes, clothes, jewelry . . . When will I wake up from this dream?

then stick-thin legs and arms. A lot of things just didn't hang well on me. But after pregnancy and now that I've gotten back in shape, I have more curves in the right places and everything looks good on me. When you've got a skinny body it's a lot of work, a lot of hemming and things like that, to get it to fit in all the right places. But right now I'm exactly where I want to be, and it feels good.

So Lindsay wheels her portable rack with fifty different dresses over to our place and then it's up to me to go through them. I can usually pick out my top ten just by eyeing them all. Then I try all ten of those on and put a pair of nude heels on with them; I always have to wear nude heels when I try something on because they pretty much go with everything. After that we take pictures of our top choices and send them to my management team so they can okay the dress for professional reasons, so everyone is on the same page. It keeps things more organized in our lives and career; they know what dress I'm wearing in case magazines like *Life & Style Weekly* want to know who I'm wearing. Usually we'll get down to one or two dresses that work best, and then I have to have like five okays from my people before I myself say okay to it. If it's really hot I won't wait for anyone else's opinion, I'll be like, "Fuck everyone, I'm wearing this." Then it's the same thing with the second dress. I usually try on about ten dresses before I pick one. I try them on, then narrow it down to my favorites. Then we go off votes in the room: Hank, baby Hank, my stylist Lindsay, Eddie, and whoever else.

The only one who I never disagree with is baby Hank. There was a black sparkly dress that I wore for the announcement of *Dancing with the Stars*, and baby Hank had chosen that dress. That was the first dress I tried on and I walked out and I was like, "Okay, how do I look?" and baby Hank fell over and smiled up at me. So I knew that was the dress. His eyes told me that was the dress, so we chose that one.

Hank Jr. loved this dress, which I wore to the cast reveal of *Dancing with the Stars*.
I think he just liked the sparkles.

A dress fitting is usually two to three nights before the big event. That's when I also start my crash diet. If I want to eat bad or snack heavily, it will be two days before the event, because the night before the event I really lay off the carbs and the salt. It's kind of like fasting. I'll eat protein and veggies, but bread and salt bloat

me and make me look bigger in pictures (every celebrity knows this trick). I can drop a couple of pounds in forty-eight hours by doing that. And also the spray tan is essential. I don't do it two or three days before, I do that the day before. That way it's fresh and has that glow to it. And because my hair is such a nightmare, I have to plan my schedule around my hair. I'll try to not wash my hair all week and then hopefully get to do it the night before. If I shower the day before, then my hairstylist Jules comes and she'll brush it out and make it look really clean. I don't have the time to wash my hair so many times during the week. It's way too thick to be messed around like that. Then my hair is fresh and clean for the day of, so when they come back it's easily manageable. Brian Bond is my makeup artist and he and Jules do me at the same time. Listen, when you are watching the Oscars and Ryan Seacrest asks an A-list celebrity how long it took her to get ready or choose the dress, and she responds with, "Oh, I don't know. I really didn't have time this year. I just tried on the first thing I saw, showered, and hopped in the limo," I am the first to scream *bullshit*. It takes a lot to prepare for an entrance in front of the entire celebrity world. And I'm sure my little five-hour routine is on the low end of the spectrum.

Getting my hair and makeup done is a long process; we try to start about three hours before I need to be ready. Sometimes I have only like five minutes to actually slip the dress on and get out the door because hair and makeup take so long. Getting dressed isn't even a part of "getting ready" for me. It takes no time to get dressed, so the majority of the time is spent on hair, makeup, tan, and lotion. I have to make sure my skin looks smooth and nice. Lubing up and keeping the skin smooth is a really important part of the process. If you are wearing a dress, sometimes the *only* part of you that's show-ing is some arm, some ankle, and a little cleavage. So they better all be lubed up and glowing!

It takes a lot of time and effort to get celebrity-ready.

I've walked out the door pretty much naked while putting my dress on and *bam*—I'm ready! I'll just be running out the door with fresh, wet moisturizer on as I'm slipping the dress over my head and running to my car. Usually baby Hank is crawling or running after me with some kind of greasy food or cheesy snack in his hand, and I'm always worried he's going to leave two toddler handprints on my dress. And, of course, when I'm getting ready, there are burning-hot curling irons on too, so I'm usually freaking out that he's going to hurt himself. I'm always watching

him, making sure he's not getting into trouble or about to burn himself, but he always wants to do my hair too, so Jules hands him a brush so he can help. It's so fun!

Then Hank and I will run out to the car (usually fifteen or twenty minutes behind schedule) and we are off.

During a big event I don't carry much of anything. Hank is my guy and he knows there are three things I don't go to an event without: a tampon, my lip gloss, and my ID. Those are the three things I need. Nothing else matters, everything else only gets in the way. Hank holds my essentials so I never have to bring a bag. If you are being spontaneous and going to some after-party or dinner, you don't want to have to worry about a big purse you need to lug around or check with the coat valet. And if you have to leave anything in the car, you don't want to worry about the driver stealing your stuff. So less is more.

The last thing I do before running out the door is check for underwear lines. I shine different lights on my dress to see if it's see-through: a halogen, a desk lamp, in front of the bathroom mirror . . . even if it looks good in a certain light I don't trust it. I have to have different lights to make sure it works under red-carpet lighting. With a lot of red-carpet lighting your dress will be see-through. I make sure to check that. I'm very aware of it so I sometimes wear nipple covers. There was one dress I wore while I was pregnant where that happened. We went to the *Friday the 13th* premiere and I was pregnant and I wasn't trying to be sexy. I wanted to wear a normal dress and walk the red carpet. Of course, I go to walk the red carpet and it was completely see-through. It wasn't a sexy dress, it was like a casual T-shirt dress, but it was so see-through. My publicist shouted to me on the red carpet, "You have to hug Hank the whole time because we can't have any of these pictures out." It didn't look see-through when I tried it on!

It's annoying keeping track of events and things outside of my home life because I'm not one to keep a calendar very well. I do it all in my head. Sometimes I know that an event will take place a month earlier but usually I just get a message from someone on my team about a week or two before saying, "Next week you have a premiere." It's really rare if someone tells me about something two months in advance. Unless you are up for an award or something, which, being a reality star, really doesn't happen all too often. Everything else is about two or three weeks in advance. Things change so fast from day to day in Hollywood that you don't know what you can RSVP to, what you "should" go to, what you "have" to go to. You don't plan a month in advance. Most of the time I plan a week in advance and Eddie and my publicist, Kira Costello, are usually the people who call me and tell me that things are happening. Eddie arranges the stylist and hair and makeup. My job is just to show up.

I do all this stuff just for fun. It's not really a big deal for me. I go out there and try to take good pictures and then go home. I'm not into the extreme of getting ready for an event. You'll never find me getting a colonic or an enema to prepare for an event. I'd rather be constipated, bloated, or two pounds overweight than go to extremes.

The most extreme I ever got is piercing my own ears. My ears close up all the time because I never wear earrings, proof that I just don't like jewelry. The last time I wore earrings was my wedding day. I actually pierced my own ears because I had borrowed hundreds of thousands of dollars' worth of jewelry and figured if ever there was a time to wear earrings it was then. So I took the earrings themselves and just started piercing through my ears. I hadn't worn earrings in a couple of years so I was forcing them through, blood and all. There I was sitting in my wedding dress just minutes before

the wedding. It took about five minutes to break through the ear all the way. Pain aside, I was mostly worried about getting blood on the dress, so we kept putting napkins all around me. It was a last-minute decision to wear the earrings; I wasn't planning on it because that's just not my style. If I'm not into getting all done up for my wedding day, you can see that stressing over this stuff during the rest of my life just isn't that important.

Of course going out "Hollywood style" for us doesn't always mean red carpets, Escalades, and a glam squad coming over to my house. We do double dates with other couples just like everyone else.

During *Dancing with the Stars* I became close with cohost Brooke Burke. She's a mama just like me, and she and her husband, David Charvet, are nice, normal, regular people who just like to go out and have fun. They don't need wild parties every night. They just need good company (and wine, of course!). So we did a double date at the restaurant Ago and had a lot of fun. Whenever we run into a married couple who are down-to-earth, people who aren't so con- servative and have kids, we like to go on dates with them. These are people who we can relate to. We can't relate to Hollywood couples who show off their giant mansions and private jets and always have ten bodyguards with them.

Most of the cast of *DWTS* was going out to the clubs after each show to party all night. I did it once because Kirstie Alley asked me to go with her. But usually that's not my style anymore. I don't like to be clubbing all night, especially when I have to wake up to a baby and go dancing all day. My after-work style is early dinner and occasionally a nice glass of wine. That's why I get along with Brooke so well; we both seem to be past the stage of our lives where clubbing is appealing. She's so cool, she actually took the time to get to know us. She didn't say, "Let's just go out to the club and get drunk." She said, "Let's get our husbands together and all go out."

So we met them and had a double date and had great talks about life and the future and kids. We rarely brought up our careers or Hollywood. You really appreciate nice couples like that who are secure in who they are. Brooke is someone I want to get to know better and tell all of my secrets to.

I really don't have a lot of people like that in my life, who I can open up to and share my secrets with. I just don't trust anybody because in Hollywood everyone has an agenda. That's why people like Eddie become so important to me. Eddie is with me every day and he hears me vent the most. If I'm frustrated with work, he's the one I vent to. Eddie and Hank, they are my go-to people for venting. As a celebrity, my trust level is the lowest it's ever been. I'm very guarded; that's why it's so refreshing to have people like Brooke Burke come into your life.

Yes, I've got my friends from home, like Brittany Byars and Savannah Stinson. We don't talk a lot because of the craziness that has become my life, but those are my real true friends. They knew me before I was ever famous. They know my intentions, they've seen my struggle, and they know I'm not a rich, glamorous girl. People like that I will keep in my life forever. They make me feel like that girl in high school I used to be, a normal girl.

And, of course, if you watch my show you know that in recent years Brittany Binger has become one of my best friends. We met at the mansion and we became best friends. She's the same person as me, but I'm more outgoing. She's from a small town in Ohio, and she's so beautiful. She keeps to herself. She can separate Hollywood and who you truly are. Brittany is so pretty you'd think she'd be Miss Hollywood, and she knows how to dress—she wears $15 tops and makes them look like a million dollars. She's one of the few people I trust in this town as a friend.

It's hard for me to open myself up to people, because I'm afraid

Hanging out with one of my best friends, Brittany Binger, at a Too $hort concert.

they are going to run and tell the tabloids. I wouldn't share my deepest darkest secrets with just anyone. So the people I can trust, I put on pedestals: Hank, Eddie, the two Brittanys, and Mykelle. Of course there are a few other people I'm close to but not comfortable enough to really confide my deepest darkest secrets to. Then there are shady people in my life who I have to have around for one reason or another but you will never catch me spilling anything to them.

My lack of trust for people doesn't mean I close myself off to new opportunities. When we lived in Tarzana, we met Mel B and Stefano Langone, who lived across the street from us. They came over and introduced themselves one day and we instantly became

friendly. The last time we went out they invited us over to their house, and we played games and downed some wine. They are our game buddies. We get drunk and play couples' games like Catchphrase—normal couples things! They are fun and young and we love being around people like that. We still want to have crazy sex, we want to talk about sex, and people like Mel B get it. She didn't even bat an eye when Hank drunkenly told her a story about how he accidentally stuck "it" in my butt once. We all cracked up! Everyone related, and it didn't feel like TMI at all!

WINE, OYSTERS, AND SEX
IN THE BACKSEAT

*H*ank and I rarely get a normal, non-Hollywood date night alone, but when we do we try to make it as romantic as possible. We have a special date spot where we can step away from the spotlight and just be ourselves. It's a little restaurant called Vibrato hidden in a small shopping area. They play jazz music, it's very dimly lit, there are candles everywhere, and it totally puts us in the mood! It's a place we go when we want to be adults. To us date night is very simple: Get ready, go out, go home. No drama.

If Hank's mom or dad is in town, they'll watch the baby, and if not we'll hire a babysitter. We have two babysitters that we use, and one of them is Victoria Fuller—she's a former Playboy Playmate from back in the eighties; baby Hank is going to love that when he gets older! If she's not available we call another babysitter named Chelsea, who actually works on my show. Regardless of who it is, we try to put Hank to sleep first so he doesn't really know we are gone.

We don't have a full-on nanny. We just have these babysitters, so there's no guarantee that our planned date night actually gets to happen. We have babysitters cancel on us just like the rest of the world. There are some times where Hank and I have a spontaneous thought that we'd like to go out and have some fun. But then

we call everybody and nobody will watch the baby. Sometimes we reach out to friends who don't have kids and have never taken care of a baby before, but we trust them. It's not rocket science. But I would never ever leave him alone with someone I didn't fully know or trust. I need to know them in and out.

I once called my friend Mykelle, who was six months pregnant at the time, because we thought it would be a good idea to give her some baby experience. Plus baby Hank knows her and would be comfortable with her. So she and her husband came over. They spent a good hour playing with the baby before they put him to bed. And when we came back from our date, we thanked them and let them go. We woke up in the morning and found that they had put the diaper on backward! Oops! Baby Hank had peed through his diaper. We couldn't help but laugh because it was funny that for once it was someone else's fault!

We love the getting-ready process because it's almost like foreplay. Shaving, showering, makeup, moisturizing, doing the hair, painting the eyes, choosing the outfit—and I always make sure Hank is stealing a look.

I love to put on something sexy and just be Kendra again, not a mom. What I wear on a date with Hank really matters. I want Hank to know that I really try for him. It's important for us, especially because when we're filming our show the wardrobe and makeup is handled for us, so on date nights we dress up for ourselves, by ourselves, without the cameras around.

It's very important, especially with our lives, that we make date night our own with a real date that we arrange and pay for. We would rather pay for our meal than have a restaurant pay for our food because that makes it an official date. We get invited to restaurants all the time, and they want to wine and dine us for free in exchange for a picture. You know what, everyone wants a free meal,

Hot mom and dad ready to hit the town. The verdict is still out on that hat . . .

but at the end of the day that's considered a job for us. That's not an official date. It's a complete mind-fuck in that way, because we can seriously go out, just the two of us, and have a few glasses of wine and forget about all the celebrity shit and the show and fame and the paparazzi. But then if we've accepted a free meal, the next thing you know there's a photographer waiting there to snap us.

I love the time that we spend getting ready. Hank and I usually peek at each other back and forth so each of us can see what the

other is wearing. And how many husbands actually flat-iron their wife's hair? Mine does. Hank knows how much time I'm putting in with my hair and actually comes in and helps me so it cuts the getting-ready time in half. I blow-dry it and he'll come in and I'll have two flat irons plugged in, and he'll do one half and I'll do the other. One night he even helped me put my eyelashes on. He's so good when it comes to things like that. He's willing to help me, especially since he knows I'm doing all this for him. He loves it, he appreciates it, so he comes and helps me. And I love him knowing that I'm putting on makeup for him—because if I hire someone to put my hair and makeup on or the show does it, it's not the same as me putting my hair and makeup on. When I do it myself, I'm putting in the effort to show him that I love him. I want to look good for him. I don't want to seem so lazy that I'm just going to hire some hair-and-makeup person. He actually stands in the doorway and watches me do it. He looks at me with those goo-goo eyes and says, "Babe, I love when you do your hair and makeup; that's my favorite look on you." Because he knows I'm doing it for him.

Hank is usually dressed first while I'm in a robe putting my hair and makeup on. He's an athlete with an amazing body and he takes really good care of himself, so he looks good in anything he wears. Most of the time I yell at him and I say, "Babe, I didn't say dress up!" And he'll say, "I didn't dress up, this is just really regular." But what actually happens is I get really insecure. I see how great he looks and I can't help but be jealous. Physically, he's a god compared to most people: six foot four and completely chiseled. Hank can basically wear anything he wants and make it look like he spent a thousand bucks on it. Black sweaters, long-sleeve button-downs, a tight T-shirt—he can rock anything. Me? I've got to go through a dozen outfits before I can find one that will do. I'm not tall, I'm not stick-thin, and I don't consider myself a fashionista. I know I

can look a lot better in a tank top and a pair of exercise shorts. So going out and finding a blouse or a top or a pair of pants that makes me look and feel the way Hank does is not easy. I'll be done with my hair and makeup and he'll ask me how he looks. I'll get so mad and insecure because I need to find an outfit that looks as good as his.

I remember when I was still trying to lose weight after baby Hank was born and my clothes did not look good on me. I was really insecure and feeling like shit because I wasn't losing the weight. Of course, Hank would come out looking hot. I remember going into my closet and trying on every single outfit, every dress I owned. They all ended up on the floor. Nothing looked as good as what he was wearing, so I started crying. I love Hank so much because he's honest. Sometimes he would be like, "Yeah, I can see what you're saying about that dress and how it looks there. Maybe it's not the best look, so let's find something that is." I love that in a guy, but some girls hate that. I appreciate the fact that he's honest with me. But if I put something on and I hate it and he loves it, that's when I'm like, "Oh, hell no. Are you just saying that because we're going to be late and you want to leave?"

When we go on a date, sometimes we'll call in a town car because we want to have some wine and we don't want to drive—we are against drinking and driving. But it has to be a town car and not a stretch limo. We are too down-to-earth to show up at a restaurant in a limo, just me and Hank. We don't want to look like that. I get worried that paparazzi will catch us or a reporter will see us and I just don't want to look like that. I just want to be so intimate with Hank. I don't want to feel cheesy. I want it to be normal.

Other times we decide to drive ourselves, and when we do that Hank always puts on really, really romantic music. He's the man! We are people who love good romantic throwback music—we have

a handful of songs that we put on. We have a playlist on our iPod that's our date night soundtrack. I call it Hank and Kendra's cheesy love songs for the road:

- "My Cherie Amour" by Stevie Wonder
- "Caught Up on You" by .38 Special
- "Take Me Home Tonight" by Eddie Money
- "Why Don't We Just Dance" by Josh Turner
- "Sold" by John Michael Montgomery
- "When I See You Smile" by Bad English
- "Forever and For Always" by Shania Twain
- "I Wanna Know" by Joe
- "Show and Tell" by Al Wilson
- "As My Girl" by Maxwell

So we put it on, and the second the music starts I feel at ease. The music that we have and the songs that we have are so romantic. They have the words that just make you feel so at peace and so in love, it's almost like one of those late-night infomercials for love songs! When we are romantic, we go all-out with romance. We're driving at sunset, and every stoplight we look into each other's eyes and say how much we love each other. Red lights reflecting on our faces, green lights. It's a very sexy, calm feeling. Even with all the insecurities, when we get on the road I feel calm. We talk to each other about how much we love each other and why. Date night is for a husband and wife and we're able to leave the "mother and father" aspect of who we are at home.

We'll be cruising down Ventura Boulevard or Sunset Boulevard listening to "Caught Up in You" by .38 Special and "Take Me Home Tonight" by Eddie Money. Songs like that make us feel so good. We look at each other and it makes us see how much we love each

In Hawaii, Hank spelled out our initials in flowers. What a romantic!

other and want to be with each other forever. We talk about each other, memories of our relationship, what we're looking forward to in the future. We laugh at certain things, we share, and most of all, we just have fun with each other.

Hank is the cheesiest romantic guy I've ever met in my life. I'll have a couple glasses of wine and be laughing my ass off, almost peeing in my pants because he is so serious about being romantic. I have to laugh because I have the man that every girl dreams of when they're starting to fantasize about marriage. Sometimes I can't believe I have him. He's so perfect—sexy and romantic—and he never lets me go to bed without a kiss.

On date nights, we try to take our time over dinner. Our goal

is to drag out the meal as long as we can, to savor it and not be rushed. This is our time. Usually Hank orders two dozen oysters and sucks them down in a matter of seconds. He'll smile at me over the platter and say, "Oh yeah, baby, be ready for me." Every time he has oysters I know he's going to attack me later that night. I usually order soup or salad, but I might suggest that Hank order something so I can try a little too. He hates when I pick off his plate; that's his pet peeve.

Of course, besides our aphrodisiac meals, we'll also do some spontaneous little flirting like under-the-table footsie. Oh yeah, we don't just limit our touching to footsie. We've introduced handsie into the mix. If we're at the jazz restaurant, say, and it's just the two of us and it's dark and we're in a little booth with candles lit, we're going to have some fun back there. Just a little rubbing and having fun—nothing too scandalous for a restaurant but just enough to get Hank to say, "Check, please!" At that point we start talking about what we're going to do to each other and how we always want each other in the car right then and there. We always want to have sex in the car and we do, a lot. We love having sex in the car. As a married couple with a kid, that's about as sexy and risqué as we can get. Sometimes we can't wait and it's right there in the parking lot of the restaurant, or if we want even more privacy, sometimes we'll just pull over on a quiet street. Of course, we're always careful about who is around. Let's just say that once we had to stop in the middle of it all and hit the gas and get out of there!

It's a rush. And the car is not only a perfect place for us on a date night (getting a hotel room would be so much effort!), it's also less time-consuming. The apartments we were in for the better part of Hank Jr.'s life were so small that making love and doing the passionate stuff was not right. It just didn't make sense to us. I wasn't in my home; the spaces were too small to have fun with. Our sex,

with what we were going through, was short—we still had a lot of sex, but it wasn't like making love. When we're making love it's in bigger areas and it's a long, drawn-out, time-consuming process. While we were living in the Studio City apartment, I was uncomfortable making love because it wasn't our real home. During that time we, of course, had plenty of sex—two, three times a week—but we didn't make love for a good couple of months because of our situation. So the car makes sense for us when we just want to have good, quick, spontaneous, tipsy sex.

Date nights don't always go as smoothly as that. When we sneak off to a place like Vibrato, we know that's our spot; it's off the map and in a remote enough area that we aren't going to run into TMZ and Paris Hilton. But sometimes we do want a little glitz and glam. Not to say we need to head off to the *Fast and Furious* premiere and pose for the cameras, but we like to check out shows and movies and concerts just like the rest of the world. As parents, we need our entertainment too. When all you've seen is a purple dinosaur talking on TV all day, a rap concert might be just what the doctor ordered.

Hank and I went to a club recently for a concert just looking to have a good time and it turned into the Kendra and Hank show. Usually when I go out people know who I am. It's a fact, especially in L.A., a town obsessed with celebrity and media where everyone knows who is who. We went to the annual West Coast hip-hop show we go to every year to watch my friend Too $hort perform. I grew up on West Coast hip-hop; it's in my blood. It's a part of who I am. Anything to do with West Coast hip-hop, like Tha Dogg Pound, Westside Connection, Kurupt, Nate Dogg, Snoop Dogg. I'm obsessed. So I make sure I go to this every year. Too $hort had put us on the VIP list to hang out backstage, so I decided to invite my best friend, Brittany Binger, to come along. I don't get enough

time to be with Brittany and my husband, the two people I love so much in my life.

When we arrived at the club, I asked the bouncer for my stamp and my wristband. I always try to sit back backstage to enjoy the show in peace. I never sit in the crowd because we get heckled or asked to take photos or give autographs; that's just the reality of being a celebrity.

But the bouncer recognized us and just let us straight in without giving us our stamps or wristbands. So we were backstage letting loose. Kurupt, one of my favorite artists, was rapping and Hank and I were just grooving and having a great time. After his performance we wanted to go over and hang out with him and a bunch of the other rappers. So we left our backstage area to say hello, but when we tried to go back, the guards that let us in before got on a power trip and wouldn't let us in. We had been ushered in without wristbands, so when we left the VIP area and they asked us for wristbands, we didn't have ours. So there we were, standing around surrounded by about a thousand people, and everyone started coming up to us to take our picture. "Oh shit, it's Kendra!" When I hear that, I know it's time to leave. All of a sudden we went from being just a few normal people watching a show to being "Hank and Kendra." Everyone recognized us. I ended up taking pictures with people, signing autographs, and having to put on my happy face. I appreciate my fans but I was there to let loose and be myself, not greet fans.

It ended up being an appearance for me. It was supposed to be a night of fun with my husband and my best friend. It's the same reason I got a dog walker in Philly; it's just not worth it. There are certain freedoms that I just don't have anymore. There are only a couple times in my life where I put my head down and I just want to be away from everyone and have fun for myself. You can call me

selfish, but I'm not selfish 100 percent of the time. I didn't want to take pictures with people, I wasn't in the mood. A lot of celebrities will never tell you that, or they'll have their publicist make up some lame excuse. But I have nothing to hide; I'm not always in the mood, plain and simple. It's no different from letting a call go to voice mail because you aren't in the mood to chat with someone at that very moment. We all feel that way sometimes. That's the way it went on that night, so I ended up taking pictures with people and being miserable; I didn't want to seem like an ungrateful bitch. It ended up not being a fun night for me. Ultimately, we smiled and did what we had to do and then left.

We didn't let the night end there though. We had left baby Hank in Calabasas with Hank's parents, which meant we had the night to ourselves at the apartment. After we parted ways with Brittany, we went out for a few drinks and we ended up having such a great time. We went back to the apartment in Studio City and we had uninterrupted date night sex, with no baby around! It was hard to break the habit of being quiet, but we realized, wait a minute, there's no need! Of course, we still had neighbors and our apartment was so small that I felt like people were listening. I felt like people knew we lived there and if they heard moaning they'd know that was Kendra. It's kind of like having your privacy invaded, the feeling of it. If someone who was next to us heard me moan, they'd be like, "Oh, my God, Kendra! Kendra's an alien and she's having sex. Listen to her, she's an animal. I knew it!" But we made do.

14

THE DANCE OF A LIFETIME

Craziest. Experience. Ever.

Confession: In all honesty I didn't always love performing on *Dancing with the Stars*. I loved being part of the show and cast, but the dancing took its toll. I did it mostly just for the experience, and, of course, the money! Both things were worth it, but it was barely enough for me to get out of the car each day and walk into the dance rehearsal (many times I just considered turning the car around and not doing it). I was psyched about joining the show, but once those intense practices started, I was knocked out pretty quickly.

Did I want to win? Sure! It's always nice to win but it's kind of like the lottery: You don't expect to win and there's not much control you have other than luck. Hank's competitive though; he wanted the mirror ball trophy because guys love trophies.

I wasn't holding my breath. I've never been a dancer. If you're a dancer, you have it in your blood; that's your sport. You eat (or rather, don't), sleep, and bleed for dancing. Still though, I thought I was going to really love it—it's moving to music and I love to get creative. Dancing *can* be fun, and I've had my share of amazing nights filled with hours of dancing at parties and clubs. I thought I was signing up for a fun little reality show of dancing. What I got was the most intense competition I've ever had to be a part of.

I used to always ask Hank, "How come you guys aren't smiling more on the football field and having fun?" And he always told me that while football is fun, it's mostly hard work, drive, and a lot of painful sweat. Dancing is fun. *Dancing with the Stars* is hard work, drive, and a lot of painful sweat.

The first week of filming I thought, "Oh, my God, this is cool." There were other celebrities I was getting to know. And I was getting into shape from the hours of rehearsals each day. Plus, I was learning a few things. But then by the second week I was well on my way to knowing it was going to be a long road. My body was in pain, my brain was twisted in three different directions from all of the moves I had to memorize, and my confidence was at an all-time low. By the third week I started to get the hang of things and realized my memory and physical ability weren't all that bad. I was like, "Okay, I'm back up, I can handle this." That's basically how this competition went; depending on your scores, depending on your performances and practices and the amount of pain your body was in, you either loved it or hated it. The fourth week came and I got very frustrated, because you can't really do what *you* want. You have to play into the show format of ballroom dancing. For someone like me who's not always used to follow- ing rules, let alone being disciplined by a dance teacher, it was a recipe for dancing disaster.

Dancing is definitely something I do for fun, to let loose with friends, to have a good time. But it's hard to have fun on the dance floor in front of twenty-three million people. I would get nervous and want to cry because I have the worst stage fright ever. I just haven't found a cure for it yet either, despite trying recommenda- tions from all of my friends. I've been in the business for almost ten years now; I've done things like rap in front of America on MTV's *Celebrity Rap Superstar*, take off my clothes in *Playboy*, and star on

TV shows. I had fun with it all, but I will never get over my fear of the stage, especially when it's live.

If I went out there and it was *Softball with the Stars*, I would have had the attitude of "Hell, yeah!" I would want to wake up every day and do it, because that's my passion. Dancing in a club with a drink in my hand is me. Dancing around in full ballroom attire complete with makeup on *DWTS* is fun for one night, but going through the process every day became tedious. I secretly wanted to just for one night wear my own outfit, do my own makeup (or lack thereof), put on my own music, and do my own dance. I know that would have gotten me kicked off the show and the last thing I wanted to do was purposely forfeit. A few weeks into it, even though I was struggling, I knew I had a decent chance of making it far. So I put on the costumes and makeup and held my head high. If there had been judges scoring that, I would have gotten a 10.

I looked in the mirror once before going onstage and I just started to cry—I'm not even referring to the makeup and the hair. I looked at myself in the over-the-top costume with the big hair and heavy makeup and thought, "Is this where my career is going? Now I'm entertaining the world and getting all done up?" Part of me was excited and pumped; after all, they did choose me to be on the show, and week after week people were voting for me. But part of me felt like this is what selling out looks like. Maybe I just needed to buy into this after all. I was collecting a pretty good paycheck, which was a good thing for my family; making new friends; and whipping my body into shape, so my spirits were high, and each week I made it further was a little bit more of a push to get me motivated. And I needed the motivation, because other than childbirth I had never experienced such blood, sweat, and tears. Now I had blood on my feet, sweat all over my body, and tears pouring out of my eyes, and that was just after week one! I may not have been an

actress, but on *Dancing with the Stars*, I had to act like I was capable of doing it. Secretly, I didn't think I was.

I was out of my element 100 percent but in a way that was good, because you got a chance to see different sides of me. I had to constantly think and challenge myself physically and emotionally. When I'm in my element I'm a little too comfortable.

I tried to be as energetic as possible on the show and not let my stage fright and unfamiliarity with some of the classic dances come through. I also knew that you have to have charisma and energy to make it on *DWTS*. Of course, it was often very difficult to keep a brave face on.

The night of week four, when it was the Viennese waltz, I got really low scores, my lowest yet. After the taping, the other celebs and dancers, plus my friends and family, tried to console me and offer different advice about what to do: "Don't do that, do this. Don't do this, do that." I ended up crying because it's overwhelming to have people call you on the phone and reach out a million different ways and say, "Are you okay?" At some point, you start to wonder, "Am I okay? Everyone's acting like I'm not." That's one of the hard parts of being a celebrity: So many people around you are trying to give advice when you don't ask. It's not the critics, it's not the mean people, it's the people you care about the most who sometimes drive you insane.

If you think you can't relate to this because you're not a celebrity, try to think of it as if every day is your wedding day. Everyone's a celebrity on their wedding day. On your wedding day, everyone wants you to be perfect. But perfection doesn't exist. America wants their favorite celebrities to be so perfect and a lot of people have this perception that celebrities don't sweat, that they don't have acne, and that they don't get hairs in weird places. On your wedding day, you try to pull that masquerade off. You've been on a diet

for a couple of months. You've been shedding for the wedding and exercising, you've got your tan on, you've had a facial and several fittings to get the dress just right, you've got your hair did—you're a celebrity! But what if you're about to go down the aisle and one of your hairpins falls out and your hair falls down? You want to cry because it's not perfect.

That's the way I deal with my life. Then think of that moment after the wedding and imagine everyone there is like, "Oh, your hair looks good, but that's a shame it didn't stay up." That's not what you want to hear; you want to hear people say, "Oh, you're beautiful." Imagine something so little, so minor, something so small that went wrong and didn't even matter, but people pointed it out on your wedding day. You just want to move on and forget about it, but everybody in the whole wedding wants to come up to you and talk about it. So you cry because it happened, but you're not asking for sympathy. Crying is an expression of emotion. I cry a lot. I'm a perfectionist. If one little thing doesn't go my way I'm going to be pissed about it. I don't care what anybody has to say, that's just the way I am.

It's almost like I'm walking down the aisle in a wedding gown and I just have people staring at me all my life. I can't tell you how many times I've been in magazine features about "stars without makeup!" News flash—I look like a mess when I wake up; sorry to disappoint! Or every time I have a little bloat the whole world thinks I'm pregnant. I know I'm not perfect and being a celebrity reminds me of that every day.

When *DWTS* originally asked me to go meet with them, I was like, "Okay, sure, why not?" People around me had always asked if I'd be interested if the opportunity came up. But I always said, "No, that's not my style." I equated *Dancing with the Stars* with something you do when you want more fame or a reentry back into fame.

But then you look at all of the pro athletes and dancing is certainly not something they are used to dominating, but they give it a shot. So that's what I decided to do. The opportunity did come my way and it was the perfect time for me to grab it.

It was a quiet time in my schedule (aside from writing a book, filming a show, and taking care of my family), and Hank was in the off-season, so he could technically take care of the baby. So I went in and met with the casting director of *DWTS*, Deena Katz, and two other producers for the show. I dragged Eddie with me because I wanted him to hear the pitch from ABC and to be another ear for me.

Casting for a show like this seems like the celebrity version of a job interview, as if it's no different from when you walk into Papa John's and you have an interview with the manager and they tell you about the restaurant and you tell them about your job experience. Most people would go in and say, "Hi, I'm Kendra and I want to be on *DWTS*." They want to hear what you have to say; they want to see your personality. Believe me, there's no dancing involved in these interviews. But I knew better than to go in with that same plan. This was Hollywood, not Papa John's. I walked in and I stated the facts they wanted to hear: "Let's get down to business. My demographic rating is a 1.5 in the eighteen-to-thirty-four age bracket." Yup, the first thing that came out of my mouth was my ratings, because that's my knowledge of this business. If this was Papa John's, I'd tell them how many pizzas I can make in an hour.

Then one of the producers asked, "Do you have any dance experience?" and I said, "Well, I know this isn't ABC appropriate, but I did adult dancing, a.k.a. stripping, and I lived at the Playboy Mansion for five years, where I danced at a lot of parties! I've probably danced more than all the people on this show combined." That summed everything up right there. I'm married, I have a son,

I'm happy in life, I have a show already, so things are working out pretty good. Take me or leave me.

Too cocky? Well, this is Hollywood and I believe you can't look desperate in this industry. I needed them to realize I was a commodity and I already had everything I wanted in life. They saw how confident I was and knew I could perform. I'm all about getting straight down to business. I wasn't looking for friendship or a job. If they wanted a partnership, then it was a deal, at least on my end. So I left the meeting and the next thing I knew I got a call right away and they said, "You're on *DWTS*."

It always feels good to be wanted. While I wasn't going into it to be a professional dancer, it was an honor to be on *DWTS*. You can't get more exposure than on *DWTS*. I was like, "Why not? My fans will love it." Sometimes I don't even do it for me; sometimes I do it for the fans.

During my time on *Dancing with the Stars*, Hank Jr. got to spend his days with Dad, and that's a great thing in itself. To be able to have Hank and our son spend so much time together, we are a very lucky family. Hank was being Mr. Mom while I was on *DWTS*. It's so crazy how many people think that's weird. I want you to know something: Hank had the baby every day with little or no help. I don't know a lot of dads in Hollywood who could handle that situation all by themselves. The only time we hired a babysitter was Monday nights when I was dancing, because Hank wanted to come and watch me. The rest of the time Hank had that baby. I think it's hard for people to accept a father now in that role. When Hank is playing football, I have the baby. When I'm doing *DWTS*, Hank has the baby. It's fair, it's fifty-fifty. That's how we look at life; it's yin and yang. It's all about balance.

When I first met my dance partner, Louis Van Amstel, they told me he was the dancer who had Kelly Osbourne in one of the

seasons before me, and I thought, "I like her, she's fun, so he must be cool and willing to start with a beginner."

I had never watched the show, so I didn't know Louis from Maks. They said, "His name is Louis and he's the one that's gay." I was so relieved, like someone had lifted a hundred thousand pounds off my back, because I worried that Hank would be jealous or uncomfortable that I was grinding with a straight guy. Five days a week grinding with Maks—I can't imagine Hank would have been happy with that. I said, "I'm so happy I got the gay one! That's awesome," but Louis gave me a look when he heard that! He took it the wrong way. I was happy he was gay because I'm a target of tabloid speculation, and magazines are always trying to say I cheated or Hank cheated. So there wouldn't be any issues there. But it started off awkward because I said that.

Louis is very serious about dancing, but I cracked jokes and fooled around on the reality part of the show during the rehearsals because that's how I deal with being nervous in a new situation. But on the third day of rehearsals he was upset with me because I wasn't serious.

There was a move called the *ronde*, where you straighten your leg and point your foot and do a rainbow-type movement, but he kept pushing me to do it higher and higher. I said, "I can't do it. I don't have any balance!" He said, "Just do it!" So I tried and I tried. But I just couldn't nail it. I tried again and again, but keeping my leg that high in the air threw off my shaky balance, and each time I stumbled to the side. Finally, Louis had enough and he snapped at me! It was the third day and already he'd snapped at me for not doing it right. That shut me up and I was like, "What the hell did I sign up for? Why is this guy screaming at me?" I thought the way he yelled at me was inappropriate. And I just started to cry. But I didn't want to be seen as the crier of the show or like I was fighting with

my partner after the first week, so I turned it into something else. I blamed the crying on being uncomfortable with my body, saying, "I don't feel like a girl!" But I really cried because he snapped at me so bad. I didn't know how I would recover from that third day.

I cried to Hank; I cried myself to sleep. Being a mom was hard enough. Going on this show and trying to dance for twenty-three million people perfectly was even harder. Now when I left home and went to the "office," there was even more stress to deal with.

Louis was tough on me and Hank could tell it was bugging me. Hank said he'd go talk to Louis and shape him up, but I held him back. I said, "Hank, let me fight my battles. I can handle it. Maybe Louis will change." But he never changed.

We clashed constantly. He called me dyslexic, asked me if I was learning-disabled, called me ADD. He found my insecurities and would use them against me to criticize me . . . He made me feel so little. From that day on I stopped laughing. I started being serious and then the producers, realizing I had lost some of my personality, tried to get me to be funny again, but I was putting my head down and focusing on the task at hand. Rehearsals were hard work and I had no idea that it would be such a challenge. The intimacy between us wasn't there naturally either. It was hard to give all I had to someone I couldn't get along with. I just didn't feel comfortable in his arms. And it's hard to perform when you have no passion toward the person you're performing with. I'm not saying I didn't like him—I'm sure he's a nice guy off the dance floor—but I never wanted to know him because we clashed so much *on* the dance floor.

I felt like my start on *Dancing with the Stars* was cursed. First I got paired with Louis, then on the first dance night they did my hair in literally my worst hairdo of all time. I put all my trust in the ABC hair and makeup people and the next thing I knew I had bright blue eye makeup that matched my bright blue dress and big

curly hair. When I looked in the mirror, I didn't recognize myself. I looked more like an extra from *The Lion King*! It was my first episode of *Dancing with the Stars* in front of twenty-three million viewers, and I was nervous. The last thing I needed was hair that looked like a giant zoo animal and makeup like RuPaul's.

I panicked and cried and didn't know what to do because it was too late—I had to be on air, live, within minutes. I thought, "Oh, shit, this is over. I look like a mess and people are going to laugh at me and not vote for me." I'm a conspiracy theorist, huge, and I really thought they did that to me because they wanted me to lose. They had a hairstyle on me originally that worked, but they took it down because the producer made them take it down. I had found a fan in the production team and turned him into a snitch, who informed me about some of the inner workings of the show and the decision-making process. He told me that the hair switch came from an "order" from a producer.

There is always drama with me, I know that. But this was bad. I don't ask for drama. It's not my fault they did that to my hair. I try to be laid-back and hands-off, not overbearing. If they had done a decent hairstyle, I wouldn't have said anything. I sat in hair and makeup for hours, and I wasn't even paying attention. They'd ask me what I wanted and I'd say, "I don't care. Whatever you think." I try to be an easy person to deal with, an exception to the Hollywood rule, but maybe I shouldn't be that way.

The rest of the cast came from all different backgrounds and there were a million different personalities. The best part of being on the show for me was the opportunity to get to know so many cool people who I would never have met otherwise. Hollywood's a tough town, so if you're on a show with a group of other celebrities and you have a chance to forge a lasting relationship, you do it. Kirstie Alley and I clicked right off the bat. We are two people

who hate smoke being blown up our asses. I love that about her. She knows what's real and she doesn't hide her emotions. It was amazing watching her lose weight so fast; literally each week she lost a size. She has a diet endorsement deal now because of it. And even though America thought she was having a good time with Maks, he was very hard on her and very strict, because that's the way he does it. And it shows how strong Kirstie is because she handled it gracefully. I would have cried and run and slapped him, but she was so superhuman to laugh and put up with him. But a lot of times I would go over to her and just say, "Good job," because sometimes that's all someone needs to hear. Luckily Kirstie and I have similar personalities in that we don't care what other people think of us, so she didn't let the Maks stuff get to her.

Wendy Williams, on the other hand, was a little hard to talk to. She's funny and seems outgoing, but whenever I tried to talk to her and be friendly, she wasn't really having it. Everybody else tried too, but she didn't really want to be involved in any mingling or any talking. I guess she was busy. She did her own thing, but the rest of us knew we were on a show together, so why not try to get to know one another better?

I've been on Wendy's show before, so it's not like we didn't know each other. But my life is an easy target. A talk show host's job is to drum up interest and make a conversation exciting. The last time I was on her show, she was kind of offensive to me. The sex tape had just come out and she was the only one out of all the media who said any negative thing to me about it. Most people, especially if they were having me as a guest on their show, were supportive. But not Wendy. She made a comment about Hank and said, "He needs to get a divorce before the new football season starts." I was like, "Wow, okay." I didn't really know how to respond. That sat with me forever; I can't look past that. To have someone say to your face

that your husband should divorce you because of something hor-
rible someone did to you a long time ago—even to suggest that—is
totally out of line. Even with that I was still trying to be cordial on
DWTS. Behind the scenes I would be like, "Hey, Wendy, how are
you doing?" I would offer her a drink backstage or just try to make
small talk. Especially on the results show, when all we do is stand
around for a few hours. I tried so hard to break the ice. I wasn't
trying to get anything out of it; I'm the person who wants to make
everyone else happy.

Brooke Burke and I gravitated toward each other the most. She
was down-to-earth and gave the best advice. She was like the mom
or therapist, and she'd pat people on the back and ask if they were
okay. Having her and Tom Bergeron around was great because
they knew the show and the deal backward and forward. Of course,
Brooke won herself a few years ago! Tom was awesome and is prob-
ably the most fun part of the show. Ten years down the road, when
I look back at *DWTS*, hanging out with him will stand out as one
of the best experiences to come out of it. It's such a stressful show
and he is so relaxed and so funny, he made me feel like it was okay
to be myself. Everyone takes that competition so seriously, but Tom
was always there to crack a joke.

This was a big-production show. It was twenty times bigger
than my show, with dozens of cameras and hundreds of produc-
tion staffers. There was no slacking on this show and there were
no mistakes. On my show, you make a mistake and they just film it
again. But *DWTS* was very highly produced, and I didn't want to
mess up in front of the *DWTS* people. It was very stressful because
they were constantly giving us feedback and comparing us to one
another—who had the best dancing, who gave the best interview,
who had the most interesting backstory this week. I was used to
being in control of what's used, but this was different. I had no say

Chelsea Kane and I really "blonded" on *DWTS*.
(© Michael Desmond/American Broadcasting Companies, Inc.)

in the story line. So I was constantly wondering, "How will they play me? How will they use me?" Overall, I was happy with how they portrayed me, even though they made me the whiny person— and yes, I complained a lot, but they also showed me crying in spots when I wasn't actually crying. But hey, there was a lot to cry about!

Luckily, there were very sweet people on the show, like Chelsea Kane from the Disney Channel. I consider her my little sister now. She was so cute and she has so much heart and soul. She's an amazing girl. She's just getting started in her career and I'm so happy for

her. Any chance I got I talked to her, because she wasn't the least bit jaded or affected. I'm like, "Look, Chelsea, I know you don't need anybody, you don't need a mentor in life, but I'm just letting you know this Hollywood life is not always going to go the way you want it to go. If you ever need anyone to talk to, I'm here." I don't want to see a young girl getting taken advantage of. It happened to me a million times and I never had anyone who said, "Call me if you get in trouble." I wanted her to know that if she ever needed anyone, I'd be that person. I told her, "I'm not trying to be a therapist, but if at any time you get to that point where you look in the mirror and you say, 'What am I doing? Who am I trying to be?' call me. Just call me, because I will talk to you and let you know how I got through it. I'm here for you, girl. I want to see you succeed. You have so much heart and soul. You have so much potential." It would have been nice if Wendy or someone was like that to me. Since the show ended, Chelsea and I have remained close. We talked about her coming on my show, and I even put her in touch with Hef, because who knows, maybe one day she'll pose for *Playboy* and break out of the child star mold!

I also got to know Sugar Ray Leonard. He is one awesome guy. I picked his brain every chance I got because I'm a huge fan of his. Every single time I had the chance I wanted to sit by him and talk to him because he's so interesting. He's a world-famous legend. I'm sure he couldn't care less about Kendra Wilkinson, but I was so into Sugar Ray Leonard because I relate to the life of a boxer—getting knocked down and having to get back up and bearing the scars of a million punches. He's all about his prerogative and he's all about "Mind your business and I'll mind mine." That's a boxer's life and that's mine too. I've lived a very public life, and that's why I was so interested in getting to know Sugar Ray Leonard, because he became famous for fighting and hitting people. I became famous

It wasn't always easy with Louis, but I will say this: He taught me how to dance!
(© Adam Larkey/American Broadcasting Companies, Inc.)

because I was a magazine publisher's girlfriend. The best advice he gave me was "Don't listen to what other people say about you." He told me about weathering the storm and how mean people are when you become famous. He said when he retired and tried to make a comeback, everyone called him "old." They said he was too old to be boxing. He said that really hurt his feelings, and he reminded me that celebrities have feelings too, even boxers. It's good to be reminded that there are a lot of normal, sweet celebrities out there with big hearts.

If you look at the cast you can relate it to a high school classroom with nerds and jocks and prom queens. I think that Wendy might have been the too-cool-for-school person. Take Kirstie Alley, probably the biggest star on the show; she was the prom queen. And yet she was just like everyone else, down-to-earth, wanting to meet my family. She loves the baby, and she's invited us to her house. She was like, "When the show is done I would love for you and your son to come over and play with my animals." We got along really good.

Ralph Macchio was like the teacher's pet. Everyone loved him. He's not really the nerd, he's just as close to a perfect person as I've ever met. I always made fun of him because I knew immediately he was the front-runner, so I would say things like, "Ralph, I'm about to Tonya Harding your ass. I'm about to whack you."

Hines Ward was really funny. We had the same view of this show, which was basically "What is this and why the hell are we doing it?" When we would watch a ballet, like a full-on ballerina ballet on the dance floor, me and Hines were like, "Haaaa!" and just laughing, but meanwhile all the other dancers were taking it so seriously. Me and Hines were like, "We just want to go into our trailer, drink some Patrón, and listen to some hip-hop." He definitely knows how to dance, but like me it's club dancing. I was out of my element, and I think he probably was too. So I was shocked when he won! That just goes to show what an amazing athlete he is. Even though he wasn't a dancer, he was in such great shape and had such an ability to be persistent far beyond what any reality star, actress, or singer would have done that it just landed him the mirror ball trophy.

I think it was pretty evident that his dancing partner, Kym Johnson, liked him, but it always appeared to me that Hines didn't really want anything to do with her at first. Hines is a good-looking guy; I could see why Kym might have been attracted to him. But he's an

athlete and a player; I don't think he was looking to settle down. You can take the player out of the game, but you can't take the game out of the player. She's from Australia, so she doesn't know the average American guy. Hines, I think he's proud to be a player and I respect him for that. I respect a guy who walks around and goes, "I'm a player, so what?" I would see her trying to snuggle up next to him and I would just laugh.

On Tuesdays before elimination, Hank would come over to the set and bring a bottle of wine, and we would have sex in the trailer before the results show. Whenever you saw me smiling on camera on Tuesdays, it's because I just had sex. All of the celebs would be giggly and relaxed during elimination, waiting in the results room. Who knows what they were all doing in their separate trailers, but I know what I was doing in mine! I just wanted to make it fun. That day was basically just a recap of everything we had done all week. I would get there at nine A.M., get hair and makeup done (I would sleep in my hair from the night before though so they wouldn't have to spend too much time on it), and then just hang out. It was out of my hands at that point; I had already performed for America on Monday. So Tuesdays were my favorite, because Mondays were so crazy and scary and intense. Tuesdays I would be goofy and try to keep myself busy. One day Toby Keith came and performed, and I love his music, so I had a bunch of wine, and I was drunk and sneaked into rehearsal to watch him. I was a huge fan and I went up to him and I was dancing on the side of the stage like a total dork during sound check.

And then, after seven weeks, I got voted off the show. I was sad to end my run and I knew I'd miss all of my new friends, but I was happy too. I could go back to focusing on my family and not worrying about the judges and Louis.

I feel like overall it was a smart choice to do *DWTS*. I got to

show more of America who I am, and while the producers didn't always play my greatest moments, I knew that I had to create more moments and demonstrate to people who I really was. So I farted on TV. I created that moment. That was my signature moment. That's who I am. I'm so glad they "aired" that. The judges had been so hard on me all season and so critical of me about who I was that I just needed to show America who I really was, not who the judges portrayed me as.

It was important to impress the judges, but ultimately it was a popularity contest. The producers were going to keep the people on who best helped the buzz of the show. It was obvious and common sense who would be eliminated first: no one had ever heard of Mike Catherwood. Compared to Kirstie Alley or Ralph Macchio, he's just not someone who is in the spotlight. I'm not sure if he and Wendy Williams were even trying to be good; it was obvious those two were going first. Wendy's got a successful talk show on the East Coast and a family; I can't imagine she was focusing or putting her all into it. It's hard being away from your life. However, it was obvious that Kirstie Alley was going to be the star of the show from day one.

When *DWTS* told me I had the gig, I assumed I'd have a decent shot at winning. I'd been on a hit show, been on the covers of magazines, and had to be a good buzz getter for the show. But that was before I saw who else was on the show. When I saw Kirstie Alley announced I realized I wasn't going to win. I'm honest with myself; it's all about popularity, and when I saw the Karate Kid and a Super Bowl champ and a wrestler, all of a sudden my cable show and tabloid popularity didn't mean much. At that point I knew I just needed to try my hardest. I'm not saying the show is rigged—there *is* a level of skill involved—but this isn't the presidential election system either. The hard part was making Louis buy into this. He kept thinking

that the harder you dance the better you do. What Louis never got was that no matter what happened during the course of the season, Kirstie Alley and her weight loss were going to take her all the way to the finals. I was always aware of what this show was all about.

I knew my demise was imminent during week four when I did the Viennese waltz and Carrie Ann Inaba judged me on my "elegance." She said I was "afraid of elegance," but she wasn't concentrating on my dancing, she was concentrating on my life. The judges were making me into a *Playboy* stripper; they weren't letting that go.

Carrie Ann's comment wasn't that mean, it was just the way she said it. She was referring to my life. This wasn't a reality contest, this was a dance contest. If I smelled my armpits off-camera or dressed like a slob in sweatpants all day, then so be it. But don't judge me. It's not *Living Your Life All Day with the Stars*, it's *Dancing with the Stars*. Judge me on my dancing, not my elegance or lack of elegance because I talk about getting my period. They weren't looking past that and I knew at that point they had decided my destiny. It dawned on me that all season they were always commenting on my boobs or my character. So it was always just a matter of when I'd go, not if.

It was a Monday dance night. Each week has a different task you need to do, with new costumes, new interviews, and new stories, almost like a plotline for that week that producers would capture during filming, but I hadn't been assigned anything. So I knew that I wasn't moving on because the production direction had stopped. That's show business for you! It was the beginning of the end.

So we started dress rehearsal and Louis was being nice. Something was different. He was being smiley, giving me compliments, and sympathizing with me, praising me, showing me love, being nicer—it was so weird! He kept saying, "Good job!" He made me

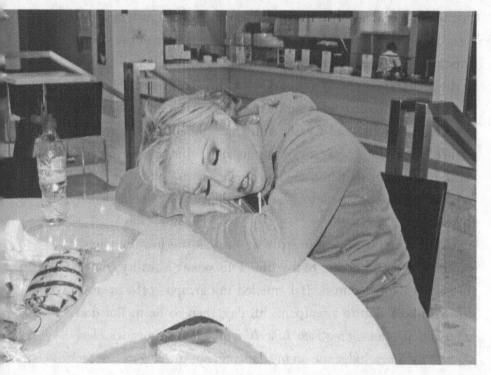

Power nap! Take it when you can get it.

believe I could do the best I could do! For the first time in seven weeks, during the tango, I finally felt good about myself because I saw a smile from Louis. So afterward I said to Hank, "Louis seemed very different, he seemed happy and nice to me." And Hank said, "Oh yeah, good. I guess that talk worked." Hank had finally had that talk with Louis. I don't know what he said and I don't want to know. He must have scared the shit out of him because Louis was a totally different person. But at least I got to walk away happy.

Dancing with the Stars was a lot of stress on my body and my brain. I spent countless hours in the tub soaking my muscles and even more lying facedown on my pillow wishing I didn't have to do it anymore. Not that I didn't have fun—I did—but it's excruciating having to get up there and perform every Monday night

after practicing every day of the week for it. Someone like Hines Ward, who's won Super Bowls and thrives on big moments and competition and and has a "practice makes perfect" attitude in life, is better suited for *Dancing with the Stars* than a mom whose only high-heeled dancing experience came with a stripper pole and crumpled-up dollar bills. It was a challenge, and one I'm very proud to have stepped up to, but I think I'm done with the ensemble celebrity cast for a long time. I don't see myself joining *Celebrity Apprentice* or *Celebrity Rehab* any time soon. I love being on E!, I love being a hidden secret. ABC rakes in about twenty-three million viewers a night for *DWTS*. E! rakes in an average of only 1.5 million for me, but if I had a choice, I would want to stay on E! because that's just who I am. I don't like twenty-three million people watching me, I like 1.5 million people watching me. If someone told me that 1.5 million people were watching me on ABC, I would have probably won the competition. Oh, who am I kidding? I'd die to have that kind of audience for my show!

It was good to get back to my life after *DWTS*. I had a couple of weeks of "free time" before filming for *Kendra* started up again. At this point, we were moving into our new house in Calabasas, doing preproduction meetings, and getting ready for season number four. I didn't realize how much I loved my little cable show until I saw how much effort and stress went into making a big blockbuster network show. Luckily for me, my skills of being a mom and housewife score me 10s across the board on *Kendra*. It was nice to be back in my "normal" home life with my Hanks.

15

KENDRA THE SHOW

*B*efore I got my own show, I had to surround myself with the right team to get me on the right path. As far as anyone else was concerned, I was just this bimbo with big boobs who liked to dance on top of bars and take tequila shots. I was known for being the backup girlfriend to Hugh Hefner. I was supposed to smile, show some cleavage, and kiss him on one of his cheeks (the other cheek was usually reserved for Holly or Bridget). But what I knew was that was just me trying to be what everyone expected. I was slowly outgrowing that and plotting my next move. What they never expected is what came next.

When I started to realize at the Playboy Mansion that I could make my own business out of me, I also realized that Playboy was only worried about Playboy. Especially during the third and fourth seasons of *The Girls Next Door*. If I wanted to appear on a show like *The Tonight Show with Jay Leno*, the Playboy publicist would call me and they would tell me what I could and could not say. "Kendra, you know that doesn't look good for the Playboy brand," or "Don't talk about yourself so much." No one but me was concerned about my future. It was always Playboy, Playboy, Playboy. That's when I woke up and I hired people for me. The "me" factor is really important. We are taught to be selfless, and share, and be considerate of others,

and I totally get and respect that. But when you are your own business and you make money off of yourself, you have to forget about selflessness and sharing and instead put your "me" mode into high gear. You can be all about yourself and still be nice.

I was searching for a manager or someone who could guide me and build me. The big-time legitimate agents weren't knocking down my door; at this point I was just a girl who had been on the cover of *Playboy* and lived with Hugh Hefner. But I did finally meet someone who promised he'd get me some deals. He ended up being a worthless nobody who used me. He just hung on my coattails, and I don't know why I let him. I just didn't know any better. I wasn't the least bit business savvy back then. It was an *Entourage* type of thing. He had never represented anybody before me but he was a smooth talker and I thought he could swing some deals for me. Instead I felt that my money had been mismanaged and I ended up almost suing him. I'm sure that happens every day in Hollywood, but I didn't know any better. I was young and had no experience, and I was desperate to break out on my own. We did a lot of cash deals and I wasn't sure what moneys were coming in and what percentage I actually was supposed to get. Now I don't even talk about a deal without some form of written communication.

It took a while to form my team. I went through a couple different publicists and associates who didn't understand how to help me make it happen, and I had to learn what I was looking for and how to represent myself before I could actually build my dream team. I had to go through the bad to get the good. But I was always aware that I needed to find people who could help look after me as a brand and my career. I just couldn't always do anything about it.

From there I went to different agencies trying to find new people. They tried to wow me with their big buildings and fancy artwork hanging in the halls. Everyone in this town tries to one-up each

other and show off. "We've got a company jet, you can use it." "We represent Tom Cruise. We represent Brad Pitt." We we we we we we. No one was talking about *me*. It was during this time that I met my current agent, Brian Dow. He wanted to meet me at Pinkberry because he was craving frozen yogurt, and I was like, "Okay, I'm going to work with you." I didn't know him at all but that sounded so much more "me" than anything about a private jet or Brad Pitt at this point, and after meeting with him, I knew he was right for me. Any guy who bases a meeting around frozen yogurt is the right guy for me. He didn't try to put out all the bells and whistles, he was merely about results (and a large Pinkberry with almond toppings).

Brian's first move was to send me on some publicist interviews so I could find someone to protect my image and help me shape it. My first Hollywood publicist was a huge mistake. I don't think she understood who I was or my fan base. What works for Jennifer Aniston isn't going to work for me. I was coming off of Playboy but was ready to branch out. I wasn't expecting the cover of *Vanity Fair*, but I did expect everyone I worked with to hop on the "let's do this" bandwagon. I was excited when they set me up for a big interview with *Us Weekly* magazine. Here I was going into a big magazine to tell my side of the story: "Hef's girl tells all." It was *supposed* to be fun and bubbly, but it turned into a disaster. My publicist didn't tell me how interviews worked, and I stayed in that interview much too long.

During those couple of hours I said a lot of things I regret, things I shouldn't have said and wouldn't have said if I had received better guidance from my publicist. I gave in to passion in the moment and I didn't know what to reveal and what not to reveal. The interview basically made it seem like I was bashing Hugh Hefner's way of life. In reality, I was just angry about the way certain things worked out and I probably got too involved in my own fame to know when to keep my mouth shut. Now I know that you don't give a magazine

like that that much time for an interview. I've done a million interviews since, and let me tell you how long they are supposed to take: thirty to forty-five minutes. Hang. Up. The. Phone. Or in this case, just walk away. But this was the worst of the worst. They were telling me it was going to be this big question-and-answer session. Next thing I know the article comes out and it's a big, explosive tell-all. Oops! It looked like I was slamming Hef and Playboy and confessing to doing all of these horrible things when really I was just answering very tough questions they had preplanned. The magazine did its job in getting the ultimate interview it wanted. I felt like my publicist didn't do her job in protecting me.

It was the most embarrassing article of my life. I was devastated that I let people down, and I felt like my career was more out of control than I realized. I fired my publicist right on the spot. She completely didn't have my back, and instead of handling my PR, she dismantled it. I almost lost my job, my family, and everything I had because of that article. My family was pissed at me, E! was pissed at me, Playboy was mad at me. Pretty much anyone I could have talked about over the course of that interview (i.e., everyone) hated me. Kevin Burns, the executive producer of my show, called my publicist and bitched her out. He was like, "What the fuck do you do? All she's got is who she is and you destroyed that and pissed off a lot of people." That is when I got really fearful.

It was at this low point that I began to really meet the people who would form my team. After a few disastrous experiences with typical Hollywood publicists who almost ruined my chances of creating my brand, I met with Kira Costello, who would become my publicist. She was very sweet and attentive. That is when I learned what this business is all about. When I met with her I said, "Tell me what you do, who you are, and what you can do for me." I should

have said that during my first set of meetings with all of the losers before. I learned a big lesson from being beaten down. So I gave her a challenge. I didn't say, "Fix my problems," I didn't say, "Go get me the cover of *People* magazine." Her biggest test was to get us into the *Transformers* premiere. Hank is a huge fan of *Transformers* and I wanted to take him to the premiere. At this point I wasn't an automatic RSVP—my name didn't always get me into things I wanted. So getting me into the *Transformers* premiere at the very last minute wasn't easy. She ended up doing it and we hired her. When Kira got that for me, I knew she was the publicist for me. Plain and simple, she was working for me and got me what I wanted. I'd build from there. The two biggest decisions I made in my professional career were based on Pinkberry and *Transformers*. It actually doesn't get any more Hollywood than that.

Now I have my agent, Brian; I have Kira, who went from being my publicist to my branding agent; and I have a group of others who, depending on what projects I'm working on, pitch in. I finally took charge of my life, which is a great place to be. I can't tell you how many people I talk to who tell me they are afraid to fire their nanny or they hate their secretary or business partner. I've learned that if you've got someone holding you back, you've just got to move on from them. Now I know my team is out there protecting my image and working hard to grow my brand. I've even got Playboy's PR people still involved in my life and I've learned to love them. As long as I stay on the up and up about Playboy I'm all good. I'm glad I still work with them. (No, they did not make me say that or pay me to say that.) And, of course, I've got Eddie.

Ultimately, it was this team and all of their hard work that landed me my own show. The successful transition from Playboy Playmate and supporting cast member of *The Girls Next Door* into full-on star of my own show, *Kendra*, had been completed.

Shooting a reality TV show is a lot harder than most people realize. A soap opera or even a sitcom takes a script and rips through that script trying to bang out as much dialogue as possible in one day. Come in, say your lines, head home. Sure, it takes a while to put one episode together, but all in all the words and the story are there and you just have to try to get it right on the first take. If you don't, you try again for take two. But imagine if the actors actually had to come up with their own material. Or invite the production crew into their home for extra footage. Imagine there was no real script. I think we all saw how Charlie Sheen did in his stand-up routine when he didn't have the *Two and a Half Men* producers writing the jokes for him. He bombed and was booed off the stage. That's my show in a nutshell, a dramedy without a script.

We shoot a whole season over the course of three months. But it could take a week to get one episode's worth of footage. For season four we started filming in June 2011, with the show scheduled to air in early fall. That is a short period of time for TV. But when you are having meltdowns and marital woes, raising a newborn, and moving all around the country, there's never a lack of material.

During the first month of shooting, the cameramen act like flies on the walls, just catching up with our lives and seeing what happens. The producers just want to get a sense of what the new issues are, what we're fighting and crying over, and what's coming up. They also try to recap some of what the viewers have missed out on over the last few months, what has happened during the time we have been off-camera. The first month is dedicated to natural "real" reality. It's almost like a documentary; they are just there for everything.

The first month we have ten-hour days, three days a week. Those are the days we don't schedule too many meetings and I try to live a normal version of my life. And I know everyone thinks reality TV is fake, but here's the thing: It's up to me to provide

good footage for the story department. They are the ones who give us feedback and say we need this and that. The less direction I get from them, the better I know I am doing. It's up to me to be funny and give them some drama. If I have a lot going on in my life, we are golden. If they just tape me changing Hank's diapers, I'm not sure that's so entertaining.

Let's say on August 15 I film a scene where I'm driving in my car and I get stuck in a traffic jam for an hour and am late for an interview (50 percent chance that will happen this week or today, FYI!) and have a complete panic attack. The producers love that. It's real, it's relatable, and frankly, who doesn't get all freaked out about being stuck in traffic when you need to be somewhere? So the story department will come back to me a month later and say, "We really like that scene you did, but we didn't get quite what we needed, so we need you to be in the same outfit from that day, and we're going to have to go out and get in a traffic jam on that same highway, but we need you to be angrier and more out of control." So we'd have to drive back out and find the traffic jam (which, in L.A., isn't that hard to do) and I'd have to react to the traffic jam again. It's basically cleaning up the first month.

I try to give them what they need that first month. I try to be funny. I'm never fake. But I might push the envelope a little. Look, if I'm stuck in an hour-long traffic jam, my reaction is going to be frustration, anger, and panic. There's no faking that. And if you drag me out to that traffic jam a month later, believe me, I will have the same reaction, if not harsher and even more pissed.

E! is kind of known as one of the glamorous cable networks, showing you the other side of celebrity. They get kind of angry with me sometimes because I don't wear makeup and I wear sweats all the time. MTV is aimed at college-aged kids and younger, Bravo is all about the fashion and rich housewives, and E! has a little more

personality and glam. They are looking for personality, pretty people, and really interesting stories. They are also looking for someone who looks good. I look good, but I don't like makeup and I don't like my hair done and I don't like to wear high heels and tight Herve Leger dresses. I'm not a glamorous person at all, so if I wore that kind of stuff you'd know I was being fake. But look at everyone else on E!; comparatively I look like someone from *Teen Mom*. Sometimes I do have to suck it up and put on makeup in the morning to shoot.

Before shooting the fourth season, my executive producer, Kevin Burns, called me and said, "I would like to see more makeup on you and I would like for you to dress a little better this season." He's a really good friend and like a family member to me, but when he goes into work mode and tells me to wear more makeup it does offend me. My initial reaction is, "Wait. One of my friends is telling me not to be me." Then I have to take a step back and think about why he's telling me that. We're trying to sell something— me. The whole "sex sells" thing really does exist. The Kardashians rule E! because they are the glamorous ones. They're gorgeous and sexy and wear tight clothes and a ton of makeup, and they talk about sex, and dating, and bodily fluids—pretty much anything goes with regard to the female species in the Kardashian world. They play it up on the show. Then you go to my show and I'm like the biggest scrub of them all. And I burp and change giant number two diapers. My executive producer is worried because he fears that I'm not glamorous enough to keep a show running on E!. He just wants the best for me. He wants me to keep my job. He feels like he is saving me by telling me to put more makeup on. He's probably right. I probably would be more successful if I dressed the part. I know the Kardashians get higher ratings than I do, but I can't imagine that has anything to do with makeup.

At the end of the day I have fans who love me for being me. The

network has allowed me to stay true to myself and I think people love that. And year after year I prove E! wrong in their thinking that without the glamour, I'll lose viewers. Hollywood always thinks, "What would the Midwest and the South want to see about Hollywood people?" They think people want to see me with full makeup on, hair done, nails done (everything big!), in tight tops and skinny jeans with heels. But that wouldn't be the real Kendra.

I do understand that I'm making a show for my fans and it's important to me to keep it accurate about my life and experiences, so everyone can relate. But not a lot of people get to live our lifestyle, so while they might be able to relate to my being a mom, there are times fans get a kick out of seeing the fun perks I get to enjoy. The episode where I went to Fashion Week in New York was the highest rated of the third season. Why? Because not a lot of people get to live that lifestyle. It was fun and a fairy tale! A little fashion, a little bit of fun and partying, with drama and realness mixed in.

This season we're going to step it up and show the Hollywood side of my life a little more. We're going to show the ins and outs of the Hollywood lifestyle and look behind the scenes. Nobody has a better story than I do in Hollywood: A stripper and a druggie and a girl who lived in the Playboy Mansion ends up with a loving family and the support system that I now have. It shows that you can overcome things and become the person that you have always wanted to be. The fact that America embraces that by tuning in each week shows everyone loves an underdog.

Of course it's fun to film the parties and the red carpets. But some days I'll sit on the couch and be like, "Go ahead and film, but I'm going to sit here and do nothing all day." Sometimes they use that to show me being a lazy slob.

We have a production assistant in charge of continuity who takes pictures so that we can piece scenes together as needed so

everything will look the same. We have to put our same clothes back on. If we had purple flowers on the table, someone will need to go out and find those same flowers again and put them on the table. That part of the continuity is easy. The hardest thing for me is to get back into the mood we were in on a particular day.

In the second season Hank and I got in a real fight in front of the cameras, but none of the viewers would have been able to understand what we were arguing about because the backstory wasn't caught on tape. So no one watching the episode would get it. The producers caught the fight but didn't catch *why* we were fighting. We had to get back in the same clothes that we were in and we had to put things in the scene that made the fight make sense to the viewers. They had the fight on-camera and they really wanted to use it, so we had to reenact the part where we made up so it would make sense to the viewers.

The fight was real. So it wasn't farfetched to have to reenact it. What happened was I was writing my first book and it was a very hard and emotional day for me; that day I was talking to the writer Jon Warech about a lot of heavy stuff. That was around the time my sex tape surfaced, so me and Hank were already on edge about that, but I wanted to tell Jon a little bit about it too. So after having this draining day, I headed home. Hank was having a bad day as well, and one of the producers told him to be serious because they wanted us to talk about what I had put in the book that day. They wanted it to be a serious scene. Then I get home and the same producer came up to me and told me to be lighthearted and just be myself. She had told us two different things accidentally. The producers like to set the mood, but in this case it backfired. We were supposed to be discussing the sex tape and Hank's acting all serious (and pissed), while I'm coming in all happy like, "Yeah, I make sex tapes every day!" Everyone had gotten their wires crossed

and there was some bad communication. I don't think the producer deliberately tried to get us into a fight, but when you've got a whole group of people meddling in your business, ultimately a miscommunication here or there will happen.

I went in the kitchen where Hank was cooking and he looked really serious. I said, "Hey, babe," and he was overly serious and seemed off. So I responded with, "Someone is in a bad mood. What's wrong with you?" I was laughing, poking at him and making fun of his attitude—trying to loosen him up. And finally he just snapped. He said something like, "Why don't you shut up and be serious?" So then I lost it. I said to him, "What the fuck? Why are you in such a grumpy mood? What's so fucking wrong with you?" I found out later that he thought I was laughing at the sex tape stuff. The show needed me to talk about it and here they were telling me to be lighthearted about it and not dwell on it. It was the one time where we had miscommunication from the producers, and it really fucked with me and Hank. What we said to each other didn't make sense for the story's purposes. The cameras had followed me from the book-writing session, but the fight had nothing to do with the book. The fight was about our response to all of the heavy things going on in our lives, like the sex tape. It was me and Hank really fighting. We made up later that night but the cameras weren't there. So we had to go back and shoot the make-up scene a month after the real fight. If we didn't have the make-up scene on tape then the show wouldn't make sense. The make-up scene is where we explain the fight and what happened.

You know what's funny? I can't even watch my show. I don't want to relive the past; I want to live for the future. I don't want to regret anything I do and say. I think that anything I shoot should be used. I'll put it on at home because I'm superstitious about the ratings, but I'll turn it on and then walk away. But I don't want to

start second-guessing myself and what I say and do. I try not to hide anything. I love to show myself and be open to the world. It really pisses me off sometimes that people criticize me for being a downer or being sad all the time. Who's happy all the time? When people say, "Why are you always so sad?" then I say, "Why are you always so happy?" It's not real to be happy all the time. I'm happy and sad, up and down, tired and energetic. I'm not one of these Hollywood stars who never show their cards. I'd be a horrible poker player because I'm not always grinning from ear to ear; you know exactly what's wrong with me, when it's wrong with me, and why it's wrong with me.

A lot of reality stars have little say in what is being put into the show and what is being portrayed. Those on *Teen Mom* have no control. Like Bravo with the *Housewives*; each one of their characters is being portrayed in a way that isn't really true to what they're like in real life. They are not always in glamorous outfits and talking shit. It just so happens that they cut to eyes rolling every five seconds. One of the Housewives could roll her eyes at a fire engine going by and ruining the scene, and the producers will cut it to make it look like she was rolling her eyes at something one of the other cast members said. It has happened to me, but not to that degree. One time I was watching a fly in the room and they made it look like I was rolling my eyes. But on my show they do it just enough so that it's funny and cute. They would never blow it up into a huge thing.

Hank and I are trying to work hard and provide for our family and our futures. I don't care how rich you are, these days it's never enough to guarantee security. And frankly, even though I have cameras in my face every time I'm changing a diaper or have garlic breath, it's fun being a part of show business, and as long as the ratings are good I'm going to keep doing it. I will stick around as long as my fans do.

16

MOMMY ISSUES

This past Mother's Day, I didn't call my mom and wish her a happy Mother's Day. It was one of the saddest days of my life. And while I believe everything happens for a reason and I always seem to come out okay in the end, I'm not sure what's going to come of my relationship with my mom.

My mom gave birth to me. She raised me, loved me, and gave me a good childhood full of wonderful memories. And for the most part she did it all by herself. This is a strong woman, and I may not have always chosen the right paths, but deep down I know and I believe that I am where I am because of something she did.

It wasn't always easy either. I had done drugs and been a maniac, but she always let me back in the house. She gave me tough love, kicking me out, trying to discipline me, and just being a mom. But she always let me know that our house was my home. And even though the moment I turned eighteen I was out of that house and started stripping, that was my choice, because I needed money. But I always knew that she would be there for me.

Since then we've always had a solid relationship. We would talk a lot and I would invite her out to events or to Philadelphia for football games; I always tried to include her. And when I got somewhere in life, I tried to make sure she felt secure and enjoyed some

of the new freedoms and fun we could have. I'm not a saint—if you've read this far, you know that by now!—but I tried to do right by her, like any kid would want to do for their mom.

When I was living with Hef at the mansion, I introduced her to Dr. Frank Ryan, plastic surgeon to the stars (he recently passed away in a car accident). He showed her what they could do with her face because I wanted her to feel better as she got older. I wanted her to feel more comfortable in her skin. I thought it might help her find confidence and leave the house more and find a man or go see friends. I was worried for her because she never left the house to do things with friends, never really had friends, and basically just worked, came home, popped some dinner in the microwave, and watched TV. That had become the extent of her life, and it was hard for me to see my mom live a life that I considered to be so sheltered. She'd always say, "That's me, there's nothing wrong with doing that." So she came out to the mansion and I took her to get the plastic surgery done—she had a nose job, had a face-lift, had her lips done, got rid of her wrinkles, and had a little bit of laser surgery. She stayed with us while she recovered, and I tried to take good care of her. When she was healed, she had a whole makeover, and she revealed herself during a *Midsummer Night's Dream* party at the mansion. She looked amazing, like a new woman, and I could tell she was having so much fun in her skin. Afterward, she started to dress differently, and she acted ten years younger. She loved the mansion, she loved me, and that made me happy.

Things change though.

When Hank started moving around a lot for football, keeping in touch with friends and family became a casualty, not just with my mom, but with my brother and grandma and all of my friends. When your whole world is in California but you live in Philadelphia, Minnesota, and Indianapolis, you tend not to see the people

in your life very much. That's the way it goes. Throw a newborn baby in there, and even phone calls and e-mails became secondary concerns. It's got nothing to do with my heart; in my heart I love my friends and family. But that first year, man, I just had to focus on the baby. I was struggling to stay afloat. So Mom and I didn't see each other a lot because of all the moving. Sometimes in life you're apart physically, but that should never affect the way you feel about someone in your heart. But my success in Hollywood and ultimately my preoccupation with being a mother took its toll on my relationship with my own mother.

Being a celebrity has its pros and its cons. My life went somewhere I never expected it to go. I'm just doing what I'm supposed to do to live and pay my mortgage and take care of my husband and son. If I'm not a celebrity I have nothing. I never went to college, I don't have another job opportunity, and frankly, if I wasn't doing this I'd probably be stripping. So I'm doing what I need to do to get by. I don't let it affect me and I don't bring it up at the dinner table. My shit stinks just like everyone else's; it's just a job to me. But my mom and other people in my family don't know my life. They just see the fun side, like the occasional influxes of money or vacations or red carpets. My mom, my grandma, and my brother think it's more of a hobby that I'm doing for fun. They'll see a couple minutes on TV of what we are doing and they think, "That's it? You are getting that money to smile and take photos?"

I love my family, but they also need to understand that I have a new family. I would love for them to be a part of that, and luckily my brother and grandma have chosen that path. I don't always do everything right, but I'm trying my best. There is no handbook that you automatically receive when you have a baby, and there isn't one when you enter Hollywood either. Jack Nicholson isn't standing on Sunset Boulevard passing them out, saying, "Here's how to

handle being famous." For me, the rule is just "Don't ever forget where you came from." And I don't mean the 120 miles from San Diego to Hollywood. I mean in your heart.

There are celebrities out there whose entire careers are based on partying. They're not married and they don't have children; they just get drunk and host a party. For a short period of time in my life several years back, that was me! I'll be the first to admit that I can see why the average person would be jealous of them. Who wouldn't want to live that lifestyle when they are twenty-two years old? But if you know me, what I've gone through, and what I do every day, you should be able to see past that and realize that's not me now.

My mom became one of those people who watched me on TV and saw me in magazines and thought those were what I was choosing as my priorities in life. Because we haven't seen each other in a while, and I went two weeks without calling her, she started to believe I was choosing fame over family. She'd watch *Entertainment Tonight* and see me posing on the red carpet and blowing kisses at the TV and wonder how I had time to make the appearance and blow kisses at all of America if I didn't have time to call her. If I could call a reporter at *Us Weekly* and give an interview for thirty minutes, then why couldn't I leave her a voice mail? In her mind, it seemed that, Kendra Wilkinson didn't exist anymore. I was now "Kendra."

Well, she's right. I didn't call her for two weeks. We used to talk every two or three days. The baby came, we moved around, and the calls dwindled to about once every week. Then we moved across the country to Philly (where Hank subsequently left me) and the calls dropped to once every two weeks. Time flew, I forgot to call her—and anyone else I loved too—but she couldn't accept that as an honest mistake. I wasn't feeling like myself and I didn't

have anything upbeat to share, so I just didn't feel like talking. She wouldn't accept my apology, and she appeared unable to accept the fact that my marriage and having a child and a career became my priorities. I did put my child and my family life before her. I'm just not sure if that's wrong of me or not. I look at my beautiful son and I know that I have to give him my all. He's so thoughtful—he shares his food and toys, he loves getting hugs and giving kisses, and he loves nothing more than to be around people. He's a good boy and a direct result of the time and effort I spent with him. I wonder if my mom thinks I've done something wrong in that department. She's never once said, "Kendra, you did well."

The first week I went without calling her I was really busy. Monday turned into Tuesday, which turned into the weekend. But then the second week came up, and I wondered why she hadn't called me to check in. Hank Jr. was teething and had a really bad cold. I wasn't sleeping and neither was he. As a mom, I had to focus on what my baby needed. I just couldn't call, and anyway, we should just call each other when we want; it shouldn't always just be me having to check in. So I tested that a bit and waited to see when she would call me. I didn't make that a big deal at the time because I was so busy; if a call didn't happen it didn't happen. I still loved my mom, I just didn't have a moment to spare in a hectic fourteen-day period. That's life!

Then the two weeks came and went, and Hank got released from the Eagles and we were trying to plan our life and future with him leaving us. Hank was gone after that day so I was dealing with all of that. Calling my mom dropped on my priority list again. But what I really needed during that time was for my mom to call me. I was twenty-five years old at the time. I still needed guidance and a mom to say, "How are you, Kendra?" I know she probably needed that from me as well.

I could have made more of an effort; maybe I *should* have made more of an effort to call her and make sure to update her on our lives. But truthfully, our relationship had been deteriorating, and phone calls became stressful for me. I was struggling with some things she had said to me and the way she was treating me. It was easier to push off calling, until eventually I just stopped. Deep down, I love my mom and I just kept assuming that she would always be there for me.

So eventually, I called my grandma and asked, "Why isn't Mom calling me?" She said that Mom was going through stuff that I would never understand and that as she was getting older, it was hard to watch me have so much in my life. I was so happy and had a family, success, and my whole life ahead of me. But really, I was also struggling at the moment—my husband had just gotten fired from his job and was leaving us to go halfway across the country; my life wasn't perfect and certainly wasn't easy. As a mom myself, my family was my concern. I just wished my mom could be happy for what I'd accomplished and help support me when times got tough.

Finally my mom did call me later on that day when she heard I'd called Grandma. She was furious that I had called asking about her. And we got into a big fight!

I asked why she didn't call me when Hank got released from the Eagles.

"Me call you? Why haven't you called me?" she said.

And I agreed with her. I said, "I see your point there and I'm sorry. It's been a really hard time for me, I'm not perfect. Raising a baby with everything going on in my life has not been easy. I'm completely overloaded."

During this phone call, I realized we had more issues between us than just not having spoken in two weeks.

At that point I had to see her. I couldn't travel down to San

Diego to visit so I flew her into Philly, and we sat down on the couch, face-to-face. She said what was on her mind: "Kendra, you are so mean. You treat people like shit. People around you just kiss your ass and are doing everything for you to please you and kiss your ass."

I sat there and took it all in. The only thing I said in response was, "Mom, I pay the people who work for me. They work with me. I'm a boss just like any other boss in the world. I run a business; you have to realize that."

She has it in her head that these people work for free and just do whatever I say because I'm famous and they want to tag along.

Our face-to-face chat only made things worse. I got to see who she really is, and while I wanted to understand her, help her, provide for her, and make sure she knows she can be a part of our lives, it was obvious she had years of anger at me built up. Maybe she felt like she was being left behind, but for most of my life I had always lived less than ninety miles away. I hated thinking it was jealousy or abandonment, because I didn't want to feel guilty for the beautiful things in my life. My family, my husband, my son, my career—they are all things I shouldn't be made to feel ashamed of.

But she started saying and doing things that made me question everything.

She actually told Hank that the day he proposed to me was the day she lost her daughter. My heart skipped a beat when I heard that. She was smiling and so happy the day of my wedding. I thought she was so happy for all of us, happy that with everything we had been through I finally had found a man who loved me and we were going to build a life together and give her a grandchild. But I think that was all an act. That devastated me.

I feel really bad that she has turned all of these positives into negatives, which makes me feel sorry and completely compassionate

toward her, but I also can't hide my own feelings. I'm angry at her and think she's being selfish. I know that's not right of me, I should be concerned for her and I am, but I'm also angry. No mother should disapprove of the day her daughter finds love and happiness. Hank and I were in shock. To think the most important person in my life disapproved and wasn't happy about it drove a stake right through my heart.

My heart still aches thinking about it, and my stomach ties itself in knots. This is another one of those adult situations where you wish you could just crawl into your childhood bed and wake up in the morning and find that everything's gone. But the weeks go by, and nothing changes unfortunately.

I've come to the point now where even though Hank and I don't have a relationship with my mom, I've allowed her to keep seeing baby Hank. I wouldn't keep her from her grandson, but my husband is done. After she told him that she lost me when he proposed he was done. That made Hank cry, because for him that too was the most beautiful day of his life. My relationship with my mom aside, I want my son to have a relationship with his grandma. Right now baby Hank is saying "Grandpa" and "Grandma" to Hank's parents. It's the cutest thing in the world. And he could be saying "Mimi" to my mom too, but he's not. I let my brother, Colin, coordinate time between my mom and baby Hank to make sure they get to see each other. He lives with my mom in San Diego, and while I know this situation has him stuck in the middle, he's trying to stay out of it. I really respect him for that, because it would be very easy for him to choose a side, especially that of Mom, because he lives with her. But he's been trying to stay out of it and just be a son to my mom and a brother to me. Colin spent Memorial Day weekend with us, and thankfully our relationship is great.

Family is family and you only get one. But dollars you can always

make more of. Money is only important to me because it provides security for my family, which I didn't always have. Since the day I kicked cocaine, I started to work my ass off. I could still be doing drugs and I could still be stripping, but I made some good decisions and have luckily gotten out of that world.

There is a part of me deep down that secretly knows to work, work, work, make money, and focus on a career so I don't *ever* get back to that point. If I sacrifice things along the way, so be it. I *know* I am doing right by myself and my son.

When the opportunity for *Playboy* came up and I got invited to live at the mansion, my mom didn't fight that. And I gave her money many times. Hef would give us $2,000 every Friday and I would always give her a quarter of that, in cash. Even to this day I have an account that direct-deposits into her account. I don't even pay attention to it or keep track of it; it's just automatic. Money means nothing to me; I've set up situations like businesses, real estate, and bank accounts (and now a college fund for baby Hank) so we can all be secure. But she still calls me selfish. She's been receiving financial help from me since the day I started making it in Hollywood. She can have that to the day I die; I'd want her to.

I worry that my mom holds everything against me. The things that have made millions of people across America love me—my honesty, my success, my family, and my personality—are things I think bother my mom the most. It's sad that I would have to choose between living my life and my mother, but what I hope I can accomplish is to somehow make both coexist together.

Hank's parents are great people and they don't judge. They are the type of people who you need surrounding you, the type of people who are there to help, not take. Hank's parents never do for themselves, they do for other people.

They have never had a problem with my being a celebrity. Hank

was scared his parents wouldn't like me initially because I did *Playboy* (they are very conservative and old-school). He is a huge mama's boy, so it was hard on me at first because I had to tell Hank I didn't want his mom in my room folding our laundry all the time like she liked to do for him. I loved the fact that his mom offered to help out like that, and I secretly loved having a parent around in that role. But I also needed to set boundaries because I couldn't just have Mrs. Baskett roaming around my bedroom whenever she wanted. If I want sex toys lying around in my room that's my right! I don't need my mother-in-law coming in and seeing my vibrator sitting on the bed. But Hank was used to having his mom come in his room to iron and hang his clothes. He cried when I told him she couldn't do that anymore, and when we told her she cried too. But she respected that I was the woman in his life now and that I needed her to have boundaries. She never held that against me. She stepped aside and to this day loves me, Hank, and the baby as much as she possibly can.

As I write this book, Hank's dad is occasionally staying with us at the house because he has cancer. He comes in every few weeks for extended stays to get chemo treatment. That's our family dynamic; we know it's not all about us. If my mom ever needed that attention from us, she could come stay with us.

Would I love to have my mother-daughter relationship back? Yes. Would I want little Hank to have his other grandma in his life more? Yes. I would love for her to be happy with how he's growing and to be proud of me. After where I came from—from being addicted to drugs and partying and *Playboy* to now having my own home and career and having a son and doing the best job I could have ever imagined doing in that department—I would want my mom to be proud of me. Just to reach out and say, "I'm so proud." That's all I need. I have fans who come up to me and say how proud

they are. Neighbors come up to me and say it. I say it to Hank all the time. The world tells me, "Well done, Kendra." The whole world except my mom.

I've set up an e-mail account so my mom and grandma can send e-mails to baby Hank, since no one writes letters anymore. It's an e-mail account that Hank Jr. can have forever and where he will always be able to read e-mails from family members, even after they are gone. So far, only my grandma has sent them.

My mom reached out to Hank when she heard about his dad having cancer. I guess someone told her. Maybe there's hope after all.

tend for himself, so I need to do that for him. So, no, it's all about when life did "just in case."

But as any mom knows, you can't make sure you've got it *all*: bottles, cream, food, milk, formula, pacifiers, toys, false, medicine, and a change of clothes but there's always something you forget, without fail. I was mortified until I prepared for battle. Diapers, check, and food are the items. If I've got all that I to win the battle. I bring extra... as just in case. We are stranded for forty-eight hours straight her... I wish I could walk out the door with just my sunglasses and keys, but those days are

17

PARENTNOIA

*B*eing famous doesn't exempt you from the neurosis of being a first-time mom. Every new mommy is desperate to make sure that she's doing everything right and beats herself up whenever she gets it wrong. And, trust me, there have been plenty of times when I have gotten it wrong.

I am not a perfect mom and I don't play one on TV. But I do a damn good job; not bad for someone who spent the first two-thirds of her life snorting, smoking, and drinking whatever she could get her hands on. I'm not one of these perfect stay-at-home moms cutting the crust off her kids' peanut butter and jelly sandwiches, and I certainly don't throw out a slice of bread because there's a tiny piece of mold on it. Just cut off that part and toast the rest!

I try to be the best mom I can be, focusing on my kid and trying to do it all fast, efficiently, and right. And that's not to say I'm not going to have a little fun with it along the way. But I've learned that once you have a kid, every day is a battle, and no matter how prepared you are, you still never have everything that you need.

I also try to be the most prepared person ever. I always overpack. If we're going out for a few hours, I pack enough diapers for a week. For one day at the park I pack like I'm going out of the country. What if I get stranded? Hank Jr.'s a baby; he can't

fend for himself, so I need to do that for him. For me it's all about what-ifs and "just in case."

But as any mom knows, you can make sure you've got diapers, bottles, cream, food, milk, formula, pacifiers, toys, bibs, medicine, and a change of clothes but there's always something you forget, without fail. I view motherhood like preparing for battle. Diapers, cream, and food are my armor. If I've got all of that, I win the battle. I bring extra food and diapers "just in case" we are stranded for forty-eight hours somewhere. I wish I could walk out the door with just my sunglasses and keys, but those days are over. My pockets are full, my diaper bag is packed, and my head is cluttered! Who have I become? I'm hardly the Kendra that Hugh Hefner discovered or Hank Baskett married, but people change. And caring for baby Hank is my number one priority.

Am I overdoing it? Probably. I guess I overcompensate because the whole world just assumes I'm some dumb Playboy Bunny who got knocked up, so I want to prove everyone wrong.

One time I was in the only place on earth where you can't just go and get whatever you need—on a plane. We were on a charter flight from Indianapolis to Miami for the Super Bowl with just the wives, kids, and some team staff. So here I am on the plane, and it's the one and only time I forgot baby wipes. Wipes: the must-have for all things involving poop, pee, throw-up, cleaning, wiping, and everything that could possibly be wet, crusty, or smelly. I was like, "Oh, my God, no wipes!" My body temperature immediately began to rise, my face turned red, and my heart started beating fast. Real fast. I was minutes away from a nasty case of mom hives and, of course, right while I was in the middle of this panic attack baby Hank pooped badly. Real bad. Like a four-alarm poop, with odors spreading from row to row. So I had to improvise and get a pile of cocktail napkins from the stewardess (can I get a drink with that

too, please?)—or in this case a whole box! It's kind of silly, having a panic attack about not having baby wipes, but I made out just fine. I just had to spend a few minutes doing a little extra scrub on baby Hank's butt cheeks. Things like wipes just make it easier to take care of a child, and we freak out when we don't have them. But I know decades ago wipes didn't exist and everyone made do. Yes, I was crazed, yes, everyone was staring at me while munching on their snacks and drinks, but looking back everything was fine. And he got a clean tushy in the end.

Being a mom has completely transformed me. Freaking out over baby wipes and packing enough diapers to cover the butts of an army of babies is part of that paranoid, overprotective, neurotic frenzy that we moms all seem to have in common nowadays. We just want a better life for our kids. We try to be prepared for everything. But at what cost? About a thousand days ago I was prancing around the Playboy Mansion with not a care in the world. Now any time I walk into a room I automatically look for the safe zone. That's my latest "parentnoia." In case there's an earthquake, I need to know exactly how to get the hell out of there. It's like I'm in a video game, scoping out the lay of the land, eyes and red lasers focusing on the exits and windows and doors. I always have to have a safe zone and plan an escape. I even travel with electrical socket covers everywhere I go so the baby doesn't accidentally get electrocuted. I feel like I have eight eyes in the back of my head, looking at everything suspiciously and always wanting to know who's around me.

I also have these new OCD habits that came with motherhood. I spend half of my day obsessed with disinfecting everything around the house, spraying, mopping, washing, polishing, and, of course, vacuuming so we all are breathing in good air. And we have humidifiers running all over the house, one in the baby's room, one in the bedroom, and one in the living room, and I turn them up to

the max like it's Miami in there. I know that's overdoing it, but I honestly want nothing but the cleanest, safest, most perfect environment for my baby. Plus, when I'm vacuuming and cleaning, I get immediate results, and how often can you say that?

Since I became a mom, I've become a little paranoid about baby Hank's overall safety, and I'm very cautious about going out alone with him. Because of what I do and who I am I feel like I have a huge red bull's-eye on my forehead. I'm not ignorant of the fact that everywhere I go a lot of people recognize me. So all bets are off if I'm with my baby. It's not that I don't want to interact with my fans—I do—but when I'm in "mommy mode," that's it, I'm being a mom. I'm not Kendra when that happens—I'm Mom. As a mom my number one priority is to protect my baby, and my ability to do that is completely compromised when people (strangers!) approach me when I am out with the baby and want to talk or stop me. How do I know their intentions?

There are a lot of freaks out there and I don't trust the world nowadays. I watch Nancy Grace every night. Hank yells at me for watching it as much as I do and tells me it makes me paranoid. But by watching reports about kids being abducted or women being assaulted, I feel like I'm more aware of what is going on in the world and able to build this protective shell around my family. By being prepared and aware of what is going on around me, I can be the mama bear I need to be. The world is so different from the way it was when we were growing up. We don't know who's living next to us anymore, let alone who's fixing the roof or mowing our neighbors' lawns. So yes, I'm defensive. Hank thinks that paranoia forces me to lead a little bit more of a sheltered life than is actually healthy, and I need to work on that.

In most of the places we've lived over the past year and a half, I didn't have the balls to go out much with baby Hank and walk

him anywhere by myself. Hank always did that. I just didn't feel safe walking on the street by myself with the baby. Even if I wasn't famous, never mind the fact that a million naked photos of me are floating around on the Internet, I'd just be some little blond mom walking her baby. There are a lot of creeps out there and I'd be defenseless. Hank—he's a six-foot-four-inch NFL athlete; I'll let him take the baby out for a walk. No one's going to mess with him. It's so sad, but I just don't feel safe. You'll notice that in any of the paparazzi pictures of me and the baby outside, I'm usually with Hank—part husband, part bodyguard.

One of the things that I worry about every night before I go to sleep is whether I'm raising my child to be the best that he can be. I think I am, and I work hard at it. But it's not always easy and I can't always say the world caters to my needs. So sometimes you just have to improvise. Life, as we all know, is not perfect, with the neat little front yard and the white picket fence. I worry a lot about safety, and health, and money. When you've been in danger of losing all of them or have at any point lived without any of them, you tend to want to protect yourself from that; you never want to go back. I married an NFL athlete, starred in my own hit cable TV show, and had a bestselling book, and during all of that time I basically lived out of a suitcase. So much for the white picket fence. Money can't buy you happiness and apparently can't always buy you a place to call home either! But I had my family, and I'll take that over a stupid fence any day.

While life was really stressful during those times, there are some things we as parents just have to do, those "you just gotta do it" moments of parenthood. One that comes to mind is the night we were sleeping in a hotel and I had to make Hank Jr. sleep in his stroller. Babies can sleep in strollers for a nap, or even a few hours if necessary. In fact the last thing you want to do is have a baby who can *only* sleep in his crib. You need them to be able to fall asleep

anywhere so you can go about your business and not be tied to your home. But I had never put Hank Jr. in a stroller for a whole night's sleep, from seven P.M. until seven A.M.! Until I *had to*.

The hotel that we were staying at in Miami during the Super Bowl in 2010 gave us a crib, and it wasn't exactly something that I would ever put my baby in. Some cribs are cute and safe, some are just temporary pieces of plastic you can live with, and then some are just absolute death traps. You can just tell by looking at them—this thing is going to collapse at three o'clock in the morning when we're all in a deep sleep. I'll be damned if I'm putting my baby in a death trap. So we had him sleep in the stroller. Probably not the most comfortable night of sleep he ever had, but certainly safer! We just reclined it and had him sleep in it. Of course that still wasn't good enough for me. Because we had him reclined all the way back, we couldn't strap him in with the safety belts. We just had to kind of hope that he wouldn't roll over (he was really little and wasn't really able to do that, so I wasn't overly worried about that happening). But regardless, I kept him right by the bed and slept with one eye open to watch him. That was back when he was waking up every two or three hours or so to feed, so I went back to sleep one time and then woke up just in time to see him almost falling out. I was like, "Oh, my God!" He was about a minute from literally falling out of the stroller and flopping on the floor. I don't know what it was—maybe a mother's intuition—but by sleeping with one eye open and worrying about it, I was there and able to catch him. Needless to say, I moved him to the bed that night.

As a parent you worry about your child developing as fast as everyone else's kids, being able to talk or walk at the right time, and, of course, making sure he gets into all of the right classes he needs to. So parentnoia changes from stage to stage. While it's worrying about safety when they are infants, it turns into developmental

worries and keeping up with the Joneses' kids as they turn into tod-
dlers. I don't lose too much sleep over it all because I know every
baby is different, and knowing that we are very hands-on and it all
will play out well in the end gives me patience. Every minute of
the day we teach him; we don't stop teaching him. We are doing it
naturally; we know his ability and we don't try to force anything.

Hank Jr. was brushing his own teeth at seventeen months. He
knows what it's for (so the dentist doesn't get mad) and what it does
(cleans out all of the food), and he brushes upper teeth and bottom
teeth.

He loves to know how things work; he loves tools and he knows
how to use a screwdriver, a hammer, and a wrench. He naturally
loves to be a handyman. He's technically from Indianapolis and he
loves cars! It's in his blood. He loves to sit in cars. Sometimes we'll
bribe him by saying, "Let's go take a bath and *then* we can go into
the car." He's a year and a half old and very smart, and he knows
how to use the iPad and he knows which apps are his; he knows
how to use the phone and the buttons to press, and how to use the
remote control for the TV—he's such a boy!

But even as smart as he is and knowing and doing all that stuff
(not to mention physically—he is huge and fast and strong!), he
doesn't know how to verbalize or open his mouth to talk. He's talk-
ing but he's not opening his mouth. That's the hard part about par-
enting: knowing when to be concerned. So many parents love to
talk about milestones and it's hard not to compare. They'll say, "My
son started talking at one," and then I get that little panic in my
stomach that something's wrong with my kid because he doesn't
speak all that much. We are doing everything we can; sometimes I
even open his mouth for him, because I know he's smart, so the first
step is getting him to figure out opening the mouth. Right now it's
all just babble and closed-mouth moaning.

Sometimes being a mom requires patience. And sometimes it requires strength. But sometimes it comes with perks! Lately, being a celebrity mom means getting a lot of free stuff, which I do my best to take advantage of (come on, who wouldn't?). We get gifted so much stuff by companies who not only want to see me in their outfits but also Hank Jr. using their products! I'm not ashamed; I take free strollers, tricycles, and tons of kiddie toys, clothes, and accessories. It's cool! Sometimes if we don't need the product, I won't use it and we'll just donate it to charity, like an L.A.-based women's shelter where moms in need can give it to their children. But if it's stuff we need, I use it. Strollers these days can cost $500 or more if you want a really snazzy one, so when a company offers one, I'm not too proud to take it.

Hell, sometimes I wear free clothes I get sent too. Plus it saves time on shopping! Some mornings, I'll look in my closet and see something new that Eddie put in there because someone sent it to my agency or my business manager. If someone sent you ten free gorgeous pairs of jeans in your size that fit you perfectly, wouldn't you wear them? Companies find a way to get their products to me. They'll send boxes of clothes, books, jewelry, or alcohol. Sometimes they'll see their product on my show that we use, like a drink or a type of snack, and they'll send cartloads of it to me.

I know a lot of celebrities will only wear clothes that they endorse or only drink a water that they advertise for, but I can't get caught up in that stuff. If I get a pair of jeans and I like the way they fit and look, I'm going to wear them. If the company profits from it, good for them! Same goes with my kid. He needs toys and clothes and baby stuff—if someone's going to send them and I don't have to go to the store to buy them, all the better. Anything that saves a little time and effort is fine by me!

18

KEEPING IT ALL TOGETHER

The last two years have been a wild ride. I feel more at peace with my life now than I ever have—and it took a lot to get here. I remember the struggles, and I try not to take anything for granted. I am in a loving marriage, so I have to nurture our relationship and appreciate my husband. I have a precocious, beautiful son, so I have to kiss him twice before bed and do everything in my power to give him the best life I can. And I have a wonderful career full of opportunities I never dreamed of, so I try to find new challenges and new ways to connect to my fans.

In the past two years, more than ever, women come up to me and say, "Kendra, I'm worried my man may cheat on me. How can we keep our men from cheating on us?" Here's what I always say to people: You can't.

Hank and I talk about infidelity several times a year. It's not something to hide; we are very open about everything. Life is going to go in directions you can't control and people are going to do whatever it is they want to do to try to have a life that is happy. The news of Arnold Schwarzenegger's infidelities came out this year. He had several mistresses, had fathered a love child, and had just been an outright ass to his wife and family. So Hank and I talked about it. We've always had these big chats, whether it's about Tiger

Woods or Sandra Bullock and Jesse James; these are really impor-
tant things to talk about in a marriage. If you are in a marriage and
you see the Tiger Woods scandal breaking, you need to talk about
it with your spouse. Because that guy was supposed to be one of the
good ones, the role model, but it's obvious he wasn't.

Hank knows I will never cheat. I consider him the one and only
man for me, ever. But it's very possible that that type of idea existed
in Sandra and Jesse's relationship or Maria and Arnold's relation-
ship too. You never know.

So one day while the baby was napping, right after the news
of Arnold's infidelity broke, Hank and I were in the kitchen and
I asked if we could talk. And I said, "Did you hear about Arnold
Schwarzenegger? Well, he cheated on his wife; he actually fathered
another child with the woman he cheated with. She was his house-
keeper, and Maria Shriver and his family didn't know about it."
It was all just breaking on the news and I follow all of this stuff
way more than Hank, so he just looked at me stunned. The idea of
him cheating with someone in their house really angered me. I told
Hank, a bit agitated, "Now you know why I don't let any stranger
in my house. Now you know why I don't trust anybody." I limit the
people I allow in our lives in this day and age. I don't trust anyone.
It's not that I think Hank is going to knock up the housekeeper or
I'm going to have an affair with the plumber, but I just don't want
random people around in our lives. Chalk that up to my paranoia,
but my friends and confidants are who I let in. I don't need anyone
else.

I felt bad because I was basically implying that I didn't trust
Hank, which isn't true. I completely trust him. Hank replied,
"Well, what about me? You don't trust me? You don't want people
in the house because you don't trust what could happen?" Infidelity
and cheating is not a fun thing to talk about for a married couple.

But I think it's important and I like to get it all out in the open and reassure myself. It's not that I'm accusing him of anything or that I'm admitting to anything. On the contrary, I just want to make sure we talk about it. It's dominating the entertainment world right now, couples splitting, families getting ripped apart, cheating scandals, so I just want to make sure we talk about how that makes us feel and our relationship. I don't want to ignore it. I always ask Hank why these men can't just divorce their wives. I don't understand why it's so important to stay in your marriage while fucking your housekeeper or the nanny.

When kids are involved that's when I get pissed off. Those children now have a tarnished image of what marriage should be, but even worse, who their father is.

It sucks for the good guys like Hank. They never get shown in the limelight; only the bad guys get reported on. Right now because of guys like Arnold and Tiger, every good man is being questioned. Hank says the most beautiful things to me and treats me like a princess. And while I'm not questioning him, it's very possible that what he says to me and does for me was said and done by Arnold to Maria. Someone like Tiger Woods, who we thought was the iconic good guy and family man, probably said the exact same thing that every good guy says to his wife.

What Hank and I ultimately came to understand from the Arnold conversation is that you can't control what another person is going to do. Maybe they don't get the sex they want, maybe they have a fetish—they're into housekeepers or tattoos or prostitutes. When that fetish hits you're not going to be able to control it. That one split second that the guy (or woman for that matter) acts upon it, it's over. Because it's something deeper than that one second. Yes, they are acting on it then, but they've obviously got it in their head that they need to do this, and you can't stop that.

Thank God my husband's fetish is me. I'm not being cocky about it, I just know it. I text him hot and sexy pictures of me all the time and he gets so worked up over it. I want to be the French maid for him, the stripper, the tattooed girl. Whatever he wants, I want to be his fetish. And I don't do it so that I can keep him satisfied in order to prevent him from cheating. I do it because I genuinely love him and want to have fun with him.

Hank's gone a lot for football, sometimes weeks or months at a time. So we are separated for extended periods, and it's not easy. Crazy things happen when husbands and wives are away from each other. Everyone's heard the horror stories of what happens on movie sets between costars. But I won't let it happen. I constantly remind him of what he has at home. And I do that with video Skype.

We never plan our Skype sex sessions; it's always spontaneous. When Hank's away he'll be working out all day or playing football or hurt or tired, or maybe I spent all day taking care of the baby, so we just never know if we're going to both be in the mood. So our intentions are usually just to chat, but with us you never know where it might lead. Talking turns into flirting, which can turn into a little striptease, and then there's a spark and *bam*! All clothes are off.

Skype sex is like a fantasy, in a way. I love looking at my screen and seeing my husband but getting the chance to pretend whatever I want. For Hank, it's like watching porn, starring me!

I try to surprise Hank and keep him guessing. Sometimes Hank will log in and I'll be wearing a little skirt or a sports bra. Or I'll do part schoolgirl and part cheerleader and then do tiny little things like lifting up the skirt or flashing him my boobs real quick. Or sometimes I'll text him and say, "Let's Skype," and he'll turn it on and my bare ass cheeks will be right there staring him in the face.

It's to keep us connected when we're apart and that much more

excited for when we actually do get to see each other, which can be a day, a week, or a month away. It makes us think about each other. Foreplay starts weeks before sex. For us, Skype is the ultimate foreplay.

There are lots of ways you can go about it to satisfy both of your needs. But the whole experience can be bittersweet because while you're kind of together, you're not actually together.

Afterword

As you can see, Hank and I don't do much by the book. When Hank Jr. was born, we had a lot to learn about being parents. It all seemed to happen so fast—and, of course, on-camera. I tried a "fake it till you make it" attitude and followed my basic motherly instincts to figure it all out. It wasn't perfect, but our experiences as a family over the last two years have been perfectly us.

Most happily married couples live under the same roof. For the first two years of our marriage, Hank and I didn't even come close to that; we spent most of the time on opposite sides of the country. Most couples wait until they get back to their honeymoon suite to get it on after the wedding, and as you know from *Sliding into Home*, we didn't even make it out of the limo before that happened. Most married couples wait until six weeks after birth to start having sex, Hank and I lasted thirty days. We don't follow rules—other than no cheating and no texting and driving. We make up our own as we go. And when it comes to parenting, we found our way by going off instincts and intuition. It's not always smooth and it's not always successful, but ultimately, we're raising a pretty happy, pretty healthy kid.

Being a parent has transformed me in every way possible. And perhaps most surprisingly, it has made me be more social. I admit

I don't have *that* many close friends, but ever since we moved into our new Calabasas neighborhood, I've definitely made more of an effort.

Being a mom introduced me to a different side of friendship, based on sharing experiences, hopes and dreams, and, of course, fears. I didn't meet a lot of real friends in the ten years I spent hanging out in strip clubs and nightclubs. I trusted very few people and as a result had only a few confidants. But it's so much easier when your common interests are being moms instead of partying in the same circle. I met this mom at the park in my new neighborhood and we started talking because we were both there with our kids. That's all it took! You've got a kid, I've got a kid, we are both here watching them go down the slide, let's talk! None of these moms in a million years would have approached me without baby Hank. Being a mom has opened me up to a whole world of friends and experiences I would otherwise have been closed off to.

As soon as I moved in, I became good friends with my neighbor. She has a little girl who is about three years old, and Hank Jr. just adores her (I mean, she feeds him grapes—what more could a guy ask for?). We get together and talk and talk. And what I love about her is that, like me, she doesn't let the "mom" label define her. We'll have a glass of wine (or two) while we're sitting in the backyard watching the kids. We don't talk about diapers and creams and rashes, we talk about tanning and fashion and the news. We don't limit ourselves to just talking about raising our kids. I'm sure a lot of moms, like me, once had a wild life full of boys, booze, and late-night bashes. Now, like me, it's cribs, crying, and hopefully a cocktail here and there. Because I never want to totally give up who I am and where I've been.

Kicking back with my neighbor and a glass of Pinot Grigio, all I can do is smile at how far I've come. I used to think all that

mattered was my body, my looks, partying, and feeling good for the moment. Boy was I wrong. The less I pay attention to those things, the happier I feel. I've redefined myself. People actually come up to me and say, "Kendra, I just wanna say I'm a huge fan and I think you are an amazing mom and inspiration to us all for how far you've come." Yes! That's a far cry from being asked to sign girls' boobs with a Sharpie or posing with my lips on some drunken businessman's cheek for $20 a photo. I got to where I am because I embraced my new role as a mom. And now that I'm finally settling into that role, I can sit back and have some wine. I can fit into my tight jeans again, and who knows, maybe I will take it all off again. But only if I want to.

I know I can't keep reenacting my life forever. This show will end, and at some point (very soon) we want to have another baby. I think we are done after two—I love the balance that we have now. It's so easy to be able to hand Hank Jr. off to Dad when I need to, and vice versa. With two kids, that's just not a possibility. We want to be able to raise our kids and have time to go to the lake and fish. Right now we are planning on two kids and closing the shop. Then again, who knows how I'll feel after we are a family of four. And, hey, accidents happen—just ask Hank Jr.!

It took a few years and a few battles, both internal and external, but I'm finally comfortable with my life, crazy as it may be. Every day I strive to keep the balance between what baby Hank needs from me as a mom and what Hank needs from me as a wife. But right now, I'm enjoying the busy life—scheduling playdates and photo shoots, filming Hank Jr.'s first words and my workout videos—and I try to savor every moment.

At some point I'm going to have to slow down. I don't believe you can successfully raise two children while working as hard as Hank and I do, especially if we want to be the ones raising our kids

and not leaving it to a group of nannies. I know Hank will finish up his football career one day and he'll have to figure out what he wants to do. For me, it's just a matter of if and when I pull the plug on letting the cameras film me. I love to work, but maybe it's in a different capacity.

I have a lot of interests and I hope to find something that I'm good at after *Kendra* runs its course. I might enjoy going behind the camera or out in the field and working on something like a cop show. I would like to start a production company. Everything in my life is natural and organic (except my boobs) and I want to keep living life like that and take each opportunity as it comes. Right now my job is being me, my talent is being a wife and mother, and my goals are trying to keep it all in balance.

It's hard to think about what my life will be like as we get older. But one question I am always asked is "How are you going to explain to your kid what you've done in your lifetime?" Yes, after stripping, being Hugh Hefner's girlfriend, and having a sex tape, I will have to explain to Hank Jr. what Mommy did before he was born, and because she was famous there were consequences. I'm sure a lot of people videotape themselves having sex with someone. It happens. But not everyone becomes famous years later and then has it released. I'm not going to tell Hank Jr. it was a mistake. I don't believe in mistakes. I'm not going to shove it in his face and say, "Mom dated Hugh Hefner and shared a bed with a lot of different girlfriends," but I will tell him what was going on in my life at that time. In this day and age, he's going to find out sooner or later, and I'm not sure if I should bring it up myself or wait for him to ask questions. I'll just do what I've always done and trust my instincts.

These instincts led us to our dream house in Calabasas, now my safe haven in the world. Baby Hank has his own room, and I have my own bathtub, both of which are really important to me. I've

realized that not being in a stable, secure home was the root of a lot of problems when I was pregnant and just after Hank was born. I didn't know where I was going or where I belonged. Of course, there were other forces at work, but I'd like to think it would have been a lot easier to manage if I had been home in a nice cozy house with my husband and other supporting characters. It's like when psychologists ask a child to draw a picture and everything on the paper is floating—that's probably what my drawing would have been like. Nothing was grounded. It's impossible to make the right decisions and live a proper life when everything is in limbo.

There's another side to it, of course. As much as I appreciate putting down roots, there was a part of me that loved the freedom and excitement of moving around. It's an adrenaline rush, moving all over the country. Finally, for the first time in forever, I'm sitting on my couch, in my house with my family, and all I can think about is: "Maybe we should move into a different place." Crazy! I know at the end of the day we bought baby Hank's home. That's all that matters. Unfortunately, not staying still is in my blood. I often feel like life is over if you stay still; I can't accomplish anything sitting in my living room. Getting up and leaving has always been the best move for me. Whether it was getting out of the house at age eighteen, getting out of the mansion, or leaving Minnesota after a total meltdown—leaving and finding a new chapter always works for me.

Of course, I've never really had it this good before. And for the first time, I'm thinking about staying.

Acknowledgments

I'd like to thank my family, friends, and "Team Kendra," especially Hank Baskett III, Hank Baskett IV, Patti and Colin Wilkinson, Mary Stotz, Hank and Judy Baskett, Randy Curtis, Brittany Byers, Brittany Binger, Mykelle Sabin, Jessica Hall, Hugh Hefner, Kevin Burns, Brian Dow, Kira Costello, Eddie Bochniak, Lindsay Albanese, Julia Papworth, Brian "Roxxy" Bond, Allan Avendaño, Steve Fisher, and Jared Shapiro.